P9-DFN-239

3 1113 00733 8645

GAIL BORDEN
Public Library District
200 No. Grove Avenue
Elgin, Illinois 60120
(847) 742-2411

BOXING

James A. Fox

Stewart, Tabori & Chang

New York

All rights reserved. No portion of this book may be reproduced, stored in a retrieval system, or transmitted in any form or by any means, mechanical, electronic, photocopying, recording, or otherwise, without written permission from the publisher.

Original edition © 2001 Editions de La Martinière
Photographs © James A. Fox

Published in 2001 by
Stewart, Tabori & Chang
A Company of La Martinière Groupe.
115 West 18th Street
New York, NY 10011

ISBN: 1-58479-133-0

Printed in France

10 9 8 7 6 5 4 3 2 1

First Printing

At night, on the weekends, on vacation, while his colleagues were enjoying a home life or seeing friends, Jimmy took out his cameras and led a secret life. Jimmy's work had great merit, because he was able to separate his own images from the thousands he saw every day, made by the most distinguished photographers, each with different styles yet all of them with a great inner force. He somehow managed to develop his own independent, personal, creative and inventive style without letting himself be cornered in any way, and he did it with both an innate delicacy and a great determination. As a consequence, Jimmy Fox devoted several decades of his life to photography without many of his colleagues ever suspecting. This is really something extraordinary in these times of superficiality and self-promotion. Over the years he has built up an unbelievable body of work, an almost mystical masterpiece of tremendous intensity. Instead of taking pictures here and there, he has recorded an unusual visual story. Night after night, year after year, the art of boxing has drawn him in and become the great theme of his life. The boxers and hordes of supporters and fans around thousands of rings in different countries of the world have become his friends and family. He has looked for images among the unknowns, fighters who had few chances in life, catching the sparkle in their eyes and the dawning of impossible dreams. Personally, I have often reflected on his artistic talent and been amazed, wondering if there might slumber within the body of Jimmy Fox a boxer or fighter. I also ask myself how he has kept such a consuming passion for photography secret for so long, and whether we didn't realize that a great unknown boxer was right in front of us. Nevertheless, I have never ventured to ask him for an answer.

SEBASTIÃO SALGADO

The Making of a Prizefighter

I was sitting in the private projection room of a film company on the Champs-Elysées in Paris for a preview screening of the first *Rocky* film, starring Sylvester Stallone, amid a selected audience of boxing aficionados. Next to me sat my friend, the boxer Joël Bonnetaz, with his manager Mr Jean Bretonnel and former European middle-weight champion Jean-Claude Bouttier. Before the film started the manager commented that it was yet another of those movies that made everyone look like crooks: Hollywood's own celluloid vision of boxers. We enjoyed the film and laughed a lot, but when the fight sequences began, I noticed that Joël's body was moving in tempo as if he were up there on screen. I had noticed this habit previously when he was watching TV or was just a spectator by a ring; he became quite transposed. Undoubtedly his own inbuilt reflex was to foresee and counteract the punches as if he were the opponent, perhaps an automatic thing for a boxer after years of training and fighting. But Joël Bonnetaz was not a make-believe Rocky but a boy whom I had followed for fourteen years, and I had become part of his life and his family.

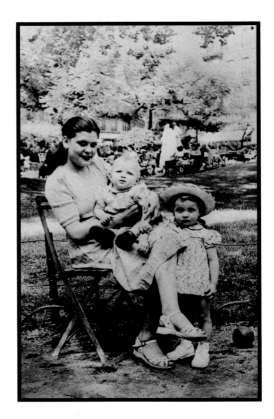

It all started one night on 8 February 1973 when I first saw him fight. Let me say that I had never previously watched a boxing match, apart from perhaps seeing one on television, and to me it was simply a way of testing out a new camera. Walking along the avenue Wagram not far from the Champs-Elysées in Paris, I saw a poster advertising a boxing competition and decided I would go that night to try out the technical capacities of the camera lens. The event was taking place in the Salle Wagram which was once a ballroom but for many years had been a venue for wrestling and boxing matches. Joël was a boy with curly blond hair and a rather gentle appearance and I felt a little sorry for him against a muscular black opponent. After his match he returned to the basement of the building where the boxers changed and I followed him later as he was surrounded by some of his young friends.

He was born in Paris on 4 July 1951 but had lived all his life in a small seaside town called Berck-Plage in northern France. He told me that he had met his wife Josette when he was seventeen and she was a few years younger; they married shortly after-wards and now had a baby son called David. 'As a child a great deal of my life was spent being shunted around between relatives, as my parents were divorced. I am a rather unusual case in comparison to other young boxers. The fact is that I started boxing when I was fourteen-and-a-half years old and had already been in thirty-nine fights before I reached sixteen, the legal age to enter competitions. My first legal fight was on 21 October 1967 which meant that I had already notched up 110 fights before I turned professional. I started in boxing by accident. As a child I was interested in sports and used to play a lot of football, and when I was thirteen I joined a club. At school I got to know another boy from the football team who was two years older; he was an amateur boxer and through him I met some other boys outside of school who also boxed. They eventually took me along to their club and the man giving the train-ing was a former policeman. His idea was to form a small tight-knit group of local boys that could box against other regional clubs. He had a flair for spotting those with a gift for boxing, and my family thought that since I had good grades at school it was a place to keep me off the streets. Hardly a week had gone by since my introduction to the club when they put me in the ring, and I had my first match before I turned fifteen. Less than two months later I had to set foot in the ring in front of an audience, in a match against a boy from my own town. Fortunately I was big and strong for my age, and the officials didn't realize that I was under age since boys are not allowed to fight before they are sixteen.'

'It's true to say that I had no boxing ambitions at that time. I just liked the competi-tiveness of the sport and the challenge of training and eventually having to compete in a match. It was all very much a gamble for me. I was considered a good puncher

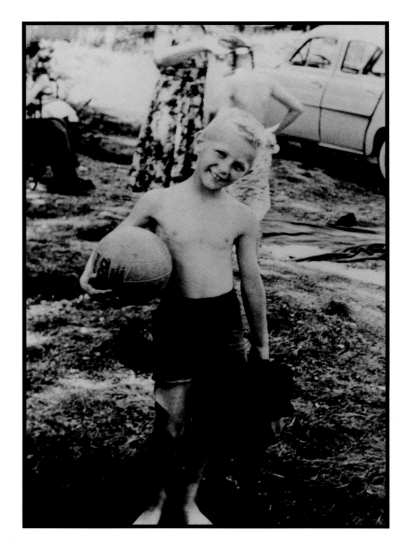

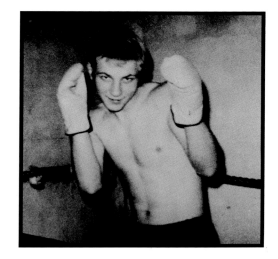

because of my youth and energy, but I had no idea that I would later become a professional fighter and never dreamed that I would eventually be three times French champion. I was the only boy there who "stuck it out" and turned professional. When you're young, it's hard to make real progress and you need a lot of determination. I left school without any real qualifications and got a job in the local slaughterhouse, carrying around hunks of meat which made me strong. Funnily enough, Stallone is shown working in a slaughterhouse in the film *Rocky*, but I didn't spend my time punching sides of beef. At night I went back to the club to train and it was really hard for me after spending the day hauling around meat. It was a tough and dirty job to grow up in.'

'I came to Paris at the end of 1972, having just finished my military service. I belonged to the Sports Battalion of the French armed forces because as an amateur boxer I had already won several regional titles and later, as a soldier, I boxed in national and international competitions and in Germany. I really didn't know what I was going to do when my twelve months of soldiering were finished and I was discharged, since I had a wife and a little boy to look after. A former civilian trainer with the Sports Battalion recommended me to a few boxing managers in Paris and I finally decided to join Jean Bretonnel who was known to the boxing world as Mr Jean. He was a trainer-manager and later a promoter for many years and had the finest young talents in town. He signed me up for a year and let me train five nights a week. In exchange I had to give him thirty percent of any money I earned boxing. He took great personal and professional interest in his team and it's true that his old fighters always remembered him and some are now internationally famous managers themselves. Having taken this step, I came to live in Paris and find a job, but didn't have enough money to bring my wife and son with me. Through friends from my home town I met some fellow northerners who looked after me and found me a place to stay. I was offered a job as a storeman in the suburbs, so I had to be up early for jogging sessions, then caught a subway train to work. At night I repeated the same procedure, going straight to Bretonnel's boxing gym for a couple of hours of training before getting back to my cold-water room after dinner, quite exhausted. Up at 6 am and in bed by 10 pm, day in, day out.'

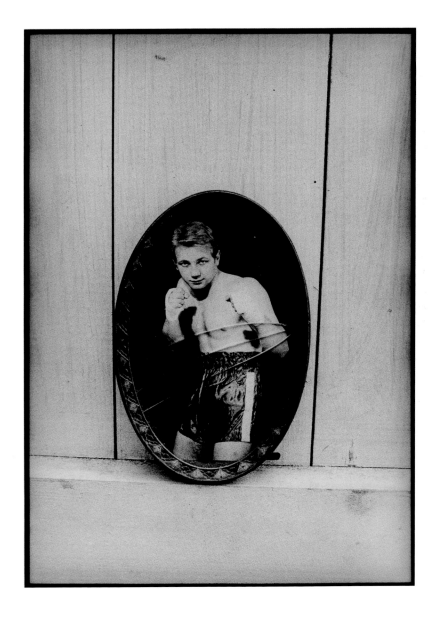

It was around this time, after I had first seen him through my viewfinder, that I began to think more about Joël's life and ambitions, and what boxing means to our society and to a young man with courage. It is well known that the sport attracts young men from the underprivileged strata of society who want to distinguish themselves and make money. If they're good they can climb the ladder of success and become an idol to other youngsters. After my first few films, he invited me to watch him training and to meet his friends, and later to go to his home town to meet his wife and family. It was not my intention to become a photographer or even to devote a lot of time to taking photos of someone I considered to be a brave and exceptional boy. A lot of young people would have given up earlier in the course. But here I was with my camera and an insight into a microcosm of society, and by giving him attention and photos I began a bond of great friendship and respect.

Joël said that the hardest thing in the beginning was to disentangle himself from his amateur days and switch to a professional training schedule, getting rid of all the bad habits and grinding it down to the necessities. He told me: 'The technique was not to practise individual movements but to give the body and mind an overall discipline. Each man fights differently so you can't foresee what your opponent is going to do or how you should react. There are few boxers who have a naturally perfect style – I would say Sugar Ray Robinson was an exceptional boxer.'

His training gym was rather small and had two rings under a glass skylight, with another area for physical training. A couple of punchbags were hooked to the ceiling;

elsewhere, a few guys skipped rapidly with ropes, and others shadow-boxed in front of mirrors and did stretching exercises. The same thing happens in many countries and many towns; the only thing that changes is the physical environment. In the many years I have watched training I have always been astonished by the similarity of the procedures, the noise and the strong smell of sweating bodies. Often the floorboards are soaked with the odour from dripping sweat and hours of skipping. 'In the gym we are under the watchful eye of Mr Jean. There are no rivalries between the boxers and it's not good to have fathers or friends coming along to give their tips and advice – if you listened to them you would end up a pretty messed-up boxer. The idea is to pre-pare us gradually. In my first three years as a pro, I managed to move up from doing six-round fights to ten-round fights, and little by little you steadily progress from four rounds to six, eight, ten, twelve rounds. Some guys get put into a ten-round fight when they're not ready for it and are doomed from the start. In my team there was one guy who was a terrific puncher, a real streetfighter and strong as an ox. He wasn't scared of anyone, accepted all the fights he was offered and the crowds adored him. At first he was fine, and the public and the press acclaimed him as a new hero, but when he was matched against more stylish fighters he couldn't stand the punishment. He got slaughtered a couple of times, became discouraged and stopped coming to train until at last he gave up. You can't just push a guy into the ring because he has endurance and stamina – if he doesn't have the skill, he won't survive.'

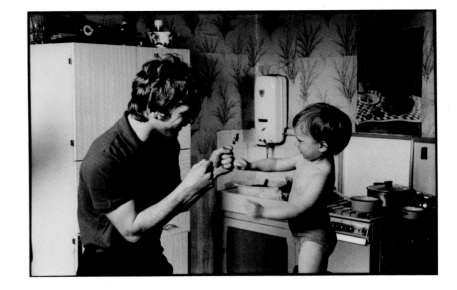

'It's usually the fighters with an inbuilt vicious streak that get out of control in the ring. Strange as it may sound, it's the boxers themselves who build up the momentum, not the screaming crowd. You mustn't react to them, otherwise you'll get carried away and lose self-control. That would be stupid and you'd open yourself up to a lethal attack. At all times, you need self-control. The public may think that we all have a killer instinct and that beyond a certain point we'll lose control but that's stupid – a boxer's aim is to win, not to destroy. I know it's a dangerous sport and the risks are high, but I never think about that when I'm in the ring. I've had my nose broken a cou-ple of times, a lot of bruises and disappointments, but in the ring there is a momentum and the trainer is there in the corner to give you advice on how to proceed. If you sit close enough to ringside you'll see fighters glaring at one another as they are called; this is psychological, a kind of wearing-down process of submission, seeing who is the strongest. Once you're inside the ring fighting, you realize that in a strange way your opponent's eyes reflect in advance his next move, and yours. Most of the punches are done at head level within a certain radius of the chin and the centre of the face, so you can see your opponent's eyes in the centre of this confined circle. You can then estab-lish which way he might be turning his shoulder, which helps you to predict his next move. That way you can foresee a danger and work out your own next move.'

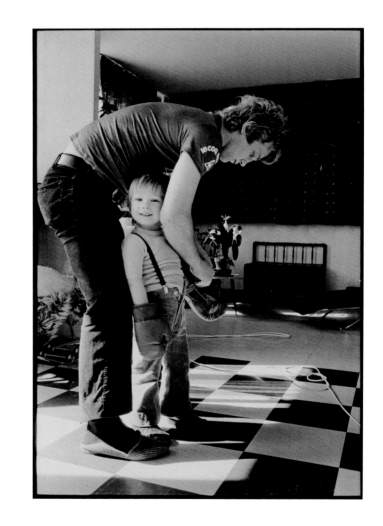

Joël let me go along to several pre-fight and post-fight medical examinations as he went through a tremendous treadmill process. Once after he had been knocked out, the French Boxing Federation called for an obligatory brain test, so he was taken to an ultramodern hospital to be given electronic tests to see if he had suffered any post-fight reaction. He was strapped into a chair inside a small cubicle, and behind a glass wall were two nurses and the monitoring equipment, with needles that flickered over rolls of paper. Rubber bands were affixed to Joël's wrists and a horrendous helmet of wires was placed over his skull. Pads were pasted to his temples and hands, and a square lightbox moved inches away from his eyes. The nurses then turned on the electricity and the lightbox flashed before his eyes. I stood in front of him with my back to the wall, taking photos; he looked just like a robot or one of the early astronauts.

Something I often witnessed in dressing rooms was the ritual of bandaging a boxer's hands. Apart from the head, these are the most important parts of a boxer's body, and must be bandaged before the gloves are put on. Usually the ritual is care-fully carried out. Each fist is tightly wrapped with gauze that covers the knuckles and wrists, and is then covered over with strong adhesive tape. Next, smaller strips are cut into pieces and stuck between the finger joints and knuckles. In this way the hand is completely sealed and forms an inner padding inside the boxing glove. This not only stops the hand from slipping around but protects the knuckles and the fragile

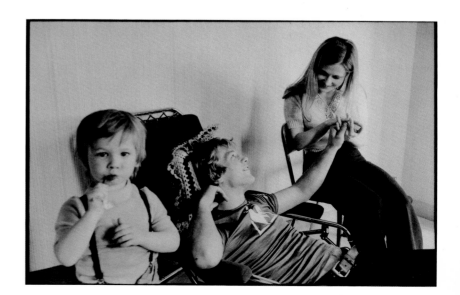

metacarpus. All boxers fear damaging their hands, just as dancers fear for their ankles, so each has his own way of bandaging up.

Once when I was waiting for Joël to come to see a big fight, I arrived early to take some atmosphere shots and wandered around the dressing rooms to see what was happening. Dressing rooms are fascinating places both before and after fights – they are like decompression chambers. In one of the dimly lit dressing rooms I saw some boxers slouched and bleeding on benches, others anxiously being prepared and waiting for their turn to go up from the bowels into the limelight. Sitting on a chair was an anxious-looking boy with his trainer waiting nearby, sorting out the boxer's gear from his large bag. At the back of the room was a guy in a suit, standing beneath a bare lightbulb and filling a hypodermic syringe from a rubber-topped bottle. The boxer had only his right hand bandaged, and normally twenty minutes before entering the ring all fighters are fully bandaged up. My glance flicked from the syringe to the bare hand, and I immediately realized that some form of painkiller was to be injected into his fist.

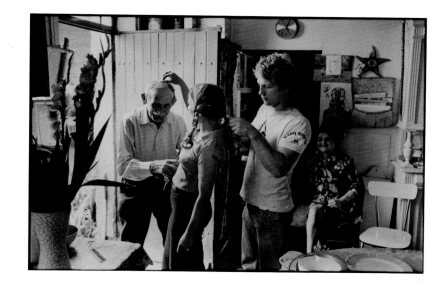

Trying not to make myself too obvious, I stayed close to the wall in the dim light and didn't do anything. Nearby was a guy that looked like a pimp, wearing a grey suit with a pink shirt and a green tie, obviously casing the place. He walked smartly over to the trainer who was sitting next to the boxer, mumbled something into his ear and then left the room. The minutes were ticking by and the boxer was getting more and more anxious: 'My fight's in fifteen minutes, do you think it'll work?' he said to the man sauntering over to them with his syringe. As I moved in closer, thinking I would get a shot of the needle piercing his fist between the knuckles, the trainer turned around to me and growled 'You'd better not do that or we'll bust you and your cameras...'. I took the warning, not wishing to be the victim of an underworld mugging. Then I left the dressing room and went to join Joël to watch the upcoming fight, featuring the young boxer I had just seen in the dressing room. I guess some six thousand spectators were cheering and encouraging him, yet I and three others knew that his fist was numbed by painkillers and would by now be as painless as stone. I hinted at this to Joël, but he did not react. It was a six-round fight and the young boxer lost. I swiftly returned to the same dressing room to collect my coat; it was partially sealed off by a heavy curtain made from dark cloth or a blanket. I could hear a sobbing noise coming from the other side, so I peeked through the gap and saw the boxer sitting in a chair surrounded by his trainer and, I think, his manager. He was angry at having lost the fight, but that wasn't the only thing: 'It's always the same, the last six fights you've had to inject my hand, I've had enough. It's ME who takes all the punishment, it's me who loses. I don't want to go on any more.'

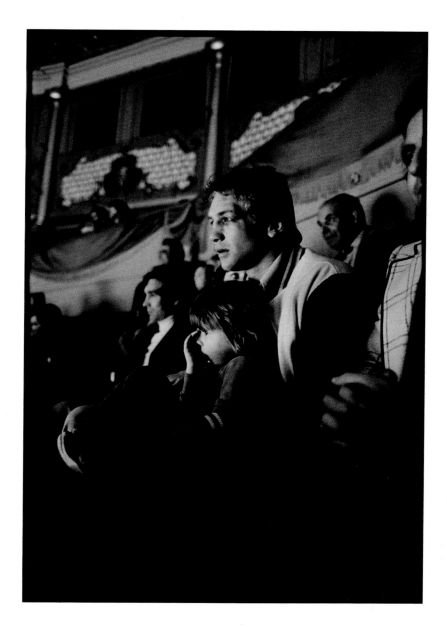

If he had carried on, he may have been injured for life. On several occasions I brought up the topic of the dangers, but boxers tend to feel it will not happen to them. They are aware of it and might kid about being punch-drunk amongst themselves, but I don't think they would openly discuss it with their family. Joël was once badly shaken by an incident involving a friend of his who had popped over for a cup of coffee. They were the same age and would often go jogging together. For no obvious reason his friend started shaking and tossing himself around, so they rested him on a bed and called a doctor. He was not allowed to box for five months. It was claimed the cause was general fatigue, but he remained depressed for some time until eventually he gave up boxing to save his private life.

Joël's career had its ups and downs. In all his twenty-one years in boxing, between the ages of fourteen and thirty-five, he told me he'd had over 204 fights: 39 before becoming an amateur, 110 as an amateur, and 55 as a professional. By my calculations from his records, since his amateur days he has had 92 wins, 22 draws, and 51 defeats. In November 1977 he was matched against Maurice Hope for the European middle-weight championship, but lost in the fifth round at Wembley Stadium at what was to be the peak of his boxing career. Previously that year he had gone ten rounds against Emile Griffith in Périgueux, France and won. Twenty-four years later, I was with Joël when he met up with Griffith again at a veterans' gala in Paris. Emile had not changed much; he was still jovial and even recognized Joël after such a long time. Joël's boxing career finally ended on 31 January 1986 when he lost in the semi-finals of the French

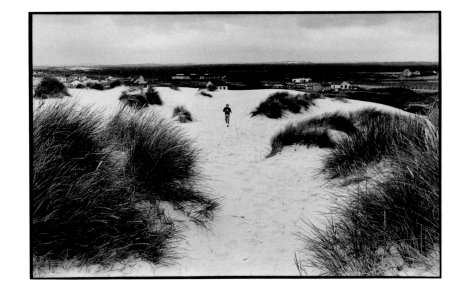

championships. He is now fifty years old, in his third marriage and has three children. He runs a municipal sports complex in Paris, and although he is a qualified boxing trainer he finds a lot of young people today less orientated towards the ring. At one time, he moved to the Dordogne region of France with the little money he'd made and opened a small sports shop, but by then his marriage was on the point of breaking up.

Boxers are often very sensitive people, although the outside world might imagine them to be all tough guys since you never see weaklings in the ring. They have a tremendous camaraderie with one another, and depend a great deal on their immediate family and fans to keep up their morale. In 1976 Joël was in training for a French welterweight championship against the current holder who belonged to the same club. As they always trained together, his trainer Mr Jean thought that for this match they should be separated and put into different training camps. Fate had decided that Joël was to fight against his best friend, so four weeks before the championship they went their own ways. It was also decided that psychologically they ought to get away from their immediate family and friends and concentrate on the upcoming fight which was an important one in their careers. In the housing complex where Joël lived and worked as janitor there were too many interruptions so he came to stay with me for a while. This was not the first time I had put him up, and as his friend I had spent a great deal of time with his family on holidays and weekends. It not only gave me an enjoyable environment to watch him outside the boxing circle, but let me see how his sport and his social life crossed or conflicted. In my apartment he had his own room and could watch TV, listen to music and relax, and in the evenings go training and in the morning go jogging. We decided that I could limit the friends who came around and some came and cooked his meals for him. He loved raw chopped meat, rather strangely for a boy who had first worked in a slaughterhouse, and would consume kilos of it mixed with ketchup and spices. My refrigerator was always full of parcels of chopped beef, and at night he came back with his wet and smelly training clothes, usually just lumped into a big bag. It's no surprise that boxers' wives are slaves to the washing machine.

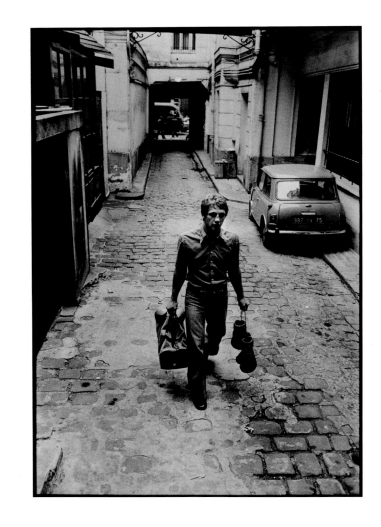

Some journalists called him the Angel of the Ring; in fact he had been a church choirboy as a child and according to his sisters had been a very well-behaved little boy. Undoubtedly it was that first impression of innocence when I saw him boxing in 1973 that made me think that this was a 'ring of dreams' situation and that Joël was aiming for the stars. But once in the ring he quickly adjusted under the bright lights and the gaze of ten thousand spectators. He knew that it would be frightening to some but to him it was very stimulating. 'It doesn't bother my wife to be out there watching me fight but I don't normally take my son to fights. It was very special for my little boy to carry the French flag into the ring for his dad at the international fight I had against Emile Griffith. Children remember that kind of thing. If he does follow me to fights, he's usually running around the dressing rooms talking to other boxers. One time at a competition the organizers had hired a group of drum majorettes to perform during the intermission. My little David loved that, he kept coming back to my dressing room asking me for more autographed postcards of myself so he could hand them out to other children and the majorettes.'

'In my first big French title championship with the other boy from my club, who was the favourite, I won the competition on points – I had waited seven hard years to get that title. We showered together after the fight, not as enemies, but realizing that one of us had to win and I had managed it. Later that night my family and friends gave me a celebratory dinner. Normally the boxer gets a championship belt but at that time the Boxing Federation had discontinued the tradition so all my friends gathered round and put money in an ice bucket to have one specially made. It was an honour to have them recognize all my efforts like that. Something similar happened during my first four months in Paris; some of the same people had a collection to buy me a leather sparring helmet and gloves since I was penniless at the time. There are times that I seriously think about my way of life, why I do this and what the consequences could be. There are times after a long training session when I am completely exhausted, and I just go back home and stretch out on my bed, worn out and aching all over. My wife has had to adjust to this lifestyle; she's not really interested in sport but knows that I

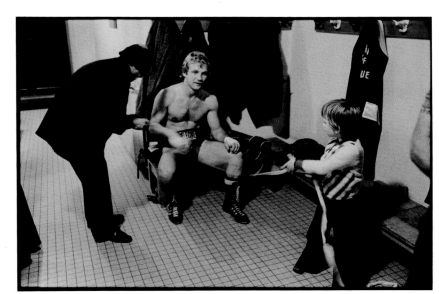

believe in what I'm doing, that this is my life and that boxing has to come before everything else. It's hard on her both physically and emotionally, and it puts a lot of restrictions on a young couple. Some people think boxers make a lot of money but that's not true if you're not one of the big champions. The general public doesn't know about all the struggles that young boxers go through, the ones who never reach fame and fortune.'

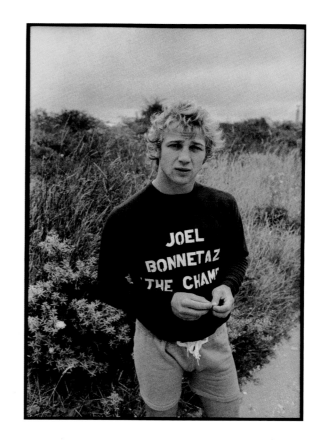

Sometimes when I've followed Joël into the provinces for title fights, he has not been the favourite and has met with a hostile welcome. On one occasion, his opponent had been psychologically conditioned by his team and fans and, as reigning regional champion, believed that he would win for them again. We could feel the hostility – Joël had become public enemy to an unfriendly crowd of over five thousand spectators. In the ring Joël immediately showed his determination but the local champion had a habit of lowering his head. Quite by accident their skulls collided, causing a bloody gash between the top of his opponent's nose and his eyebrow. As usually happens in such cases, blood started to gush out and made a nasty wound. At the end of the round the doctor was called into the corner and together with the referee called off the rest of the fight. Joël was declared the new French champion but immediately the local crowd became very agitated. The other boxer then cracked up, sobbing his heart out. He had expected to win and had been assured he was the favourite in this important match but the unforeseen injury changed all his fans' hopes. We quickly got Joël back to the dressing room: the crowd in the arena had become very angry and we thought there might be a riot looming. In Joël's dressing room there was no time to change; pulling a tracksuit over his body and a hood over his head we made our escape. Quickly we made our way along a cold and lonely country road, hiding in the shadow of trees and dodging lit areas. The new hero Joël Bonnetaz had to withdraw into the darkness of the night like a criminal.

Despite the press predicting that he should have lost the title, no boxer likes to lose on an injury after months of training. Joël has accepted a lot of fights because they are part of the process of climbing the ladder to perfection and recognition. Once he even organized his own competition in his home town of Berck-Plage but after all the expenses and taxes, he lost money. His opponent was an English boxer, but as Joël had an upcoming European title fight against Maurice Hope in London, he felt that the local match was important preparatory training. 'It's true that I've become tougher on myself. I'm no longer the same kid who came to Paris seeking fame and fortune. The conditions in the boxing world are extremely hard, and looking back at my career and the way that I'd envisaged it, it's rather disappointing. Over the years and through all the struggles I've grown more aggressive. People think you've become a sports star, but you're not really a star; that's just a figment of other people's imaginations. Getting punched doesn't always hurt, yet it is violent and virile and certainly makes men out of boys. To be a real champion you've not only got to take blows, but punch intelligently. At the start of my amateur career my trainers always said "You've got to win the next fight and build yourself a little reputation". The same story goes on and on, but it is always me making this enormous effort for little or no money. You pack in the years in the hope of getting better and making it rich but you are learning a trade the hard way. Sometimes referees make strange decisions, but it's their word that counts.'

That was Joël Bonnetaz's 'ring of dreams'. Thankfully he finished his boxing career without any serious physical injuries, yet his first marriage fell apart and it bewildered his son, who is now a grown man. His trainer Mr Jean has died, and Joël has gone back to his original interest in football. His second son from another marriage is now a teenager, perhaps not unlike Joël in his youth, always running after a ball and being extremely active. We have been friends now for little less than half of our lives, and this would never have happened if in February 1973 I had not decided to try out a new camera at a boxing match.

JAMES A. FOX

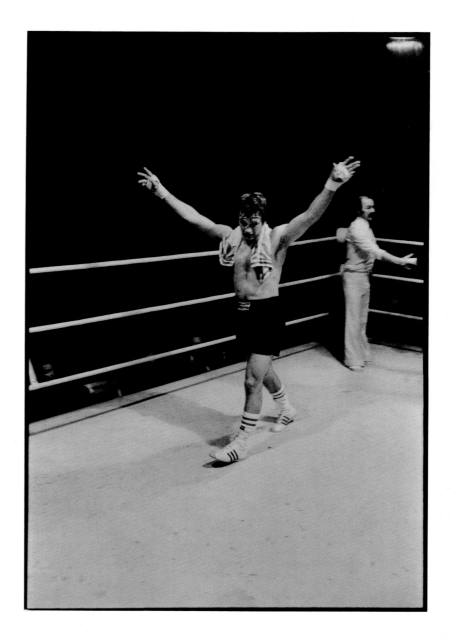

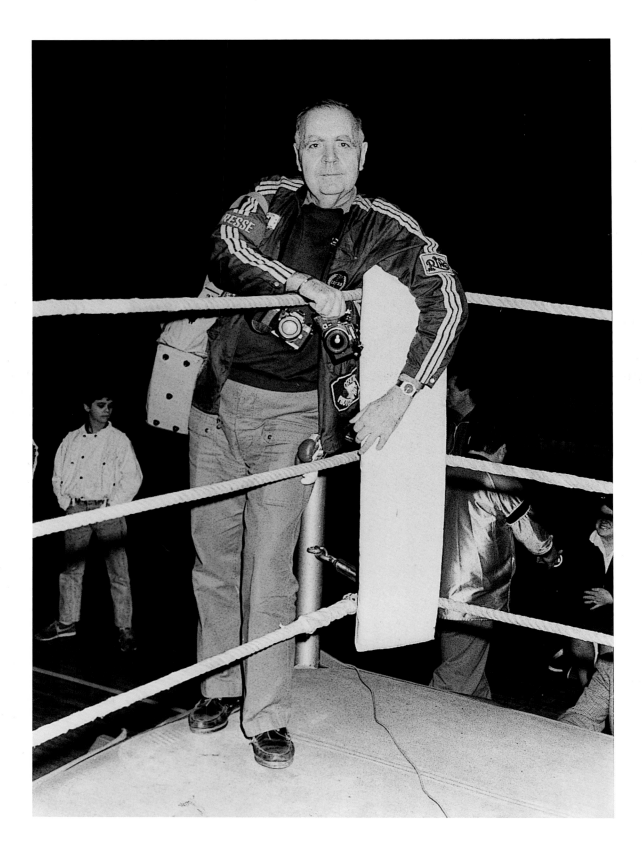

My eye on the ring

I don't want people to think that this is the work of a sports photographer, or that the focus of the images is purely inside the ring. This is about the world in which boxers live and train, and the ring itself is only the tip of an immense iceberg. As I was not working in a press capacity with deadlines to meet, I wanted to go behind the scenes of this world and use my own style of photography to get a more personalized and intimate understanding of the subject. Boxing has great momentum, with its training, friendships and high moments of pride and despair. It is a microcosm of society, with anger and lust, hope and happiness; it's a stage where actors improvise as they go along, not knowing if they will come out better or worse, or in this case, injured or alive. The big fights are like being at a grand opera performance; the ringside cords are curtains into the unknown, and the noise, lights, shouting and musical announcements can seem almost Wagnerian in the thundering atmosphere. It is the transition from dark and dim basement dressing rooms, through endless corridors, towards an arc of bright light moving inside the ring. The move from a semi-silent dressing room, to ringside's inferno of noise, is something astonishing. I now believe that a boxer must be brave, since simply getting into the ring requires courage, and training continually is a profession in its own right.

For these reasons alone, my being there is secondary. It was only when I had passed the first hurdle – that of not taking pictures but waiting and observing – that my physical presence gradually faded into the background. One can only do this type of work by giving part of oneself in exchange. Sitting with the boxers, waiting for hours in crowded or deserted dressing rooms, dim corridors, cold sports stadiums, training places like converted ballrooms, churches, synagogues, in distant lands and cities, New York, London, Paris, Amsterdam, Casablanca, Algiers, Rome, Milan, Madrid, Tunis. Hundreds of days when I have dragged my feet and camera in search of yet another good photo. All those expectant boys and men treading the razor's edge of life, whether it be in a small *pugilato* club near the Vatican, a converted garage, a schoolroom in Marrakech, or the kasbah of Tunis. I know that I have only been twice to a fight without a camera. All these years, stalking the right light and composition, often sitting with my back to the ring to watch the screaming spectators. At ringside the jeweled and mink-coated women cry 'Kill him, kill him!' as they wriggle in orgasmic passion beside mohair-suited escorts. Step by step, the pieces I had before me were assembled into a patchwork of images, visual snippets converging around the fights and the fighters, both known and unknown.

I have worked in photography for forty years, thirty of these editing the photos of the renowned agency Magnum where I acquired a full understanding of socio-documentary photo-graphy, but I never mixed my hobby with my work and only Ian Berry of Magnum knew what I had undertaken. Picking up a camera within a group like that, it's easy to see why people may have thought that my ambition was to become a professional, yet that was the last thing on my mind. As a result, when the city of Paris gave me my first show in May 1986 called 'A Skin-Deep Vision of Boxing', the photographic world was very surprised, and I was given international recognition.

My aim has been to show some of the aspects of this sad and tragic world; moments of happiness for a few, paid entertainment for some, a loathing of the sport for others. Taking a 'middle of the road' attitude, my camera and the view through the lens protected me to some extent from the harsh reality. On the other hand, having unlocked this strange world by meeting the young boxer Joël Bonnetaz, I could stand back and not be simply enraptured by the sport. I fully integrated myself into this world and usually went around quite freely, blending into the atmosphere. Obviously the best approach is to be a 'fly on the wall', observing everything, and rapidly moving in and out again as soon as the images are captured. This means an exhausting amount of hanging around, sometimes years of going back to the same places, when suddenly in front of your eyes there will appear a person or a composition that you've never seen before. These are the magic moments, when it all falls into place and you know by instinct that all the elements have blended together into what Henri Cartier-Bresson calls 'the decisive moment'. It is hard to explain, but constantly wandering through the universe of boxing was like being a hunter with a gun: marching through fields, staying alert before taking aim and then shooting to kill. For me it was a case of sniffing out moments, aiming and capturing instead of killing; perhaps the killing was taking place inside the ring.

Looking back, I am often asked why I did not take colour pictures, but to me black-and-white photography brings out the basic truth of a scene without necessarily distracting you from its content. Around me I saw photographers with motorized cameras, strobe lights and deadlines to meet, who lacked the mobility to photograph wherever they wanted. In my case it was my time, my money and my vision, not just something to fill a page or illustrate a few columns of text. Only once among the four thousand rolls I have taken did I accept an assignment. It was a championship fight between a French boxer and an English boxer, and the specialist British magazine *Boxing News* had seen my work and sent over their writer Tim Mo, a polite young journalist fascinated by boxing. He had to leave the same night with the unprocessed films, so at the conclusion of the fight I had to stand up on the ring behind the ropes, unwinding films and throwing them down to him, four rows away. In this case my priority was to take 'sporting' photos and

meet his deadline, so I'm not sure I got a good photo for myself. In later years I discovered that Timothy Mo became a writer and was nominated for the Booker Prize.

Boxing has attracted many film directors, actors and writers over the years. Its atmosphere is full of danger and all the instincts of survival; it's the embodiment of every dream of climbing the ladder to success through sheer strength and determination. There are many books on boxing: Norman Mailer understands it in every detail, Joyce Carol Oates did a superb book, *On Boxing*, as a female evaluation of this macho world, and recently David Remnick, who won a Pulitzer Prize in 1994 for his book *Lenin's Tomb*, has written an outstanding biography of Muhammad Ali, *King of the World*. The ring contains all the ingredients of drama: greed, power, lust, revenge, fame, a certain sexual power, mystery, the smell of ointments, the cheering crowds, the catastrophic disappointments where the once mighty can fall into the pits of oblivion. The ghettos are full of underprivileged kids struggling for a few minutes of fame; I've seen lollipop-sucking boys of nine in American gyms, boggled by some famous champion and aiming to 'be like him'. It used to be called the 'noble art', but in my opinion the only noble aspect is the courage of boxers, certainly not the promoters, spectators or hangers-on. Amateur boxing still has its noble qualities but somehow the professional realm has a different approach and style. There are true fans among the spectators but this is more common at small amateur fights. The big fights are a melting pot of the rich and the less rich, the famous and the unknown.

It was easy to understand the bond between a boxer and his trainer, often a very warm paternal attitude, an authority that kids off the street could accept. In turn these kids received a little recognition and their name or photo in the local press, and consequently gained a new status in their gangs and housing estates, giving them an aura of pride and self-respect. Although I did not want posed photos, they would ask me to take their picture, and once this was done, I was accepted and allowed to work freely and in my own manner. It was never my intention to visually exploit their suffering by making purposefully beautiful compositions. Perhaps through my vision I could add dignity and pride to the way the outside world would view them later. Some of them were puzzled as to why I remained with them in their dressing rooms; they thought a photographer should be out at the ring covering the fight. They stayed there alone, anxiously awaiting the announcement of their fight or slouched, defeated and depressed, often in tears because they had lost, so I kept them company and occasionally took a photo. I can't count how many I have helped after fights, unlacing their boots or finding the doctor if they were unwell and left unattended. There had to be an understanding and mutual trust. On a few occasions I noticed outward signs of mistrust from managers, especially when their fighter had lost or was injured. I began to know automatically that I could work undisturbed if they had won the fight, but if they had lost, a hostile atmosphere took over, and if they were injured then my intentions were doubted.

As we had mutually collaborated, I would often give them prints as a token of my gratitude and respect, and years later they stayed in contact. My presence had been part of their growing-up process, their transition into adulthood, and I had recorded that on film for eternity. Out of the thousands of young boxers I met, some still phone or write to me, while others have moved on, sometimes remaining in their violent suburbs, helping to convert dealers and street kids to a more dignified existence. It was the strong versus the weak. One butcher's errand boy became a champion boxer and later a TV announcer. Others dropped into a sordid underworld after fame. One fighter slid into poverty and became a vagabond begging in the subway. His name had once been in the headlines, but then he was forgotten, until one cold winter night he threw himself on the subway tracks. For some, boxing was only a youthful phase and they are now doctors, engineers, actors, computer experts. Some turned to pimping; another became a guru with a group of followers, standing in the street, barefoot and shirtless, beating drums and claiming the world was coming to an end. The good comes with the gritty.

Perhaps the most spectacular boxing venue I have seen is the Napoleon Room at the Café Royal on Piccadilly in London, where monthly gala evenings were held for private members. Dinner-jacketed, they all met for dinner and drinks, and a night of the noble art. After dining on Scottish salmon, they gathered under chandeliers in a room with red velvet curtains and large mirrors. These were not ruffians at a Saturday night fight, but gentlemen of the City, bankers, lords, the men who control major companies and maybe our lives. Every third seat had a small table and white-gloved waiters brought around drinks on silver trays. There was no boisterous shouting here; they applauded to show their approval, and the boxers were rewarded with banknotes rolled up like balls of paper which were thrown into the ring and picked up by the trainer, sometimes in a blood-splattered towel. It was not unlike two centuries ago, when the 'purse' was a little leather pouch in which the boxer's earnings were collected. It was a mind-boggling contrast to the cold and dingy places I had seen over the years.

Boxing, like wrestling, is a very ancient sport; it already existed in Crete in 1500 B.C. To the Greeks it was mostly the development of a peak physical and mental state, a means of showing courage and endurance which men would later use in their military lives. The earliest recorded event was the 23rd Olympiad in about 688 B.C. Although our present-day boxers have little in common with the *cestus* fighters of Roman times with their metal-studded gloves, undoubtedly the reaction of the crowd was the same. Many centuries later James Figg was proclaimed champion of England and showed the art of self-defence to the nobles, with patrons including the Prince of Wales, the father of King George III. This was the start of a period when London became the centre of boxing. There were no specific rules until 1743 when the Duke of Cumberland's fighter John Broughton proclaimed that a round continued until a man was down, after which he had thirty seconds to rest. No hitting below the belt, or beating a man already down. After that came many famous names like Daniel Mendoza and Gentleman John Jackson, who brought an aura of respectability to the sport and founded the Pugilistic Club. America's great black slave boxer was Tom Molineaux from Virginia, along

with Bill Richmond, another freed slave. It was not until 1839 that a new set of rules known as London Prize Ring Rules were instated, and these governed British and American boxing for the next fifty years. In 1867 four major changes were made: the fighters had to wear padded gloves, each round would be limited to three minutes, followed by a minute's rest period, and a fighter down on the ground had to get up within ten seconds or be declared out. These new rules were later called the Queensberry Rules after John Sholto Douglas, 8th Marquess of Queensberry, thus associating boxing with nobility.

Towards 1890 many poor Irish families sent their sons to the New World, America, to make their fortune. These boys and men had always used their hands and fists to earn a living so it was not surprising that once in the United States they tried their skills in the ring. America produced fighters such as Joe Coburn and John L. Sullivan, and boxing now became a skilled sport played to rules. Gradually the fighting scene moved from Europe to America, driven overseas by the puritanical Queen Victoria. The beginning of the last century was a golden age of boxing in the USA as both new immigrants and recently freed slaves won acclaim in nearly every category. The First and Second World Wars brought boxing to a wider audience, and tournaments between the wars also attracted large crowds, sometimes tainted with fascist or Nazi overtones. In France the sport was banned until around 1910, but later Carpentier and Cerdan became its ambassadors. In the 1920s it began to flourish, and even the Rothschilds held boxing tournaments in their mansion and brought in their favourites like Al Brown.

Yet the audiences I saw in my time came from all walks of life. At the big fights there were couturiers with Louis Vuitton bags, jockeys, movie stars like Jean-Paul Belmondo and Alain Delon, Jean Gabin sitting to one side under a cloth cap and dark glasses. It was often a social night out; elderly gentlemen with tinted hair and model girlfriends dressed in haute couture, pop singers, office and factory workers. Around the empty ring, the expensive seats gradually filled up with the likes of Omar Sharif, the singer Sacha Distel, a parade of VIPs straight from the pages of *Vogue* magazine.

The written and photographic press used to play an important role but now television companies have taken over. They sponsor shows and have specially built platforms for their camera crews to walk around at eye level with the fighters, as if it were a set in a movie studio. Boxing has become a vast hive of entertainment, yet high up in the cheap seats on the balcony are the real fans: a factory worker or a truck driver, young kids with their eyes full of hope, sitting on uncomfortable benches with a Kleenex-sized view of the ring. Immigrant workers come to see a friend or a brother fight; they don't just shout and sing but also bring large banners in support of their 'boy'. It is quite breathtaking when eight thousand people all stand up to sing the Marseillaise for a boxer preceded by a flag carrier. One night I even saw a group of topless chorus girls stride through the ropes to perform for the excited crowd, not to mention the scantily clad girls who parade around holding the announcement boards. It could be part of the Folies Bergères. But these shows are considered an evening of entertainment, so why not bring on the glitz and glamour? The new Madison Square Garden is different again in size and style. The ringside seats are full of the local glitterati, movie stars and politicians, yet if you stand on the ground floor during a fight and look up at the balconies with their thousands of spectators, you see a host of twinkling reflections. It was only by moving up the different levels that I realized it was the reflected light from all the binoculars people had brought along with them. In some places an in-house TV screen shows close-ups of the ring, but for a spectator sitting up in the top balcony, a fighter can be reduced to the size of a matchstick.

But audiences and purposes can be very different. I remember a fight I saw in Casablanca when I accompanied a local Moroccan boxer to a competition. We gathered in one of the city's bus depots with parked vehicles on one side; on the other side, space had been made to put up a ring and a few seats. It was winter, cold and raining; the boxers had nowhere to change and stood on crushed cardboard boxes to avoid the oil spills on the cement floor. The glass ceiling was leaking and water was dripping in several places so the spectators moved the seats to a dry area. The boys' fathers had come that evening dressed in their woollen burnous, long capes with a hood, and they sat around with their hoods up to protect them from the cold and the dripping ceiling. These were all amateur three-round competitions, and as I stood on the steps overlooking the crowd I noticed those peaked hoods pointing up like cones. This was a long way from the smart set of Manhattan, London and Paris – these were the hungry kids who didn't have a future unless sport gave them an opportunity.

Boxing matches are also organized in out-of-season bull-fighting arenas that give a chilling feeling of death in the making. After spending a week in Madrid covering the various boxing clubs, I was introduced to a famous bull-rancher who liked boxing and allowed the top champions to train at his hacienda where he installed a ring and there was plenty of space for jogging. There I met a teenage bullfighter who told me about his life and training. How similar it was to a boy of his age doing boxing: the spectacle and the drama, the parades and the music, the grace and the danger. Both require a great deal of courage and both are putting their lives at stake. Being gored and being knocked out are both humiliating experiences. I could not help but feel sorry for them, strutting around with great pride and showmanship.

In my wanderings I have met and photographed champions like Ali, Monzon, Frazier, Norton, Conteh, Valdez and Duran, to name but a few. How different their world was to that of the young aspiring amateurs: what course through hell must they go through and what lies at the end of the rainbow? To be with Ali was like floating with power, in vast motorcades in Detroit. I was amazed by his size and his humour but he always had time for young people and for helping his fellow men. Young Cassius Clay had always stood behind his convictions and helped his black brothers with education and housing programmes. It is well known that he loved an audience and chatted about his youth and his career, yet he pointed out that it was a dangerous sport where people could be killed. He was surely not in it to kill people or harm them, but wanted the financial rewards and generously contributed to worthwhile

projects. Not only was he champion of the world but he went on to become the best-loved man in boxing. Wherever I went abroad, Ali was referred to like a head of state, and his posters were stuck up in the strangest of clubs so that young amateurs could admire this man. Once in Gil Clancy's gym in Manhattan there stood before me three little boys sucking lollipops. I asked one boy why he was training to be a boxer, and he smiled and told me through the side of his mouth, 'I wanna be like Muhammad Ali, win a thousand trophies and be famous'. They don't all have Ali's charisma and style, yet they all perform between ropes strung around a square ring.

Carlos Monzon was quite a different character. I watched him train and fight several times in Paris. As well as his great skill he had a kind of wild Indian charm from his native Argentina. At that time the film star Alain Delon had decided to help French boxer Jean-Claude Bouttier to train for a world championship fight against Monzon and had given over part of his property not far from Paris to become a training camp. Boxers are usually accustomed to sparse dressing rooms and dirty showers, but here, I am told, they were startled by the luxury of the facilities: an illuminated pool and an outdoor ring to train in the cool of a summer's evening. But Monzon himself trained in a local Parisian club put at his disposal, with a retinue of friends and fans. Anyone who met him in the street would never have imagined he earned his living in the ring. Tall and thin, with jet black hair and heavy eyebrows, he often looked unhappy and even angry. His Indian origins gave him a wild look, with piercing, unfriendly eyes. They were like black shining marbles set deep into his skull; his glare alone would frighten any opponent. Unusually slim with long skinny arms and legs, he punched with a paralysing precision. Once his hands were gloved up, those slender arms gave me the impression of punching paddles, not fists. Most boxers skip around on their toes, Ali being a perfect example, yet Monzon stayed flat-footed as if rooted to the mat. The lower half of his body seemed less coordinated than the top as he swayed around to avoid blows. After training he retreated to one corner, crouching on bended knees as if admonished by his trainer. Monzon's boxing was as fast as the rest of his career; having gone into movies in Italy, he eventually ended up in prison, then finally returned only to lose his life in a tragic car accident.

Photographing the boxing world has not always been a calm experience for me, and verbal abuse has sometimes bordered on possible physical violence. France has a fairly large community of gypsies; they often live in housing estates and sometimes in campsites on scattered pieces of land near big cities. Some of them have become very good international fighters, yet many have violent tendencies and have difficulty in controlling their rage. In one incident where they disapproved of their fighter having been declared the loser, I found myself amid flying chairs and escaping throngs of spectators. On another occasion, when a similar incident happened the flick knives were pulled out and my only possible escape was to hide under the ring to avoid the flaring tempers. Usually the gypsies were a colourful lot who arrived in the four-wheel-drive jeeps that they used to haul around their caravans. One boy of fifteen always had his father and grandfather with him

as well as dozens of cousins. The grandfather wore a large felt hat and sported a magnificent moustache, and the boy was the pride of the clan. Every morning he would leave his caravan to go jogging, go to a boxing club for lessons in the evening, and hang his gloves above his bed at night. The gypsies were very religious and would make the sign of the cross in the corner before starting a fight. It was said that the referees would take the heavily weighted audience into consideration and would sway fight decisions rather than run the risk of revenge. Nevertheless they were very serious about training, since within their social group a great deal rests on pride and integration.

Going out to the suburbs with a car and with a bag of cameras is not always wise, so in later years I would usually try and find someone to escort me, very often a former boxer. One incident centred around a gang of motorcycle Hell's Angels who came to provide encouragement for a fellow member who was boxing. Normally I like to figure out who is boxing and do a kind of casting for someone I might follow, a pre-selection to see who will let me work inside their personal circle. That night there was a heavily tattooed young boxer changing into his fighting gear, and I noticed that hanging on a hook behind him was a magnificent studded black leather jacket decorated with eagles and skulls. His arms and chest were tattooed with similar designs and his body was quite a work of art. His fight was announced, it was to be three rounds, but when I started taking pictures in the second round, aiming to get him with one gloved hand resting on the rope and the other tattoo-covered arm reaching up to his shaved head, I suddenly found myself surrounded by four boys. They all wore German-style stormtrooper helmets and were dressed completely in leather, their jackets studded with skulls and insignia that sparkled in the lights of the ring. They squeezed themselves around me like a glove and one of them pointed a finger and shouted right in my face, asking what I was doing. Obviously they knew I was a photographer, but they might have thought photos could be used against them and their group. I managed to talk myself out of it and out of the corner where their friend was resting before taking on his final round, and so avoided another conflict. Their friend lost, but I had to go back to the dressing room where I had left my outdoor jacket. I waited a while and returned, thinking that by now the boxer would be changed and ready to leave, but to my amazement he was lying naked on a bench, completely exhausted. Towering over him was his girlfriend, also wearing a studded leather jacket with an eagle from shoulder to shoulder. She was in a rage that he had lost or been counted out, and the other boys who had encircled me were standing in the background. Although the scene was something I wanted to record visually, I thought that once outside I might become a target for their anger and the risk was too great. There are some images you have in your memory but not on film, images that will never happen again.

A few times when the fights were not within easy transport distance and I could not get a lift, I would not go. Once this happened on a Saturday night, an hour away from Paris. A photographer friend who took pictures for the boxers called me the next day to say that the scene the previous night was very visual and something that I might never see happen again. A

young fighter had got married the Saturday morning prior to his evening fight, and his bride in a long white gown and all their relatives and friends had come to watch him box. He got a standing ovation as he entered the ring and his win in the third round was greeted with huge applause. In the interval, the large dish-shaped copper gong was carried around and a collection was made for the newlyweds. I've seen all kinds of people around the ring, but never a girl in her bridal dress with her new husband up there punching it out.

A boxing career can be launched or finished in the spasm of a few minutes; perhaps that is the excitement and unexpectedness of life in the ring. It can all be over within seconds and I have seen months of training washed away in less than a minute. One night at Madison Square Garden, I went to see Ken Norton fight Duane Bobick. I had met Norton at Gleason's Gym at nearby Penn Station and was astonished by his power and stamina. Although I always kept one eye on the film counter of my camera and the other on the ring, it was safer to have more film in the camera rather than less. As Norton appeared in the spotlight, I noticed I only had eight shots left on the film, so I quickly rewound and put in a new roll. The preliminaries ended and the gong sounded for the first round. My eye was glued to the viewfinder and I was using a telephoto lens as I was not authorized to work from ringside. From up on a balcony I had a good view of both fighters and could listen to the commentary. But within less than a minute Bobick was down and counted out. At least I had caught the sequence on film – had I not changed the previous roll, I would never have captured that 'decisive moment'. The fight was over as fast as lightning, and in the space of a minute, Bobick lost a fortune.

Everybody knew Gleason's Gym on West 30th Street in New York. Champions were schooled there, and Bobby Gleason, although suffering from a long illness, always welcomed me in a friendly manner. The place was packed with boxers, four in each of the two rings, and others at the three punching bags. It was a temple of boxing, with over a hundred fighters training any time from 11 am to 8 pm under the guidance of eight trainers. The fees were $5 per lesson in sets of six, with a $30 guarantee deposit and $20 per month for services. I went over to one corner to say hello to Rodrigo Valdez who was training for his fight against Monzon. We greeted one another warmly although he remained his usual shy self. Later I sat upstairs with him in a smelly changing room with a hand-painted sign outside the door marked 'VIP Room – Authorized Persons Only'. We had first met in Paris, and in the following days he would always stop and come over to shake my hand.

In the same dressing room three days later, he introduced me to the Panamanian lightweight champion Roberto Duran. Duran told me how he had started his life as a shoeshine boy and worked his way to the top. At that time in 58 fights he had never been knocked out; 'The only thing that separates the winners from the losers is how hard you want to hang on,' his trainer told me. Training in the ring he was fierce; at regular intervals he made short squeaking noises, sounding exactly like Flipper the dolphin. I had often seen boxers who hiss when they train, but this could have been a wounded animal. He finished his training and I later found him in a pitch-black corridor standing stark naked on weighing scales. His trainer stood over the weight regulator with a burning match and muttered 'A hundred and forty seven pounds'. The match went out and he quickly struck another. Duran's body was dripping with sweat from his training. A few more shuffles and the scale moved another notch. Duran seemed very unhappy as he grabbed his towel and stormed into the shower.

Gleason's Gym, Gil Clancy's Solar Sporting Club, and the Times Square Gym were among the many places boxers could train in Manhattan. They had that feel of old black-and-white movies on television. Robert De Niro trained for *Raging Bull* in Gleason's Gym, and I made a call to the Hollywood production company of the film to see if I could take some photos of the pre-production training but was politely turned down. That was unfortunate, but many years later the Franco-German cultural television channel Arte devoted a special evening to the theme of boxing which started with a showing of *Raging Bull*, followed by a documentary about my photography, so somehow the two of us met up on a TV screen. As a photographer I was amazed by the camera work in that film and the incredible acting of De Niro. Cinematography allows the camera to take the place of an opponent and move around in extraordinary ways, while a photographer is always outside the ropes. Although I have photographed the ring from all angles, I often wondered what the boxer could see above and around him as he lay with his back on the mat, being counted out. The French film director Claude Lelouch, whom I had often met at boxing matches as he too liked the atmosphere, used an interesting technique in his film *Edith et Marcel*, the story of the boxer Marcel Cerdan and his love affair with the singer Edith Piaf. Lelouch used a ring with a transparent surface and placed his camera below it, filming from the feet upwards to get a vertical view of the punches. The visual result was quite exciting.

I've known boxers who became Hollywood movie stars, and others who became engineers, criminals, pimps, impresarios, doctors and models, although most were not particularly geared to the higher echelons of industry. Perhaps this is due to the high risk of permanent damage. I have become familiar with some of the symptoms: the limps and absent-mindedness, those far away vacant stares. Cuts and bruises show up immediately, but the deep-down injuries may only surface after many years, by which time it is too late to treat them. Perhaps boxers have too often willingly disregarded the danger of too many punches to the head. To look into this, I arranged to see Dr J. A. N. Corsellis at the Department of Neuropathology at Runwell Hospital, near Wickford in Essex, England. He had been part of a team doing a report on the risks of brain damage from boxing. The study examined the many features of what is known as the 'punch-drunk' syndrome. It was not concerned with the sudden fatal accidents that sometimes occur during a boxing contest, but with the abnormalities that can be found in the brains of those who have died after retiring from the ring. The research was carried out on the brains of former boxers, together with reports from friends and relatives, and a characteristic pattern of cerebral change was often discovered.

I met Dr Corsellis in his laboratory, a kindly, grey-haired professor surrounded by neuropathology books and diagrams.

On his desk were a stack of glass slides, several microscopes, and some jars in which floated parts of the human brain. I sat down in front of him and he placed before me a man's brain. It was hard, white and shiny, the size of a small plucked chicken. He went on to say: 'My work basically involves the aberrations of human behaviour, emotion and feelings, and changes in the brain structure. It became obvious to me that a punch-drunk boxer is in fact a unique case. In brutal terms it is the nearest we scientists can get to experimenting on humans, in that they are given repeated blows of certain intensity to the head, not enough to kill but occasionally enough to knock them out. They survive this, but what is really happening to their brains? Nowadays much greater attention is given to the medical aspects of boxing than before. The trouble with medical examinations is that they are done in order to demonstrate whether any abnormality is present or not; if an abnormality is present, then the brain must have already suffered damage, or else it would not be there. It is quite straightforward to describe what has happened inside the brain of a boxer, but it is more difficult to identify the mechanism that causes the damage.'

Calmly he went on: 'The brain consists of two hemispheres that fit inside the skull. Down the middle is a very thin membrane in two layers, separating the two sections. In a high proportion of people who have boxed for any length of time, the membrane gets worn and torn, and the two layers in each hemisphere tend to separate. The feature that distinguishes the brains of boxers from those of other people, sometimes to a marked degree, is the extreme separation of the layers and the almost total destruction of the dividing tissues. We've found that some people suffering from head injuries have a tendency towards violence of some kind or emotional instability. This happens a lot in boxers and may be the result of brain damage.'

'Boxing uses the term "punch-drunk"; well, what are its symptoms? At its mildest, it consists of dysarthria, a disturbance of speech, with or without disequilibrium; there is some evidence that the motor pathways of the brain are affected on one side more than the other. The memory may become less effective than it was, and in a proportion of cases boxers suffer from what is called dementia. When a boxer receives a blow on the side of the head, the skull starts to rotate, but due to inertia, the brain inside does not follow the movement immediately, so the pressure of the swivelling of the head pulls at the brain's supporting tissues. This internal displacement and shock can cause the bridging veins to become distended and can lead to tearing. A blow can also cause compression of the blood vessels leading to the brain, provoking decreased cardiac action and sometimes an arrest. *Dementia pugilistica* is in fact a disintegration of the brain where the person suffers from memory disorder and tremors, and usually occurs after boxers have ended their careers. As the progressive illness takes its toll on the memory, they become more and more forgetful.'

'It is possible to detect external physical signs in boxers today which may be the advance warning of some internal trouble. But the real problem is that a lot of them will say "I'm fine, it's all a lot of nonsense". I am not disputing this, as many boxers do survive. But it is no good me discussing the nature of brain damage with boxers or pro boxing people because it is not their field, no more than I would dream of setting myself up as an expert on the niceties of boxing. Boxers become very emotional about it, but as a scientist the more I saw of these damaged brains the less I wanted to watch boxing. In any weight category the boxer is running a risk, and it may even be better to get knocked out quickly and get it over with than to be one of those tough chaps who is constantly suffering from blows to the head. Once destroyed, the cerebral tissues can never be replaced, and the process of degeneration can smoulder on even after the boxer's career has ended. It may be true that a single severe head injury occurs in the ring no more frequently than during other sporting activities, but the claim that boxing carries no risks beyond those of other sports can scarcely be upheld. Many people on both sides of the ropes enjoy the benefits of the sport; it may build up the character of the amateur or the bank balance of the professional. The question is, does any end justify the degradation, however exceptional, of the punch-drunk state?'

After that afternoon with Dr Corsellis, I came away doubtful and have looked at the boxing world in a different light ever since. My photos are not trying to put the blame on anyone; they speak for themselves and viewers can make up their own minds. I believe that the men and boys who enter the ring are very brave, and may shut the potential dangers in a hidden psychological closet. I cannot forget a trainer shouting at a professional boxer in the ring: 'That's it, snap it at him, that's beautiful baby, keep on going. Just jab baby, hit him on the eye, the motherfucker's beat... you've got him, you got him.' Back in the corner the trainer continued: 'You gotta beat the shit out of him man, you gotta move, otherwise he'll bust you open. Keep on him all the time, you slip in and jab. There's nothing worse than a fighter with no fucking guts, if he doubles up, you can keep him away with a single punch. Don't let him come in on you... the guy's got no heart, he's a chicken. Come on, let's move, get on the horse... higher, higher with those punches, he's all pooped out. Stay off the ropes and keep in the centre of the ring, keep the bastard away, and pull back from those hooks. Move, move, that's right, jab him. He's fucked – you'll lick him with a jab. Don't get involved, don't wrestle, a left–right and catch him when he's standing still. You're closing that eye up real nice, a couple more rounds and it'll be shut, bust it baby, that's wonderful....'

Professional boxing showed me that it was all a question of attacking the other man's weakest points, damaging an already open wound. In the front rows I've seen blood gushing out of wounds, to the extent that frontline journalists covered their suits with unfolded newspapers to avoid being stained. So it was hard to understand the psychological balance between the trainer and the young boxers whose fights I had witnessed. In their dressing rooms, away from the public eye, the post-fight tension continues as they sit hiding their bruised faces behind blood-stained towels, some sobbing like children. Yet this is a man's world, and only the strongest can survive.

Two manager-trainers were sitting with a boxer in the dressing room after his fight. The eighteen-year-old had just lost, and was sitting silently like a punished schoolboy behind a bench. Despite the boy's presence, one trainer commented:

'I had to stop him, he wasn't doing anything. I know that boy inside out, and for the last five or six fights he's been just like that. It's not possible, there must be something wrong with him. You shouldn't be retreating, you've got to be in there punching. I had to stop him, he was making me mad taking punches like that. It's unthinkable – if you let the other guy move in you're finished. You'll have to stop fighting and rest, get some fresh air, go home and rest, go to the movies for the next three weeks, but no more boxing for you. I realize you met a guy who is better than you, but how come you're always feeling so tired? What are you hiding from me? Have you been going to bed late? You've got to be quick and full of nerve, always on the ready, but something must be wrong with you and I want to know what it is. If you're tired I will let you rest, I'm your friend. We'll do nothing, just rest and let you recharge your batteries. But tonight you were like a beginner, I want to know what's up. Have you been at the pussy again? Girls and boxing don't mix. In the gym we kill ourselves training you, and in the ring you are just the opposite. On Monday you did a good fight, in Thursday's fight you were fantastic, and now on Saturday I hardly recognize you. You've got no wind, you're all washed out. Already in the first round I could see that something was wrong. It's funny. On Monday you had a match with a strong guy, usually the first three rounds you keep it in your guts, but after the third round you were all washed up. The engine's not working, you're not punching anymore. I can't see you going on like that, am I making you fight too much? Have you been fucking all night? Girls and boxing don't go together, I don't want you to fight like that without feeling...'. Little did the trainer realize that perhaps he was pushing too hard, and the boy was afraid of telling him exactly that.

Undoubtedly boxing can never be risk-free, but could it be made safer? Some people feel it should be banned altogether and others suggest the rules should be changed. Other ideas include heavier gloves to reduce the damage or perhaps a complete ban on hitting the head, just as it is forbidden to hit below the belt. Now as more and more women enter boxing, that world has been turned upside down. There was already an uproar about 'ultimate fighting' in the United States, and illegal bare-knuckle contests in abandoned factories shown in films like the recent *Fight Club* brought shudders from the officials. According to one newspaper report,[1] the supermodel Naomi Campbell was rumoured to be taking up boxing training in Los Angeles, as part of her struggle to control that infamous temper. She apparently told an American television channel that since her childhood she has had a history of verbal and physical assaults. But skipping, shadow-boxing and punching a bag are very different to getting into a ring for a real fight.

The first time I witnessed two girls fighting was in France. One was seventeen and a half and the other, of North African origin, was about twenty-two. The latter was a pretty good boxer and won the competition. After the fight I asked her what she wanted to do as a career in the future and her response was 'be in the police force'. It wasn't a bad idea: the rough suburbs with their dealers and pitbull dogs are not a place to hang around, and maybe a thug would never think that a pretty young girl could be a boxer in disguise. I also saw a young schoolgirl training in the old kasbah of Tunis. Her father came to pick her up after training and was proud of what she was doing. However, this was a Moslem society where girls and women had rather conventional roles, so she was allowed to do exhibition fights but not competitions and not against boys. A decade ago no one would never have imagined that the likes of the daughters of Muhammad Ali and George Foreman would go on to fight for million dollar prizes.

After a fight, a young boxer said to me; 'I'm definitely going to win the next time, and I'm willing to go to hell and back to do it.' Several women who have seen my work at exhibitions later commented to me that although they would never go to a fight, my images somehow tempered things down. Perhaps the camera has become a kind of barrier for me; I am concentrating so hard on my work that the battle is another world. The same thing happens to war photographers: it's a kind of no-man's-land. The vision through the lens distances you from the reality. Through photography you can add a certain beauty to suffering, because you are not confronted with the noise and pain of being punched and hit. Yet 'hell and back' may mean every time a boxer gets into the ring, a space that is unknown and unpredictable. It can be an act of pride, revenge or humiliation in front of one's friends and an audience.

One night I was quietly working at the ring's edge, while in the ring was a well-known gypsy boxer and up in the various balconies of the round building were the clan members. He reacted to something, and I was suddenly surrounded by a dozen little gypsy boys who appeared from nowhere. They were coming down like bats in a belfry frightened of the bell. Knowing the situation was tense, I saw the boxer angrily shouting at the man next to me who had called him a coward. Such statements can cause a riot when dealing with the pride of the pack whose hero had been verbally offended. It is all to do with dignity and self-image. Sometimes I find the public more violent and offensive than the fighters: they are there for a night of 'strong sensations'. Women cringe with horror, and hooliganism is not only found in football – a wound-up arena can be as explosive as a boiling volcano. Boxing is not a cheap thrill, it's a matter of the survival of the strongest, a mirror image of life. Wars and crime on TV may have brought us to a state of 'compassion fatigue', where it's all happening somewhere else, but a night at a fight is the real thing for the voyeuristic or sensation-seeking. I hope my photographs are neither of those, but show instead an awareness of a different world which is not my own, one it has taken me all this time to understand.

Earlier on in this work I thought that my photos were just the result of my eye in the ring, but later I realized that they are the reflection of the ring in my eye, capturing not just my emotions but the fighters' dreams. The best images come from a combination of the mind, the heart and the soul, so images without compassion and generosity will always remain lifeless. Perhaps we will have to live with boxing, like many spectator sports, as a 'safety valve' for the pent-up tension of the masses, a means of diverting frustrations within our society.

JAMES A. FOX

1 John Harlow, 'Naomi punches out her anger', *The Sunday Times*, 19 November 2000.

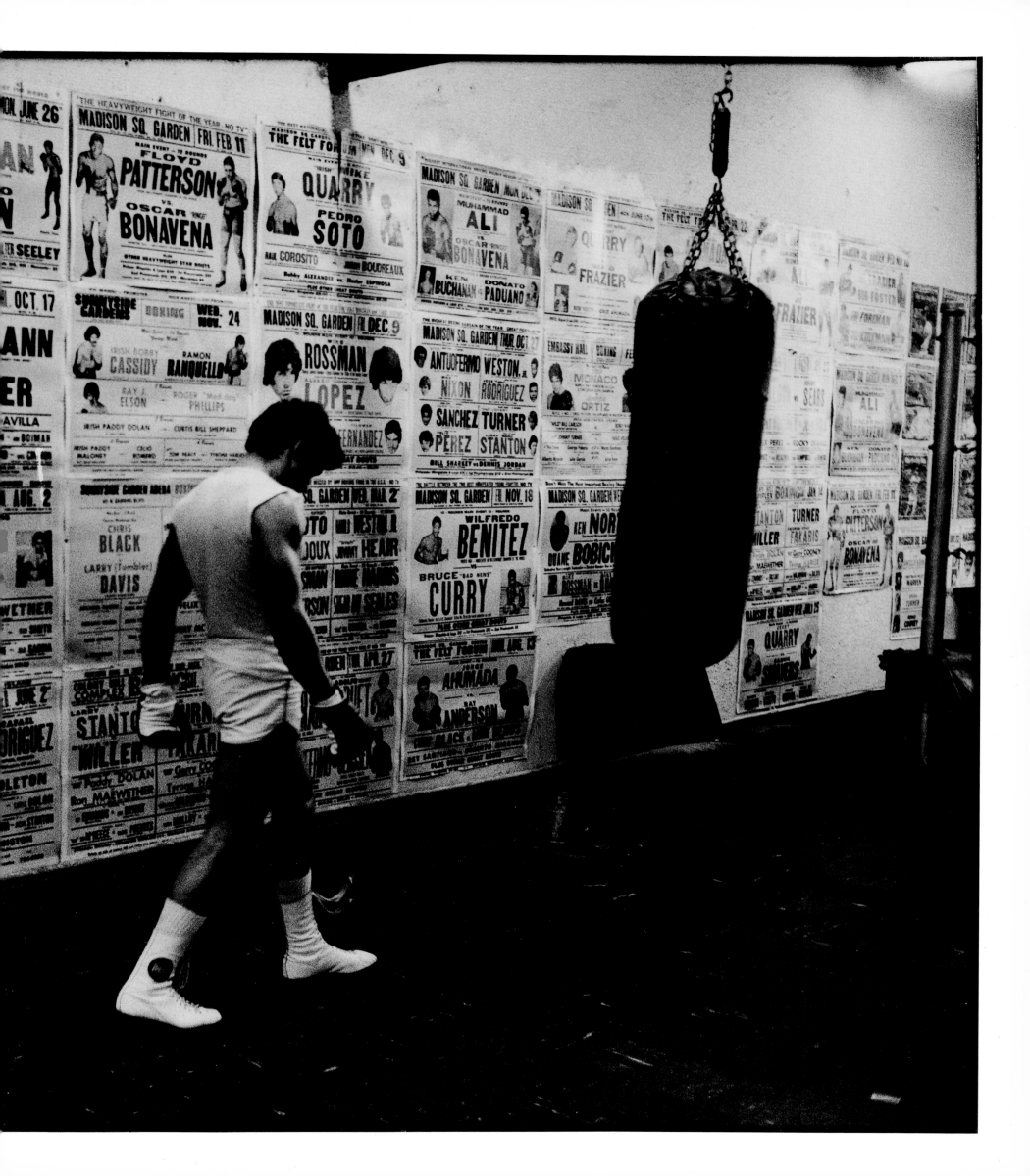

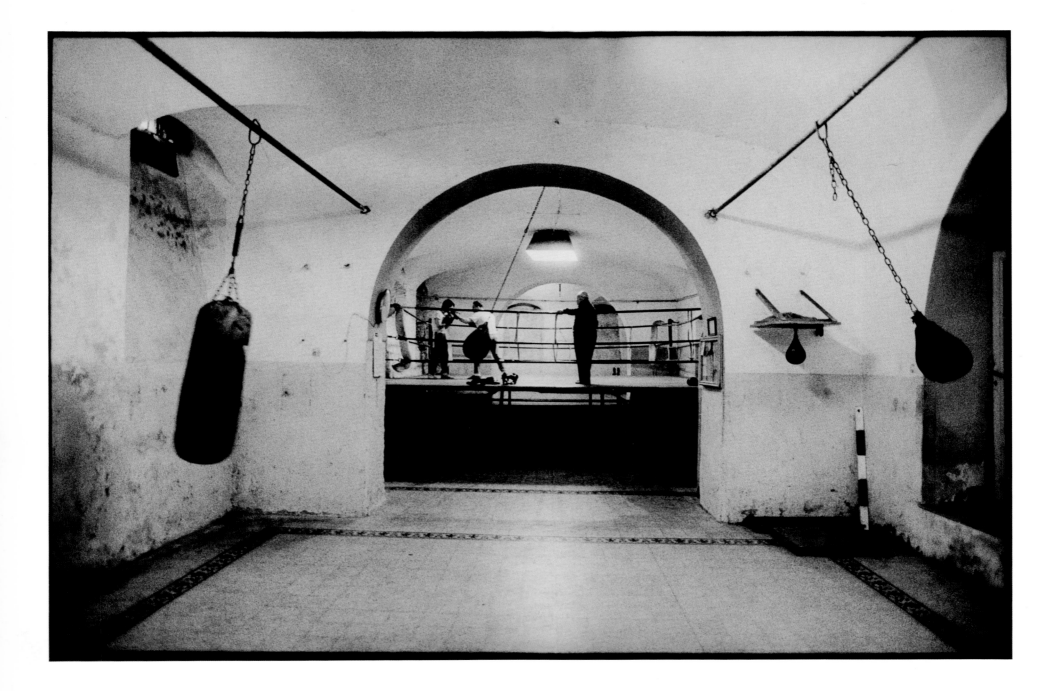

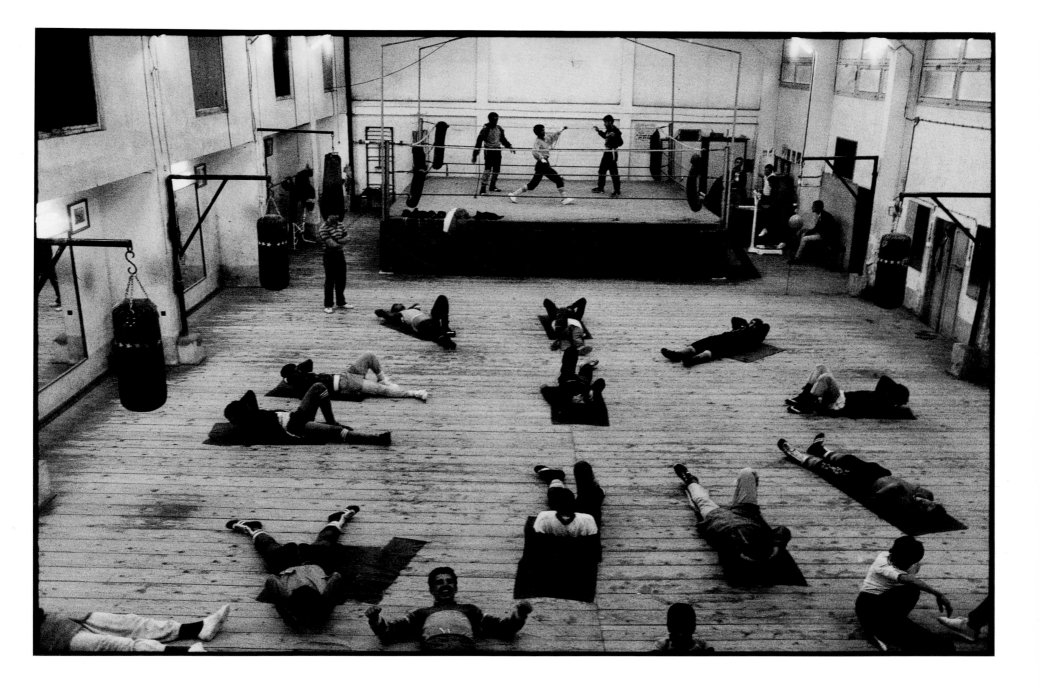

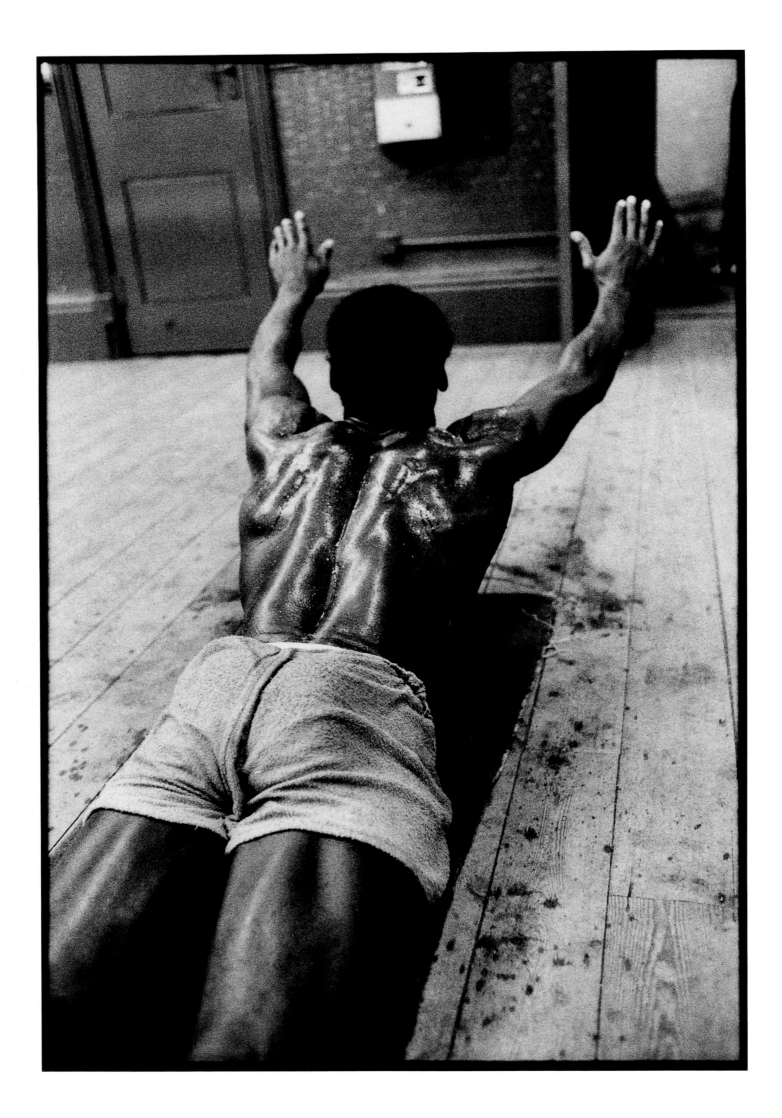

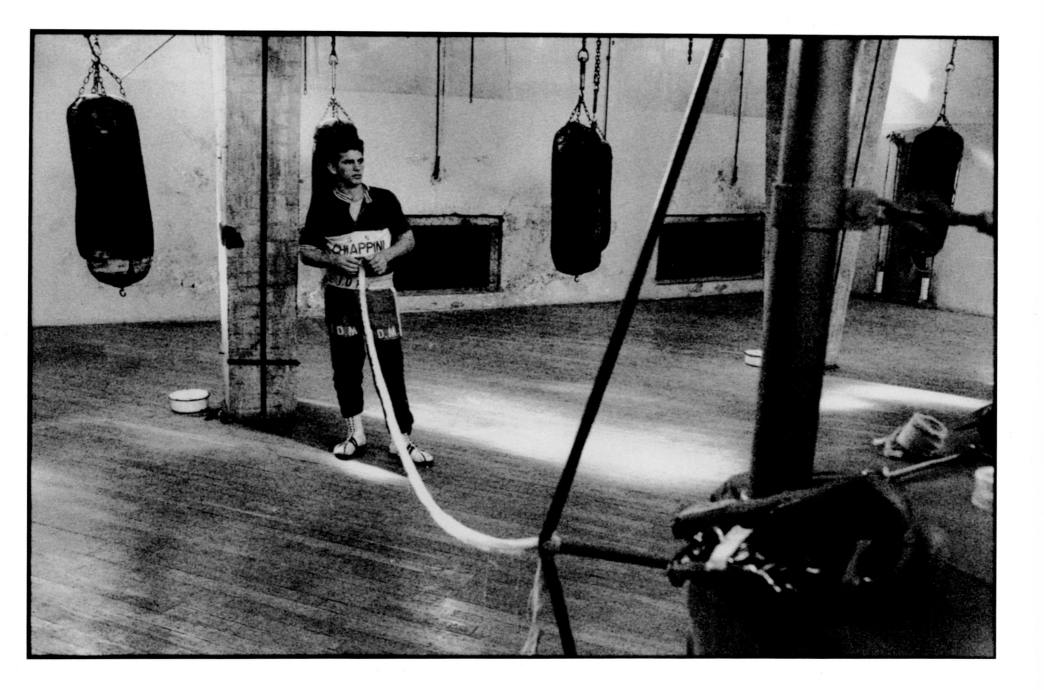

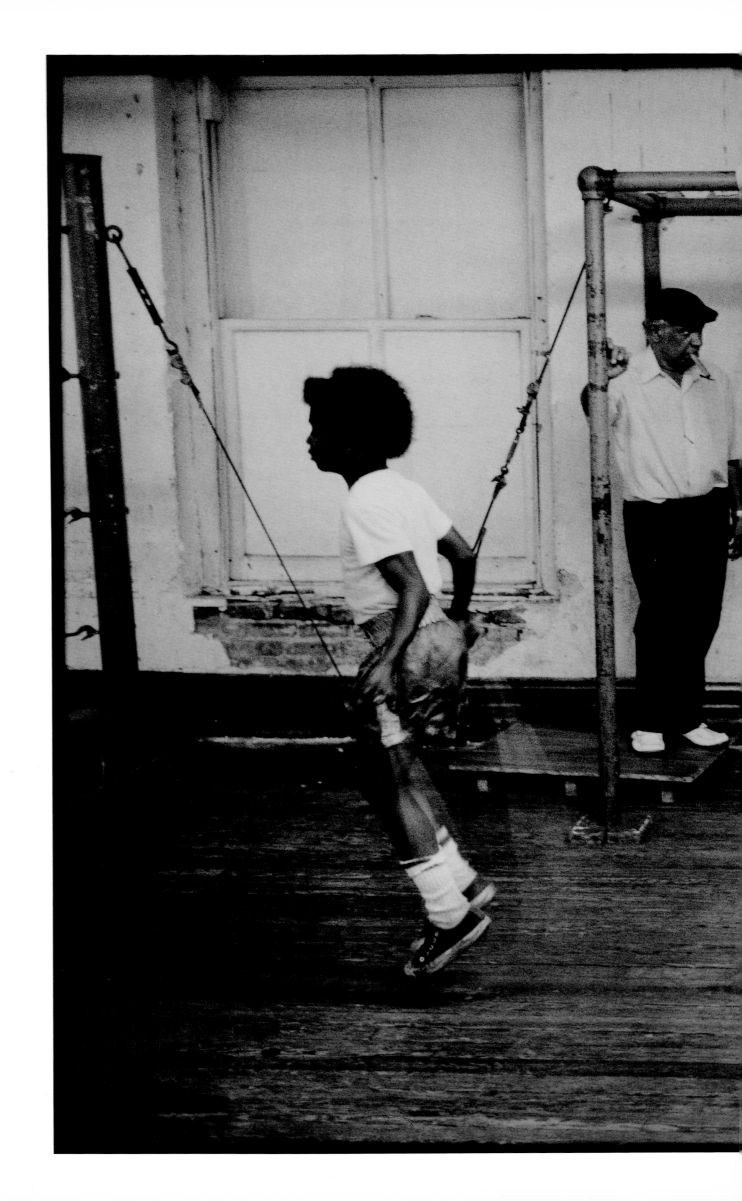

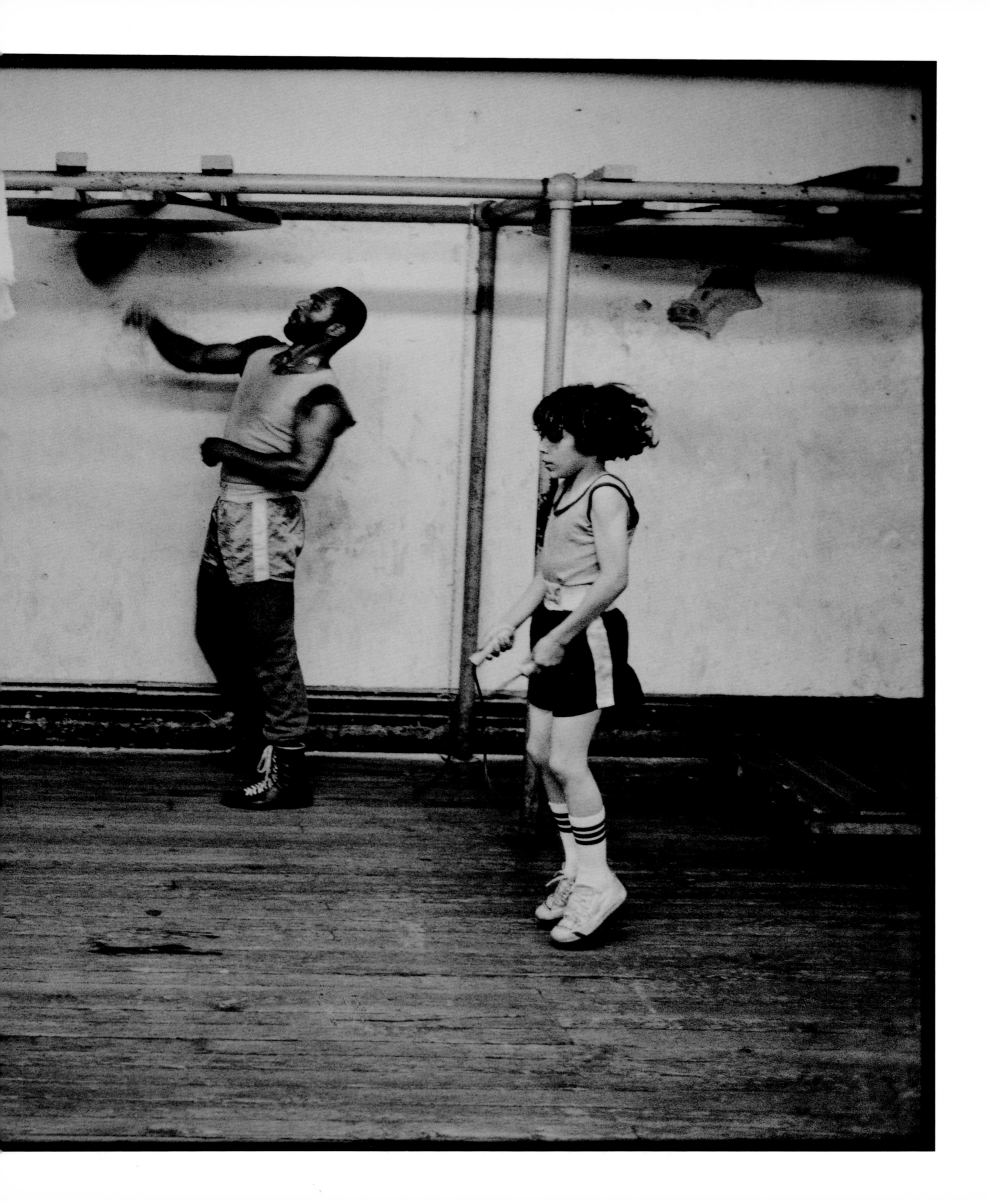

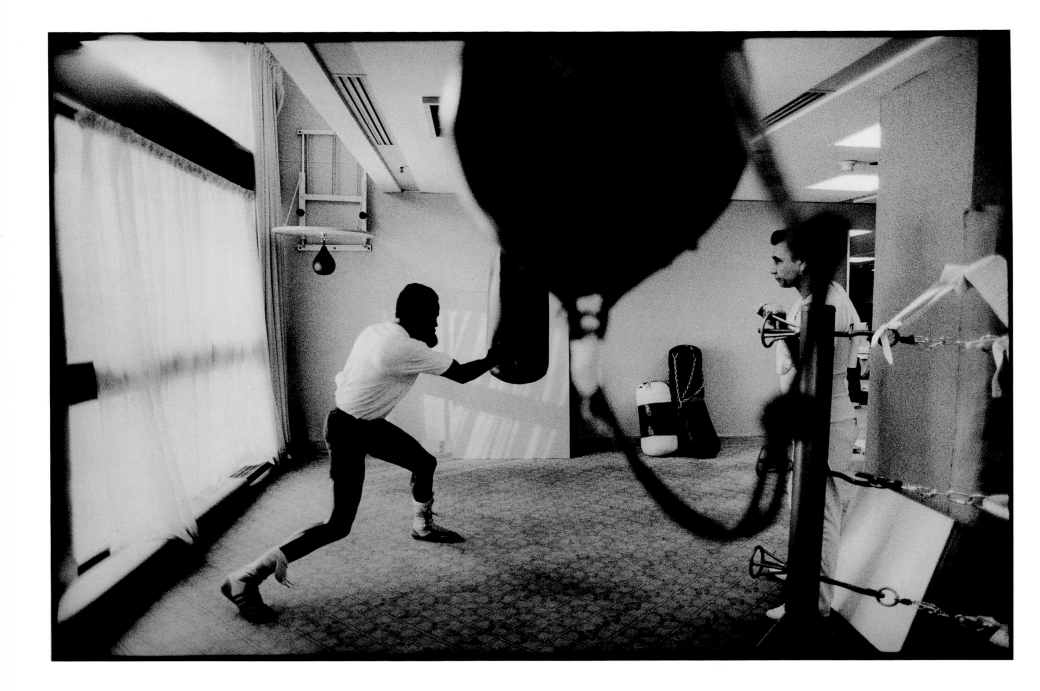

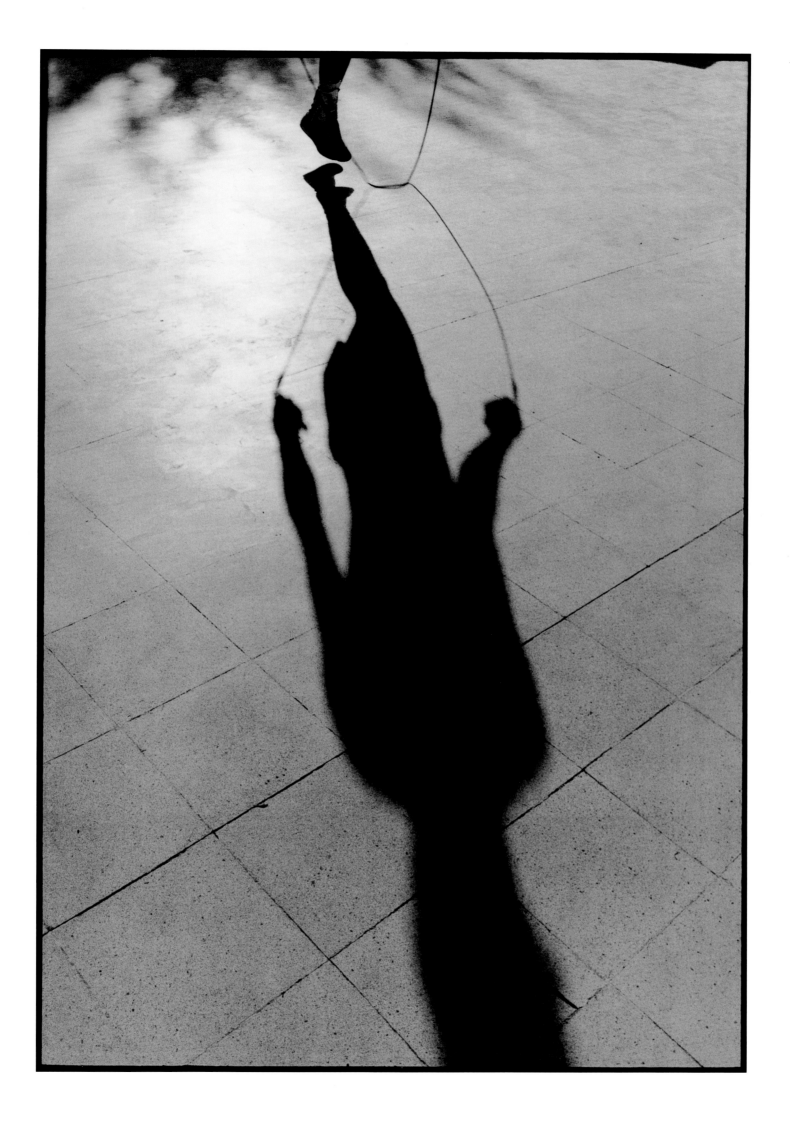

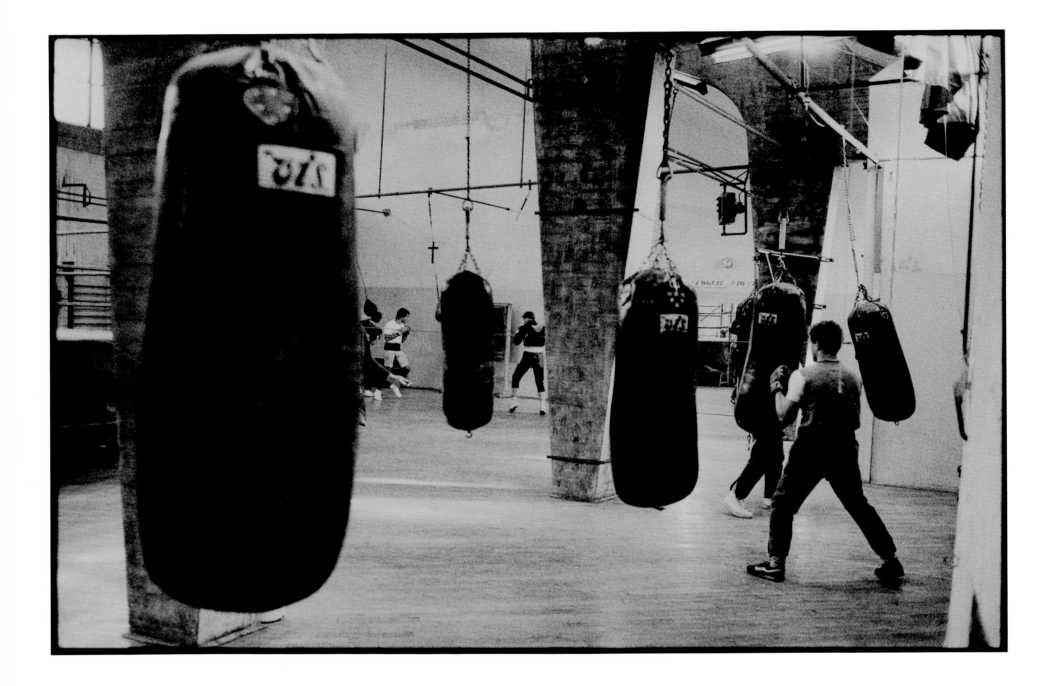

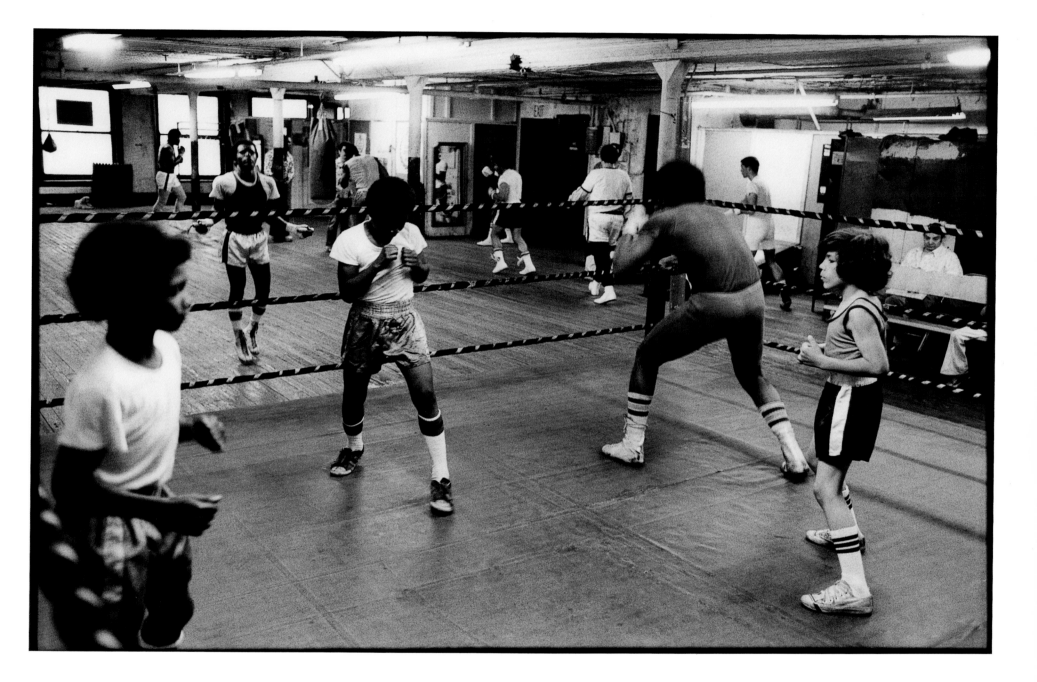

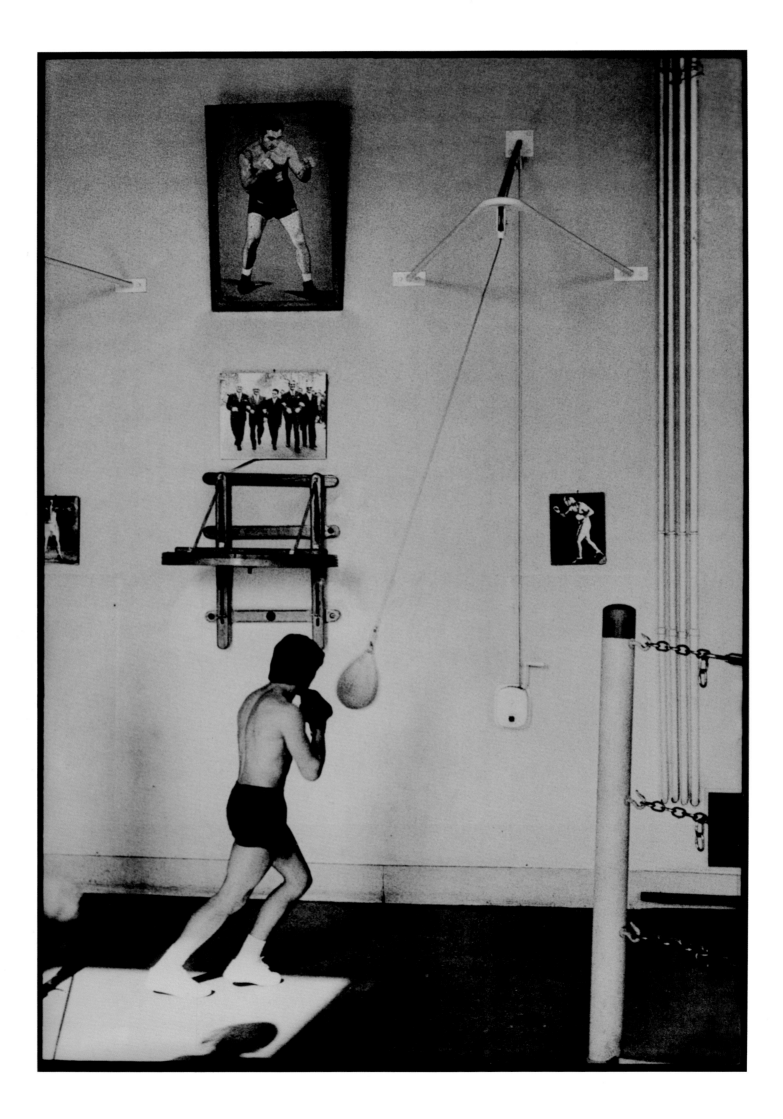

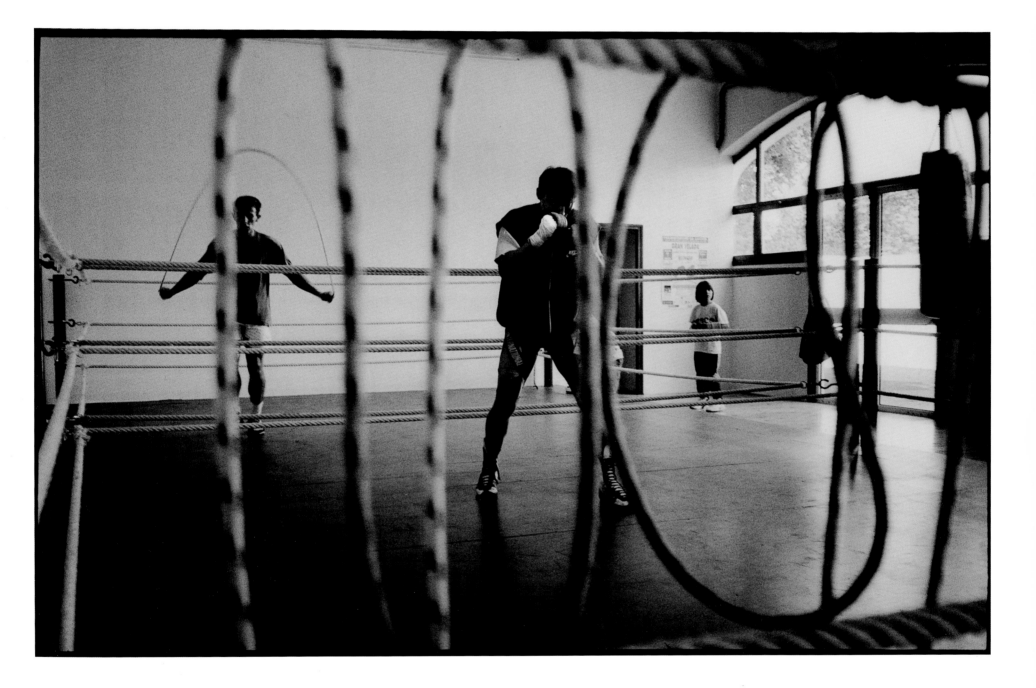

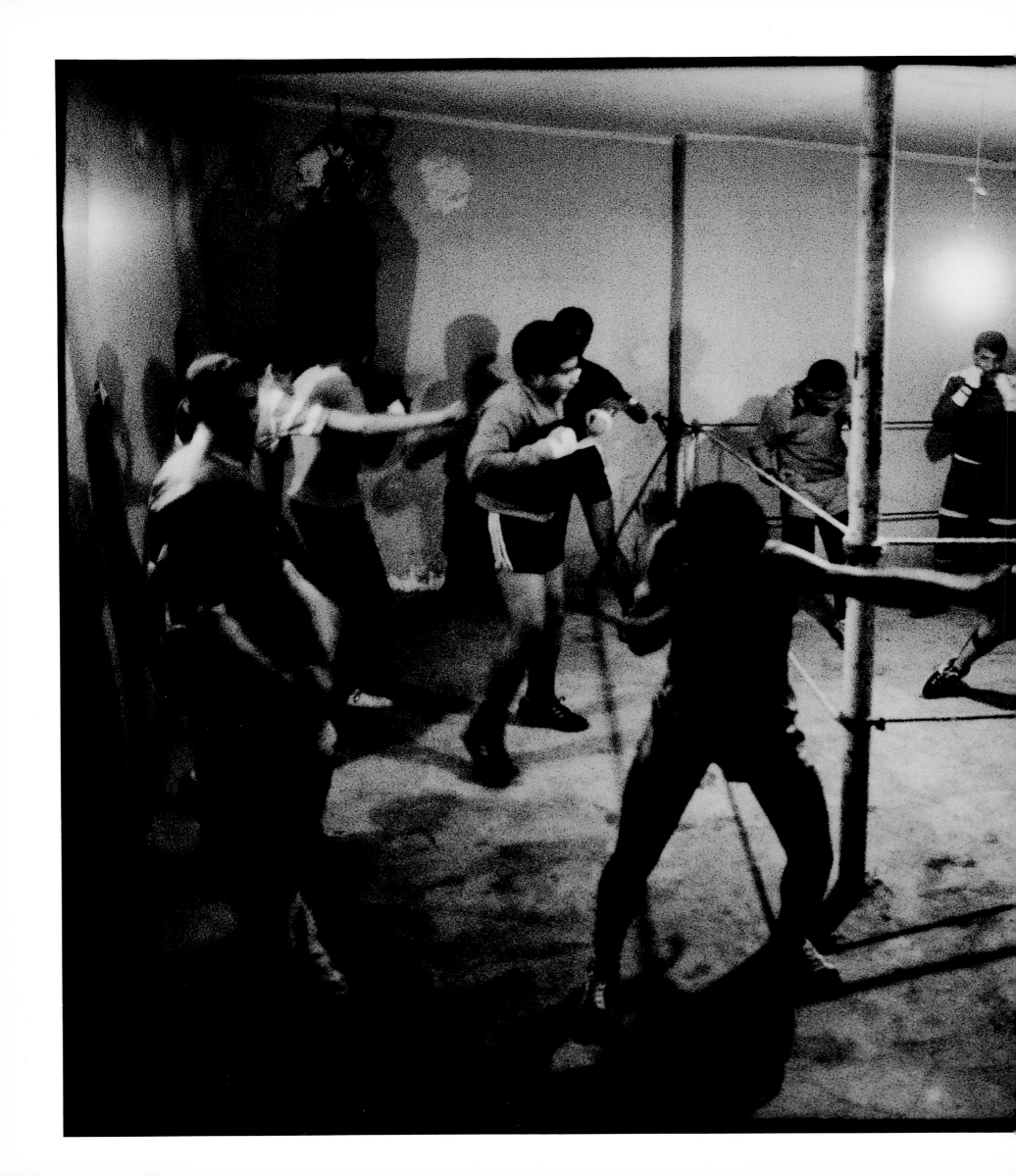

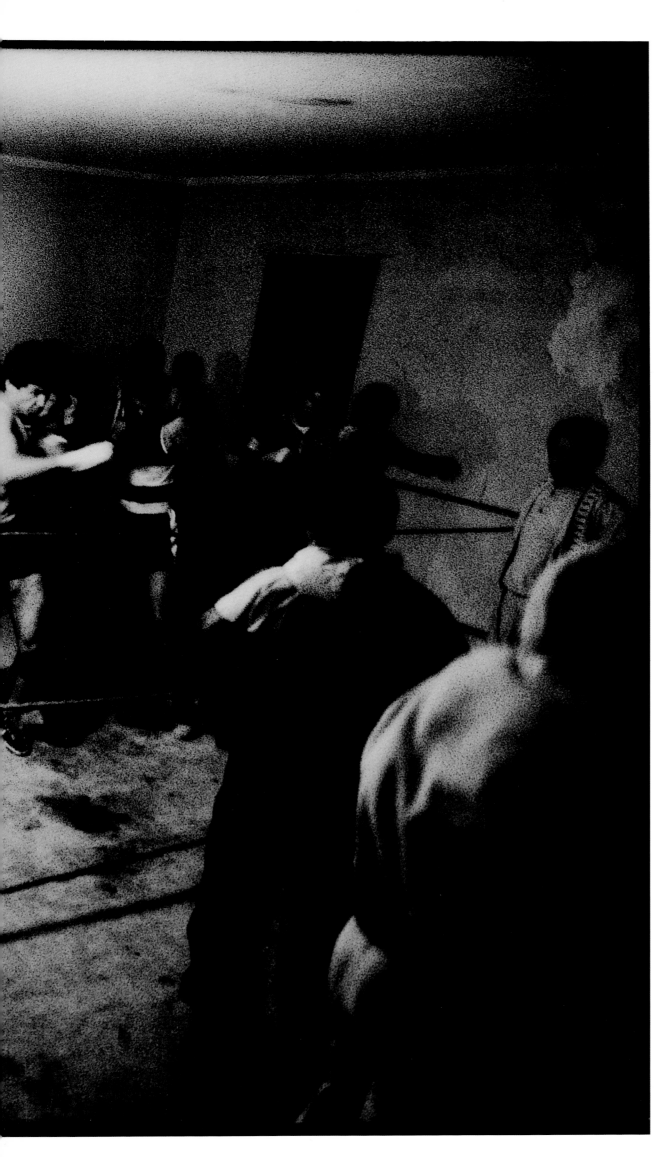

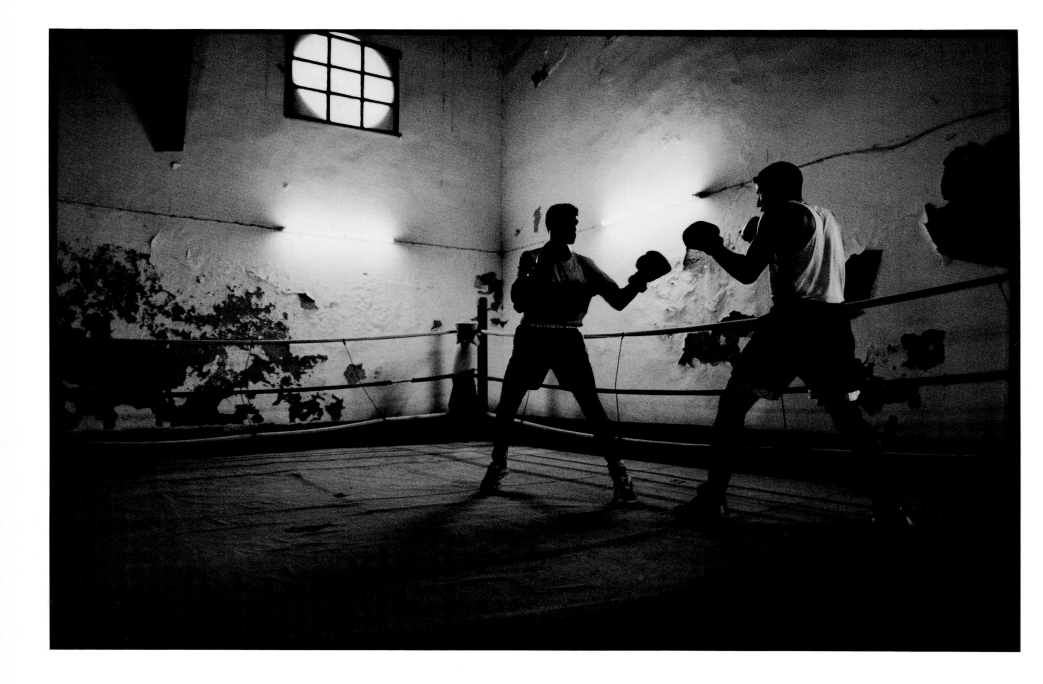

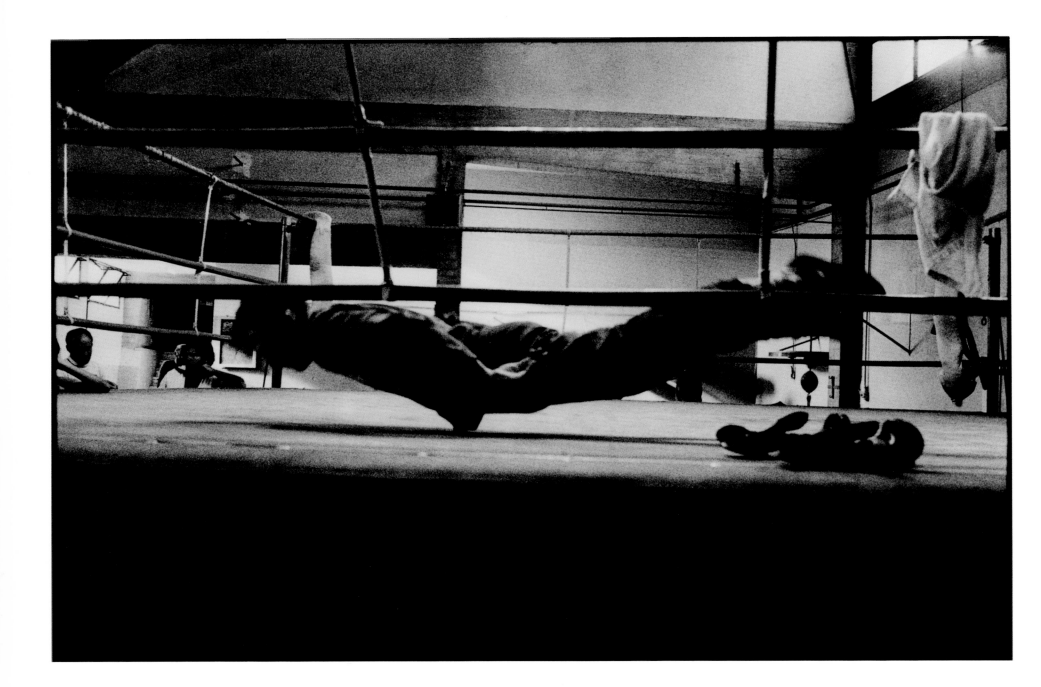

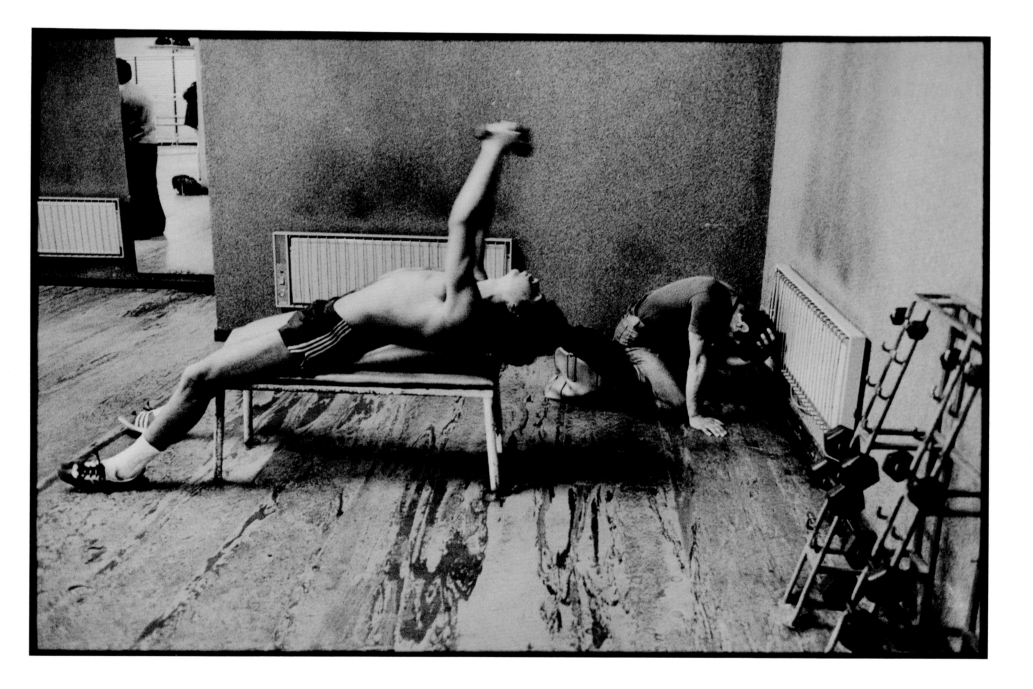

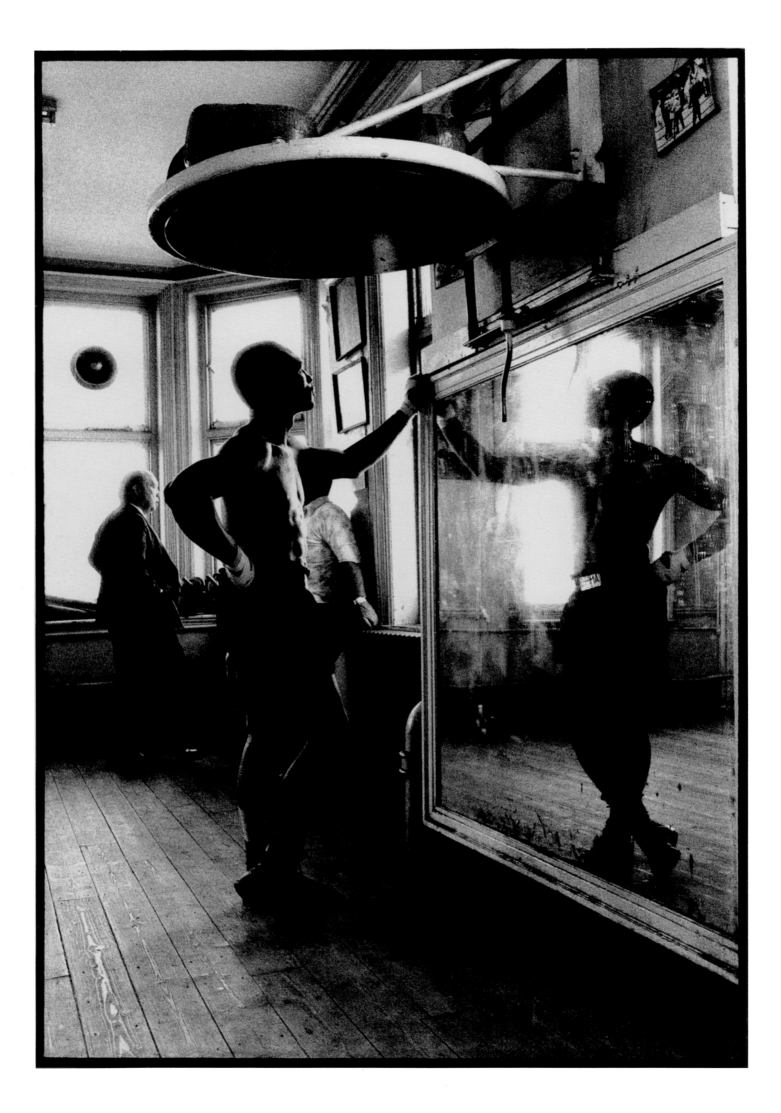

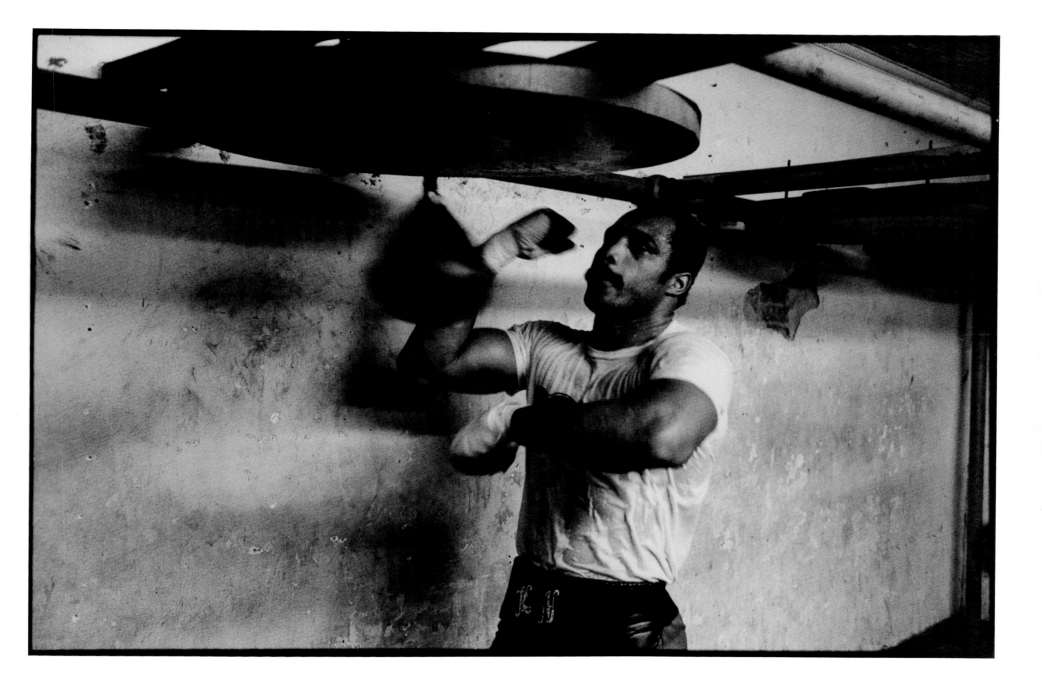

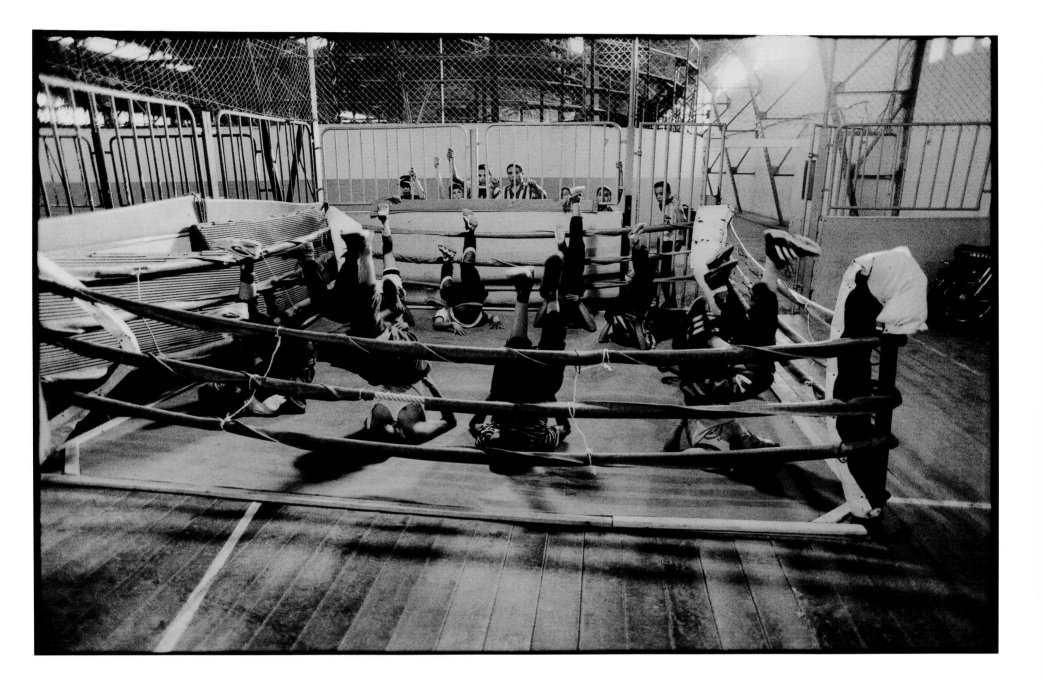

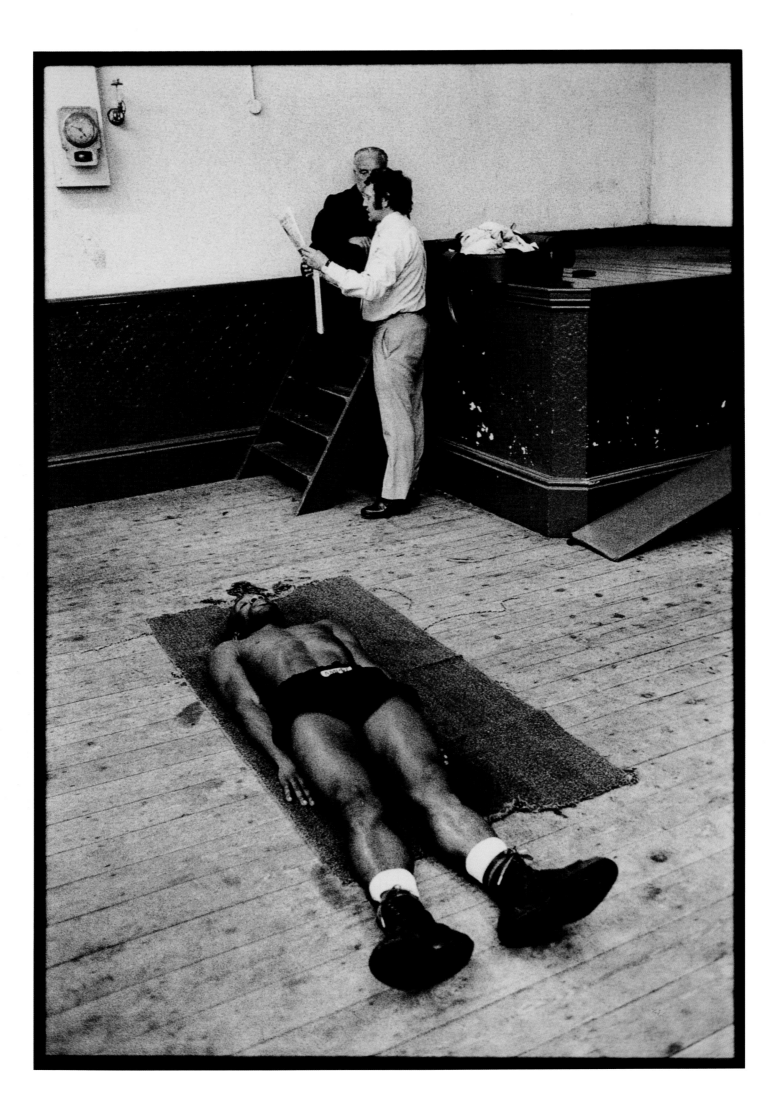

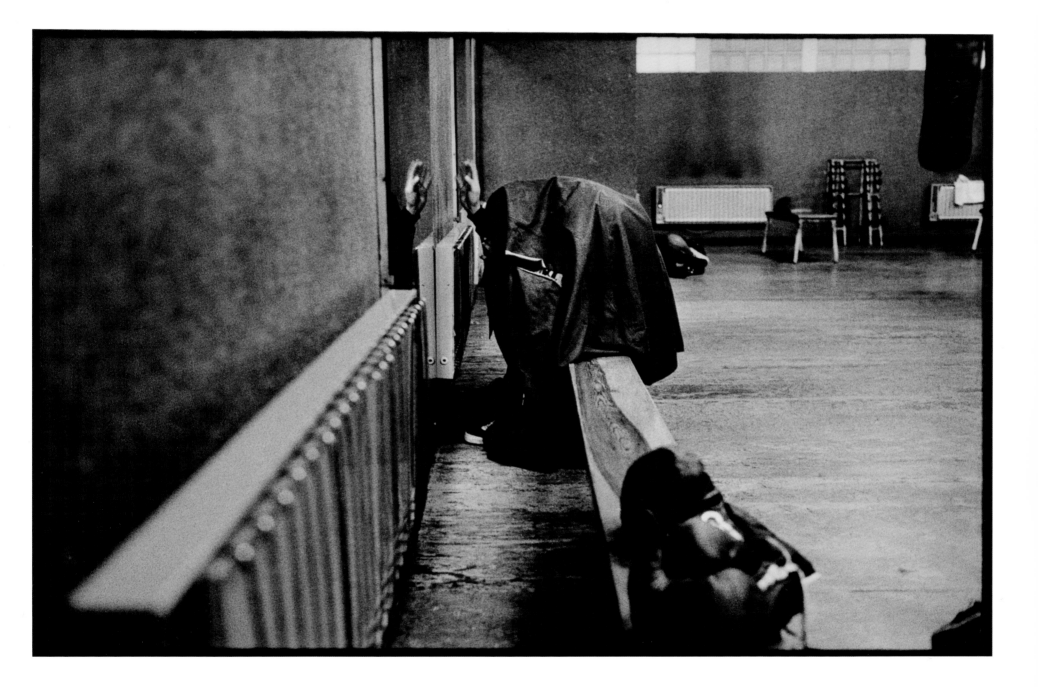

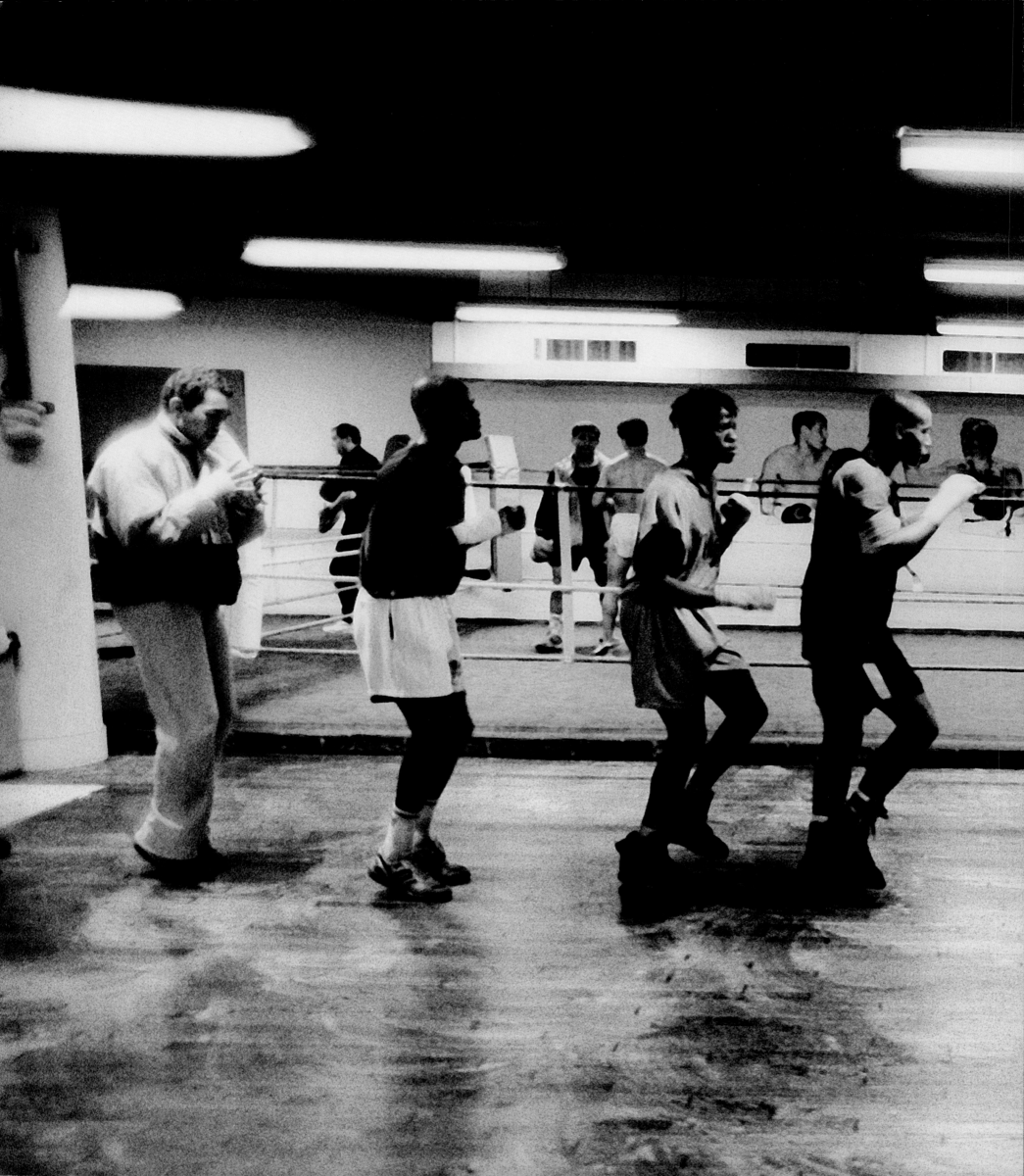

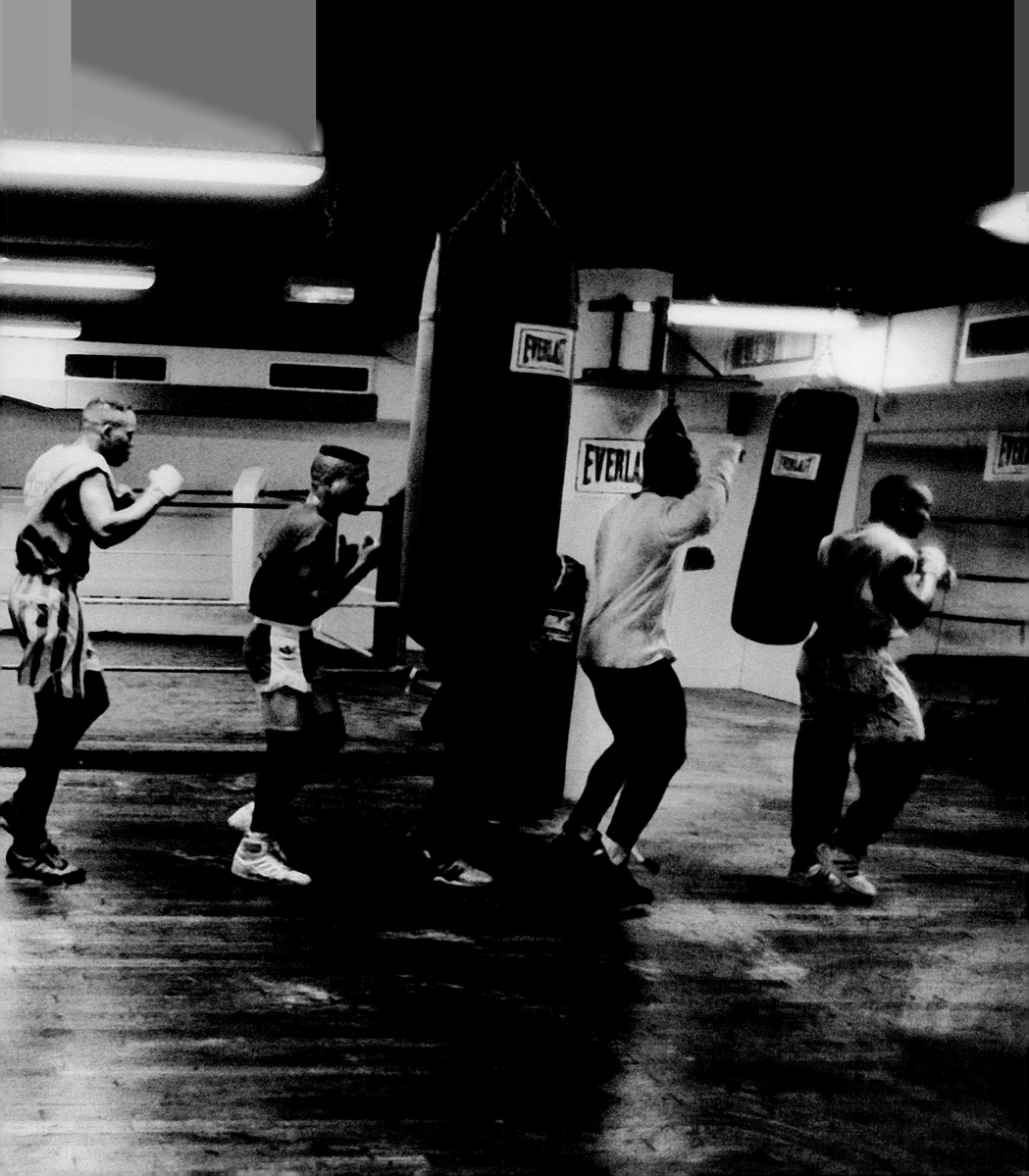

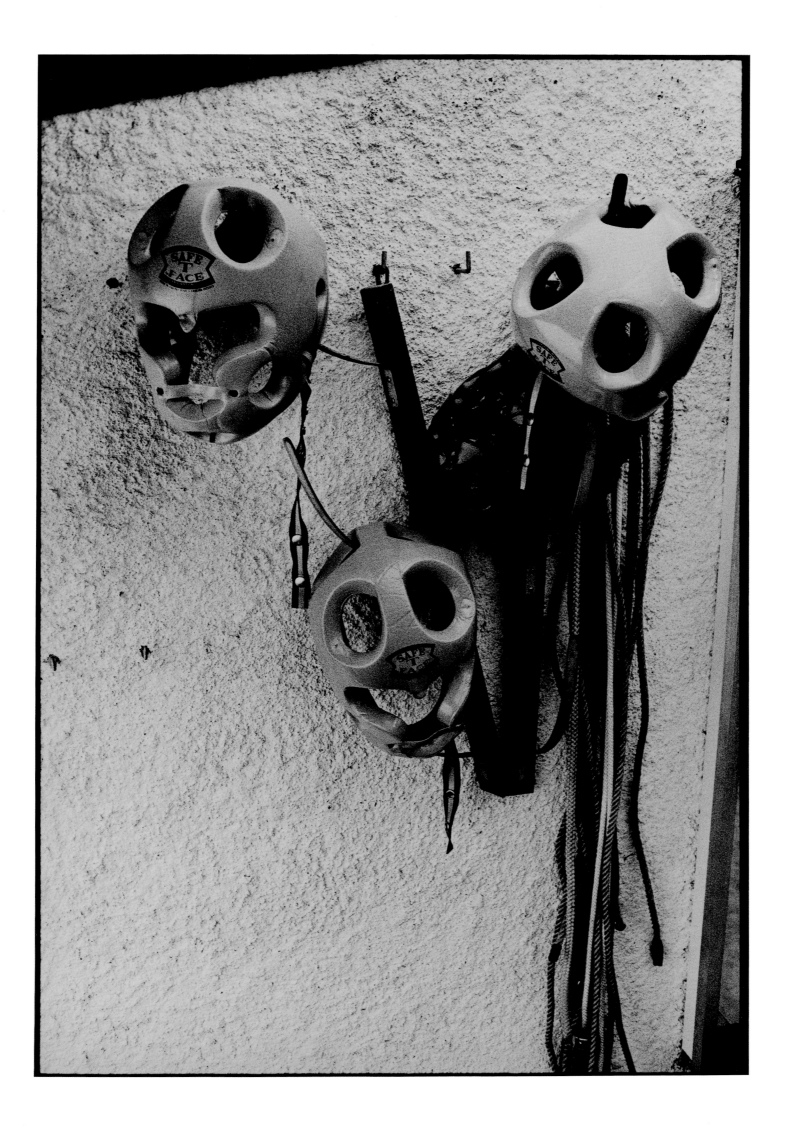

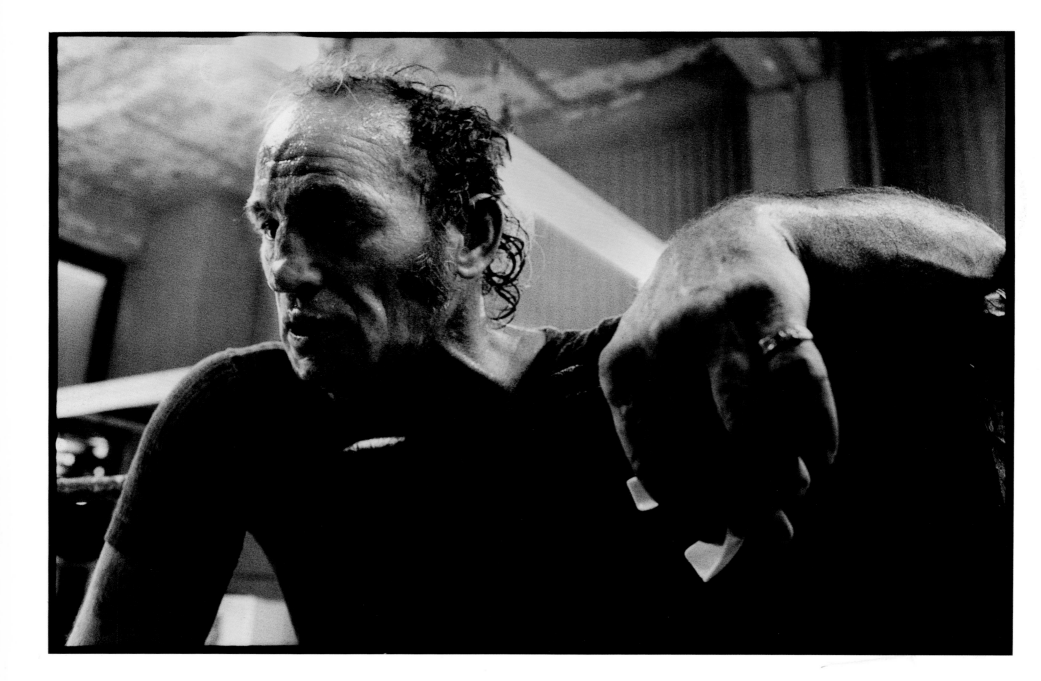

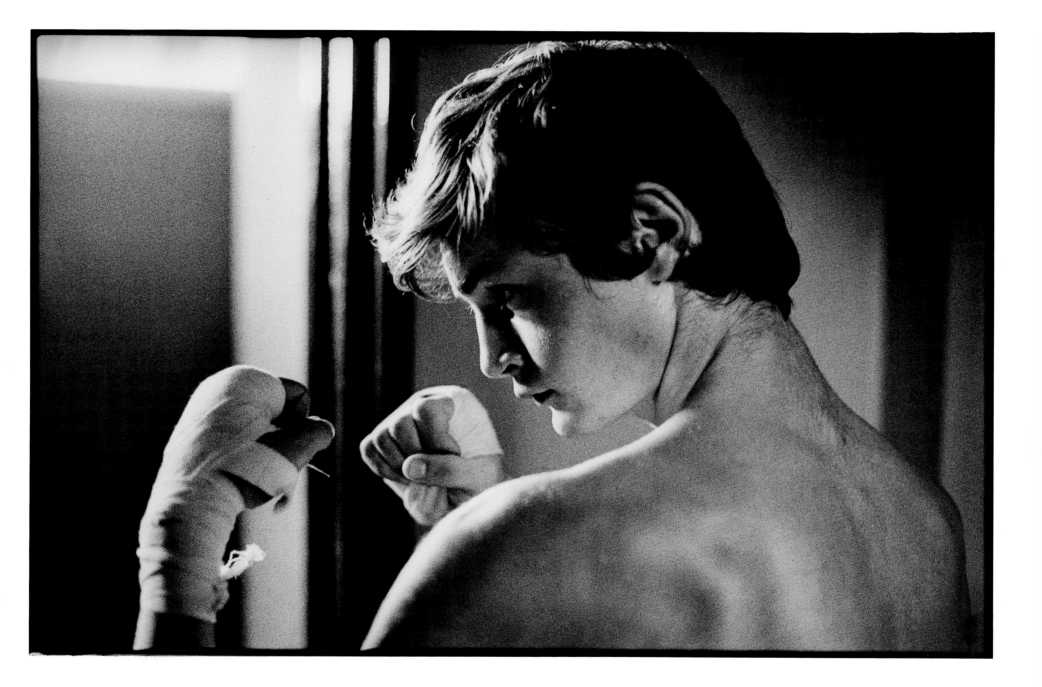

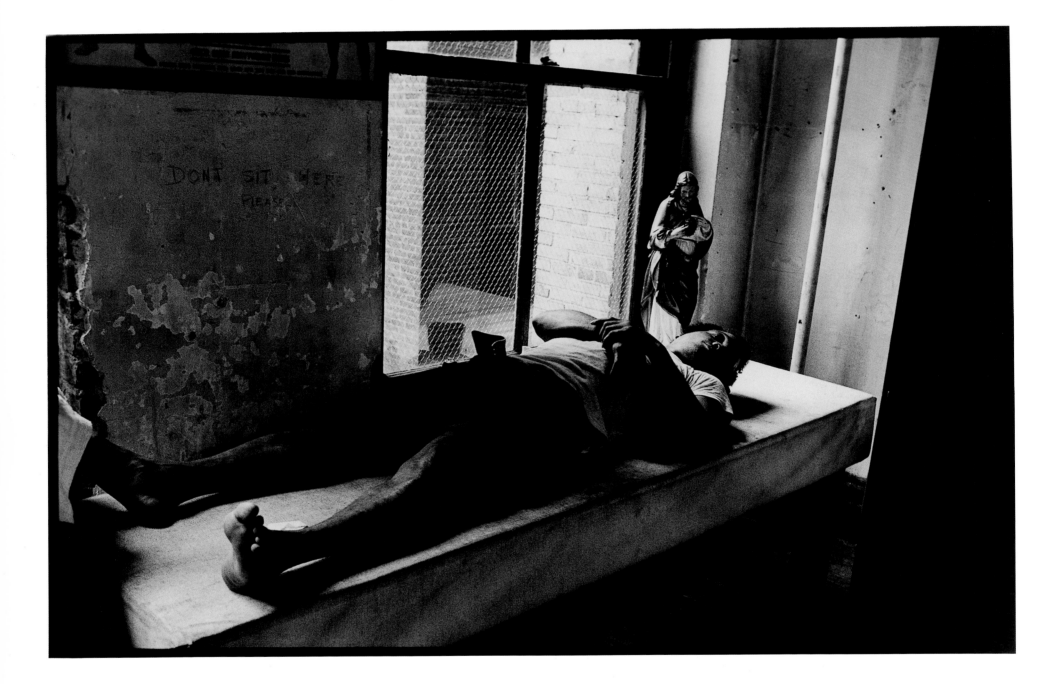

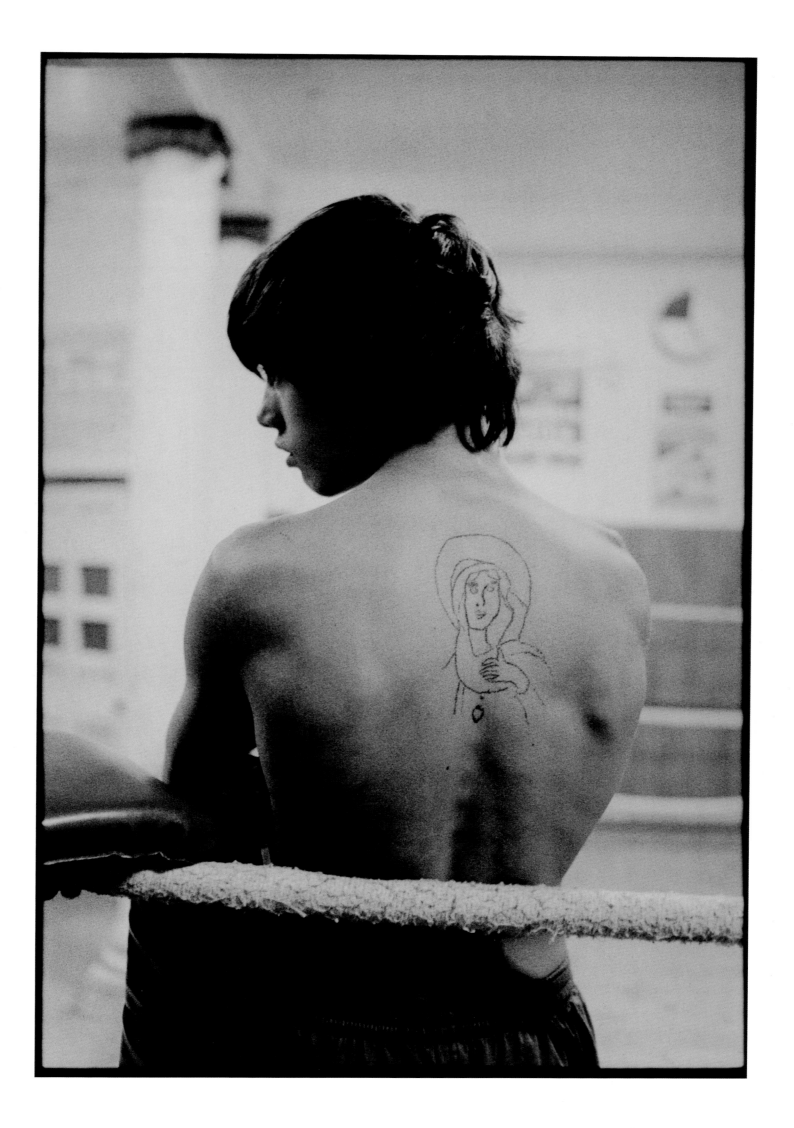

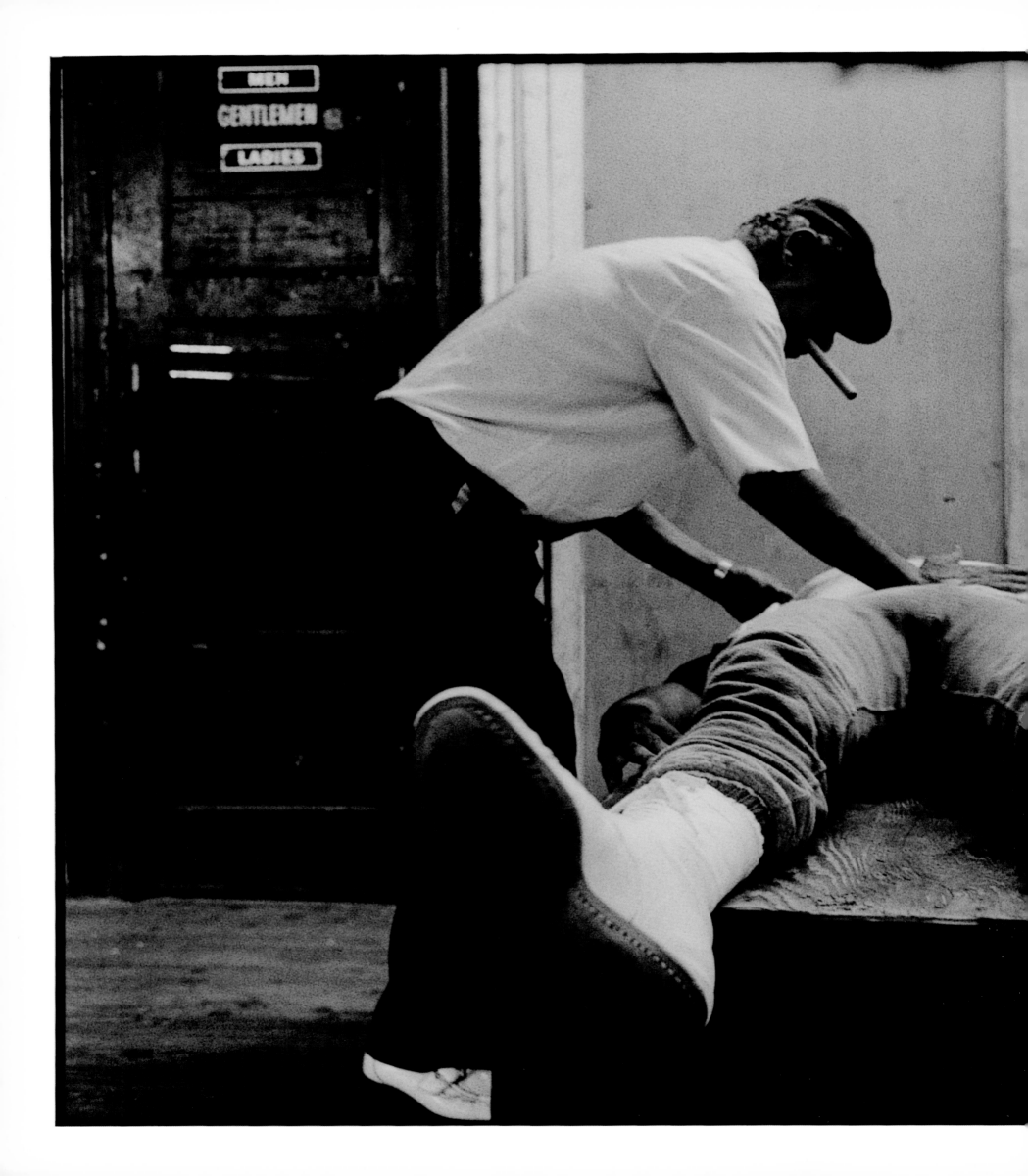

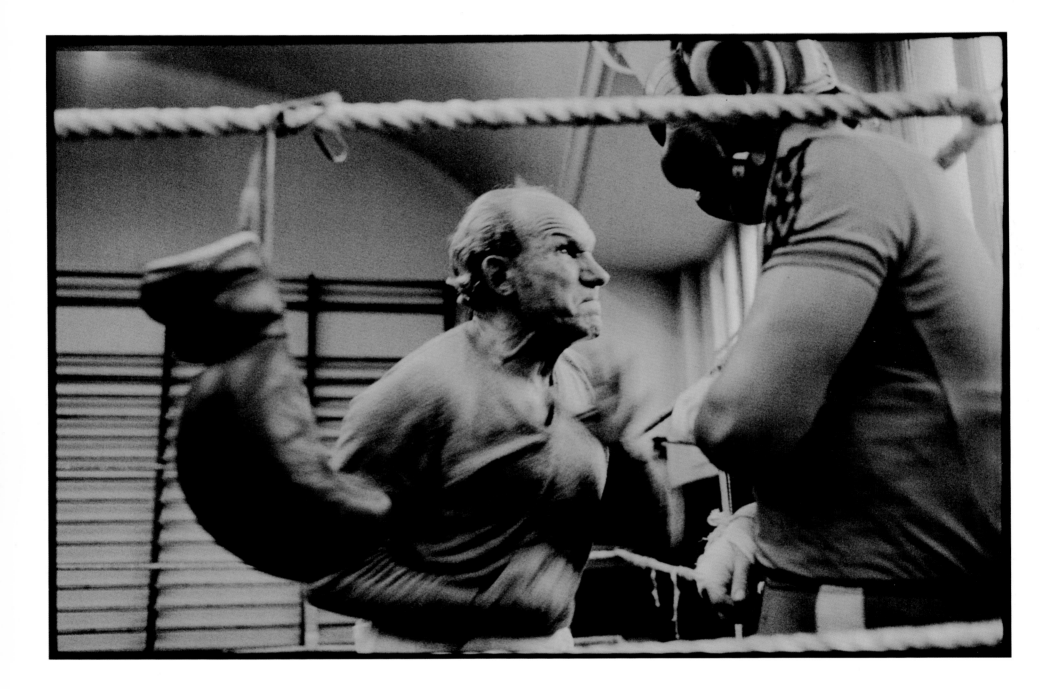

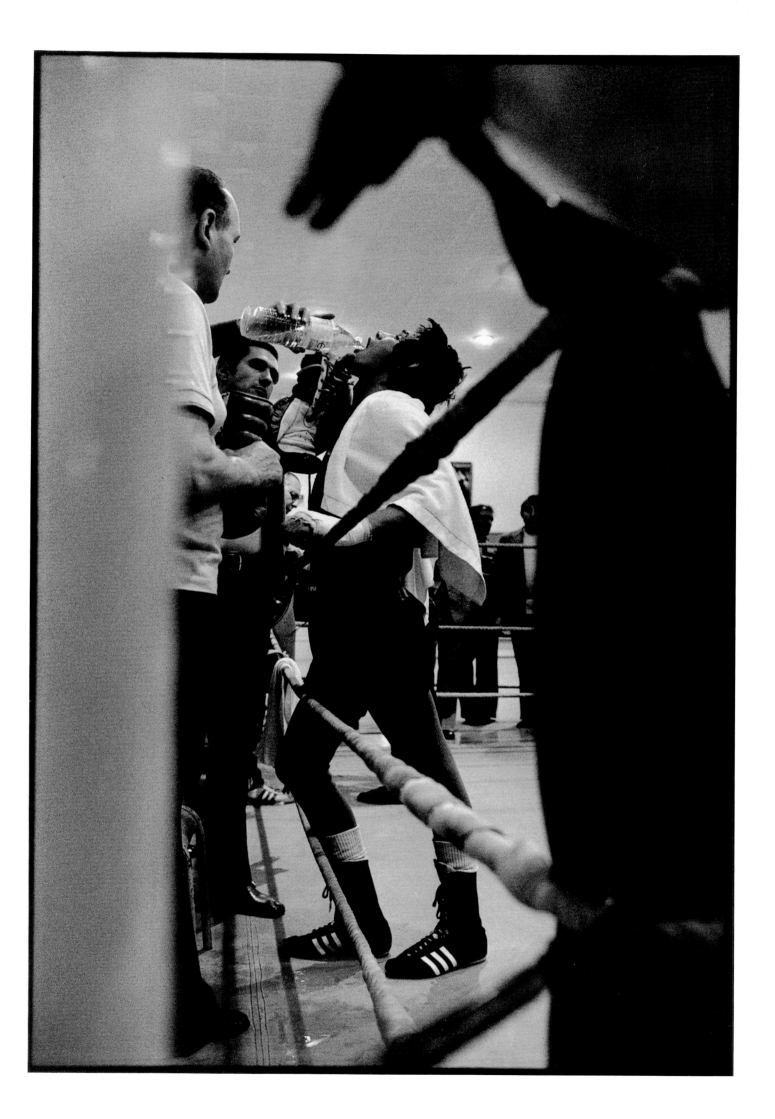

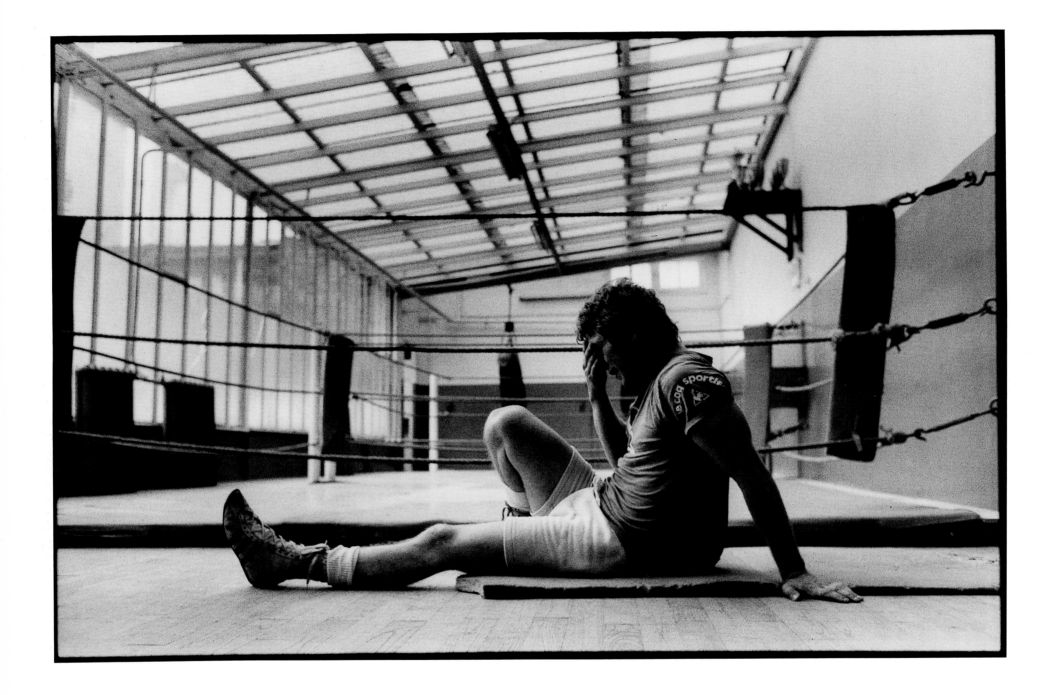

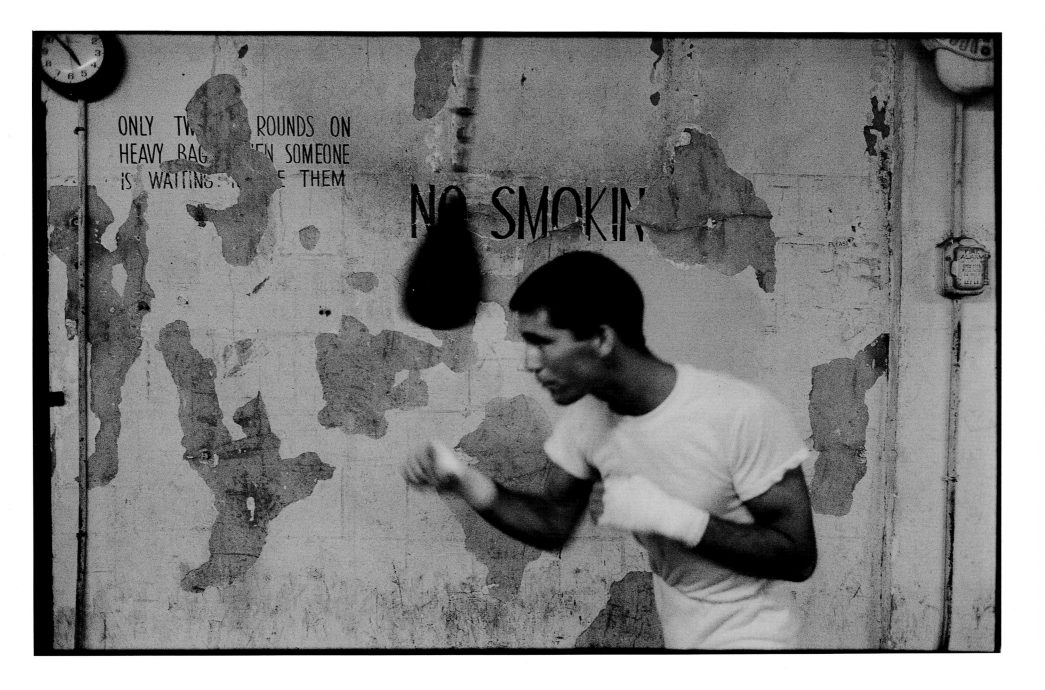

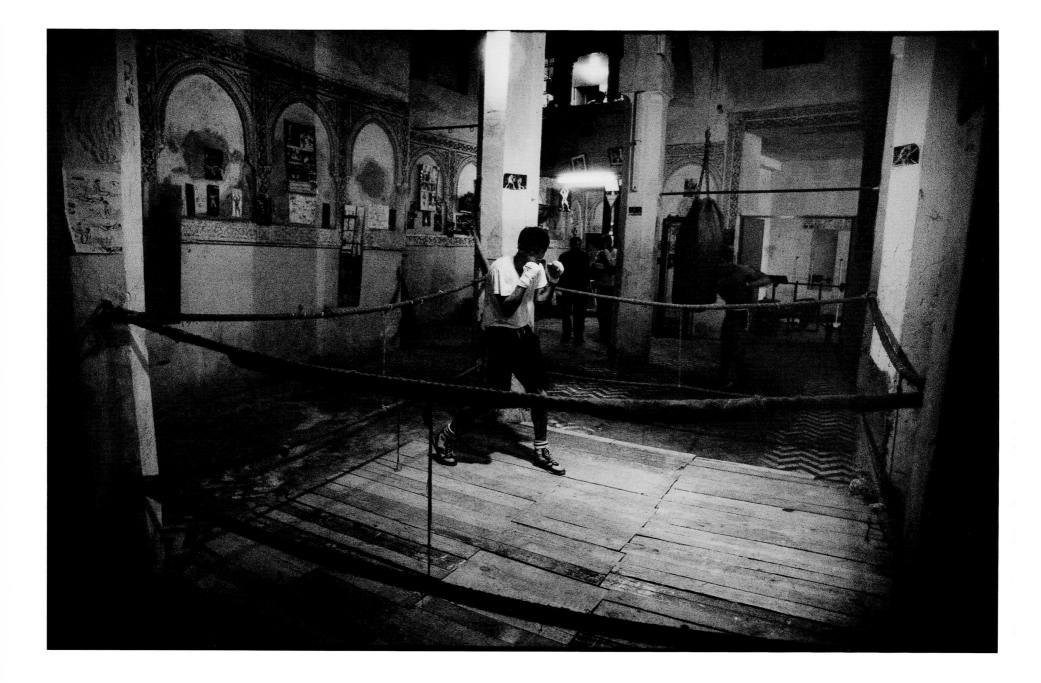

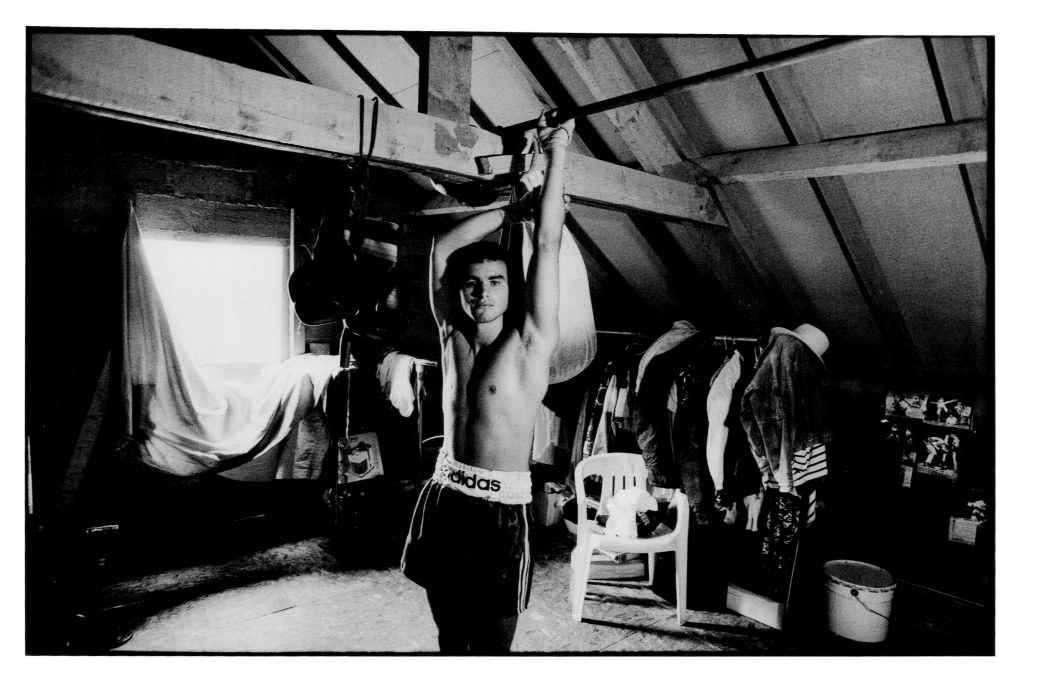

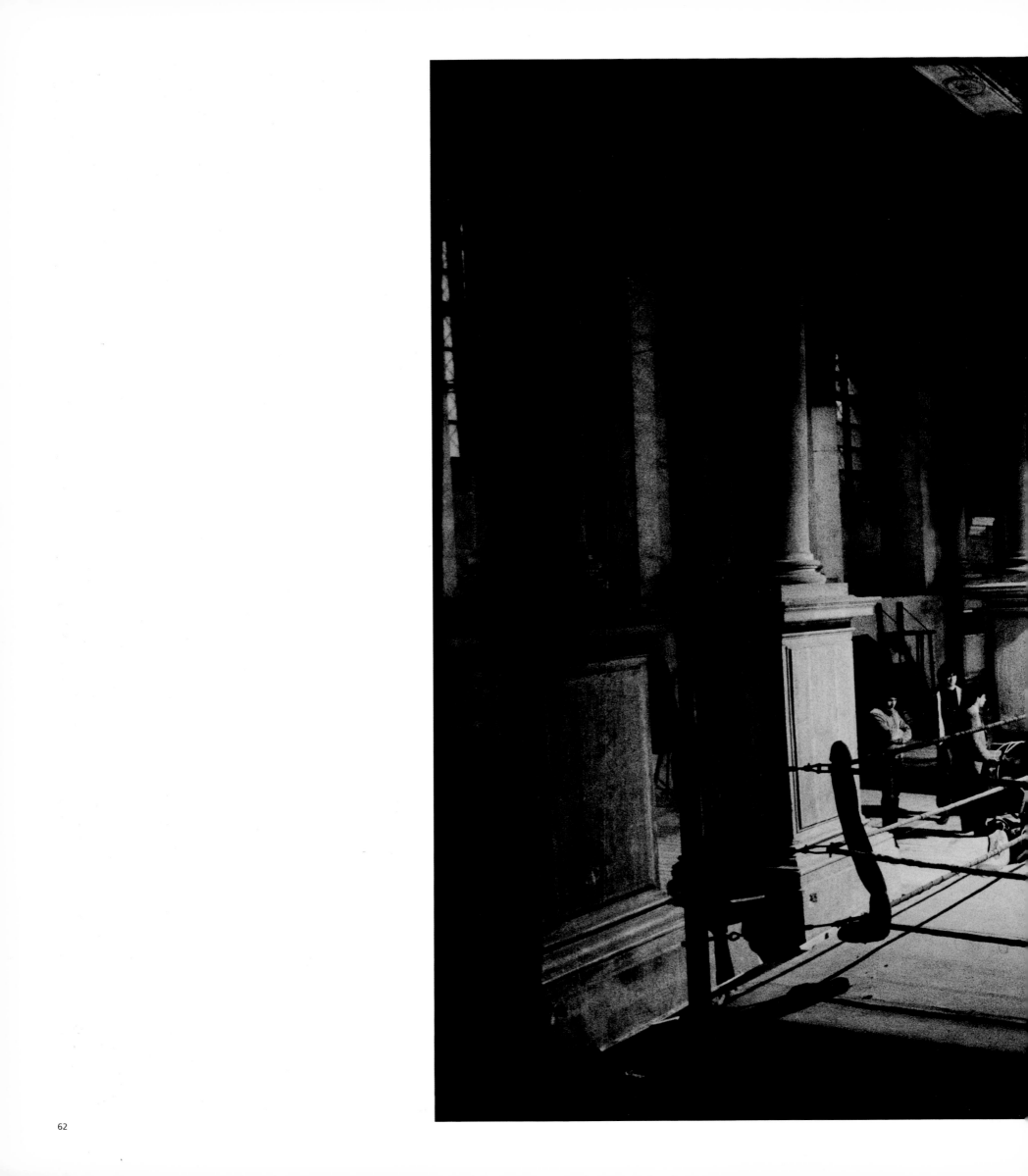

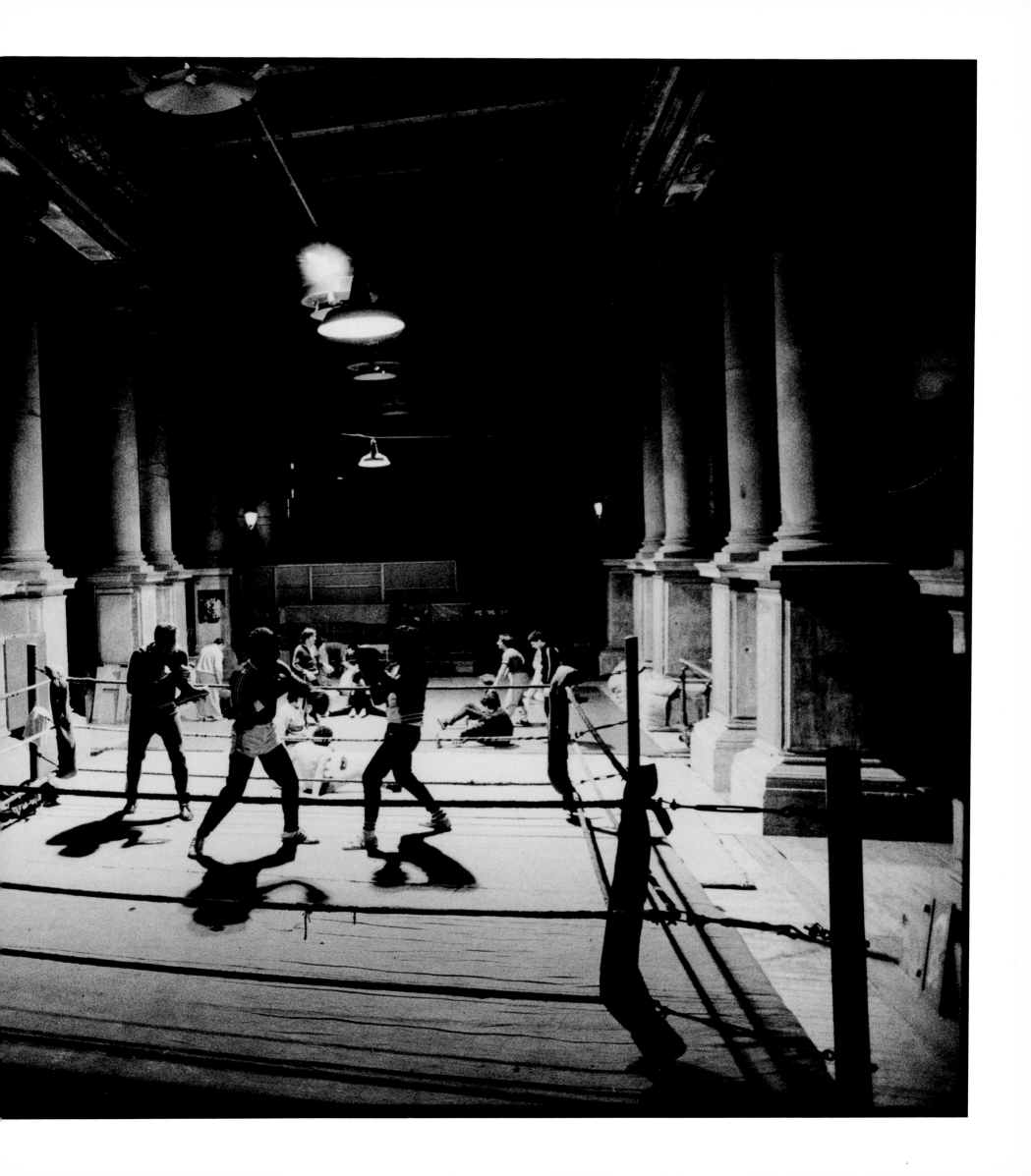

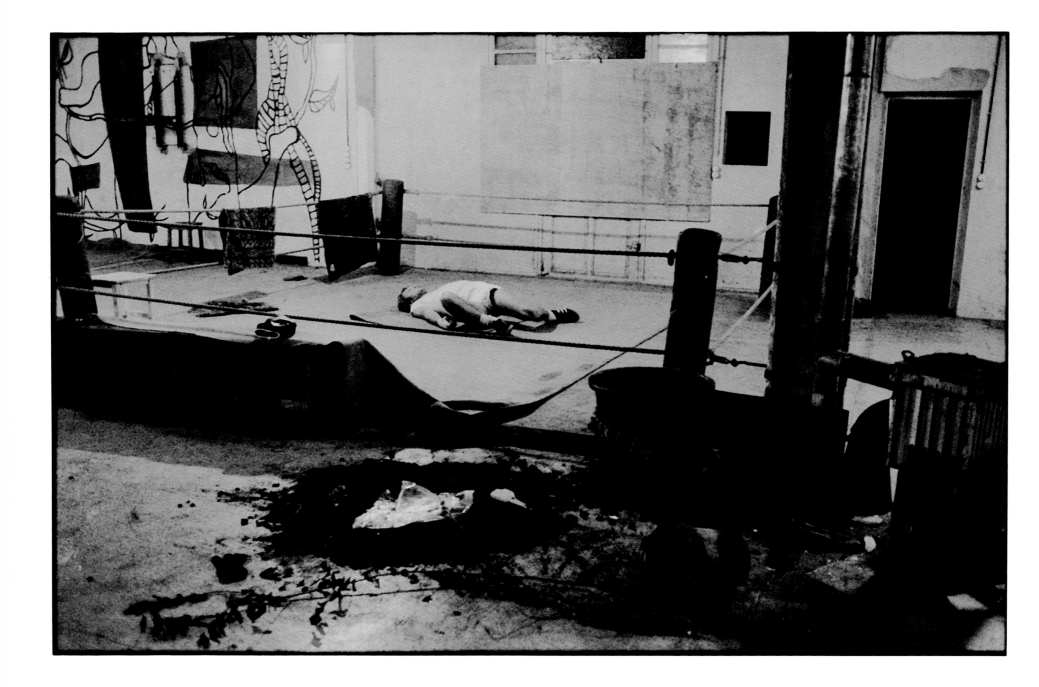

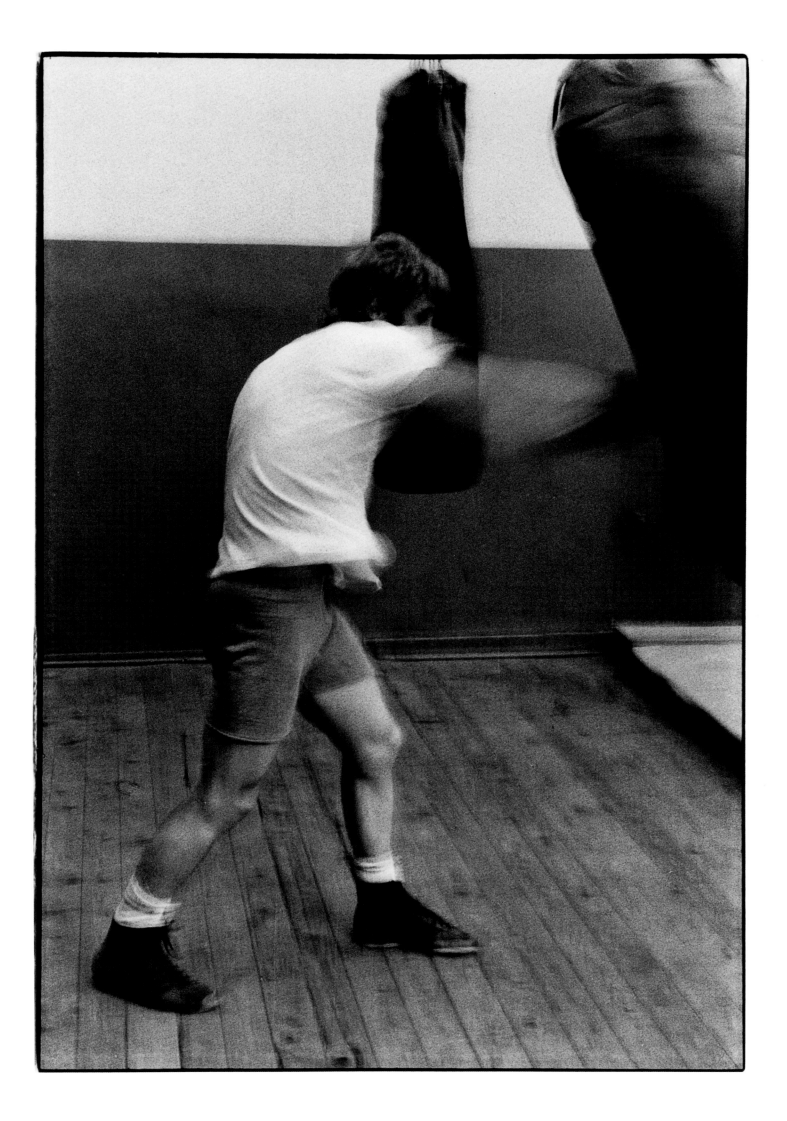

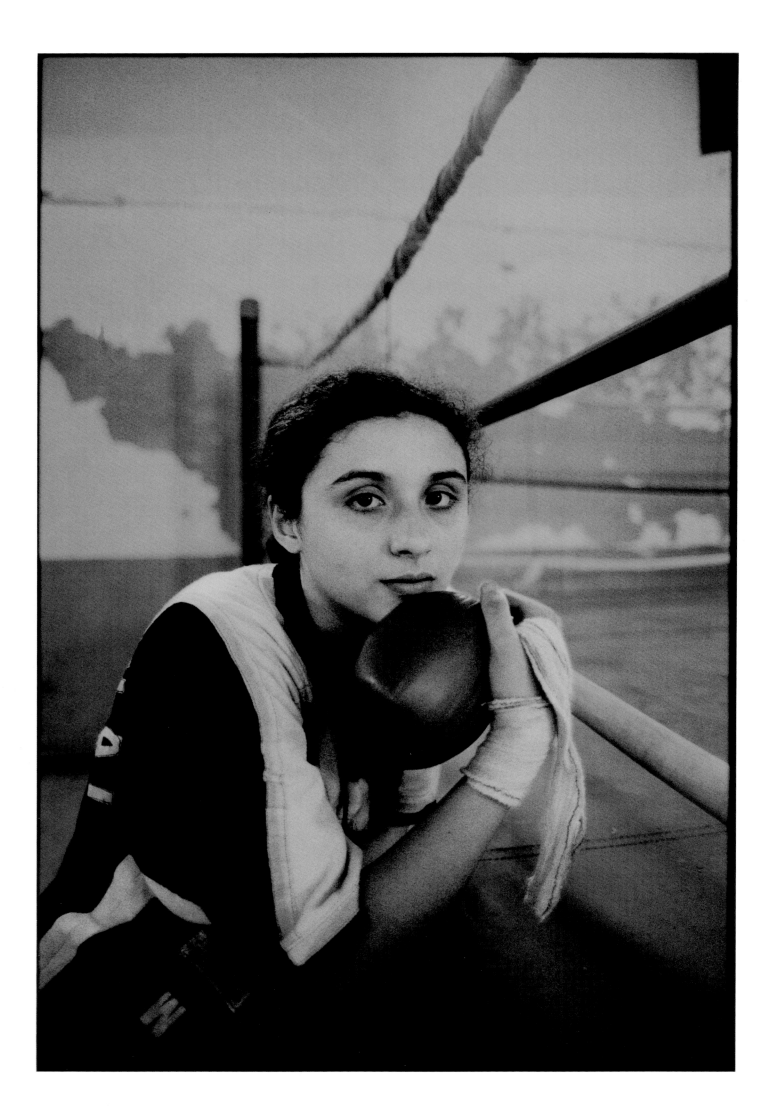

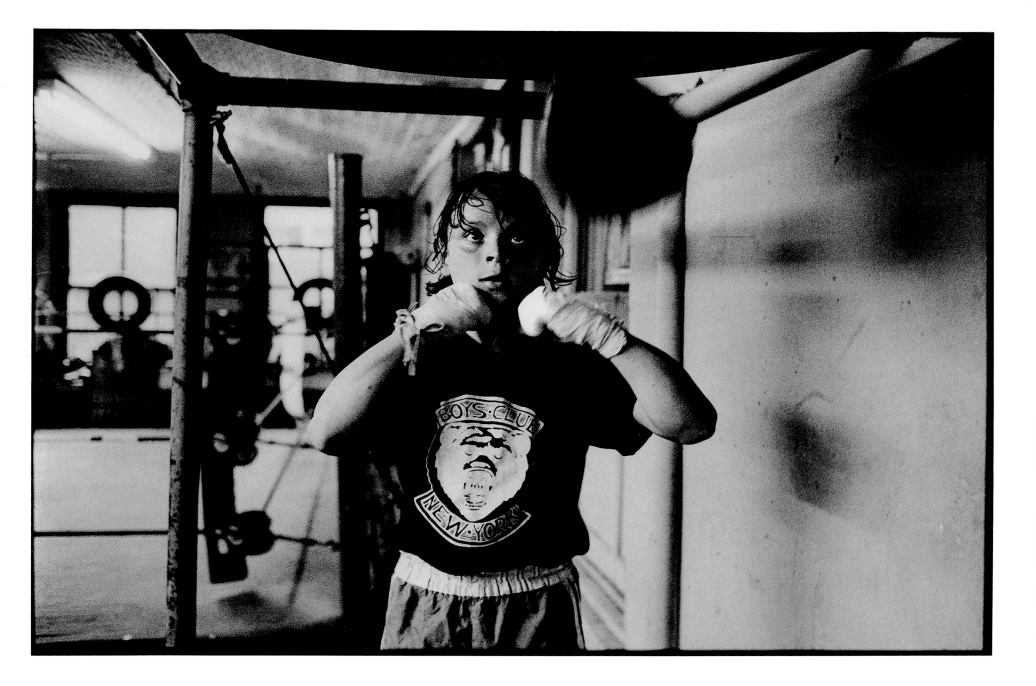

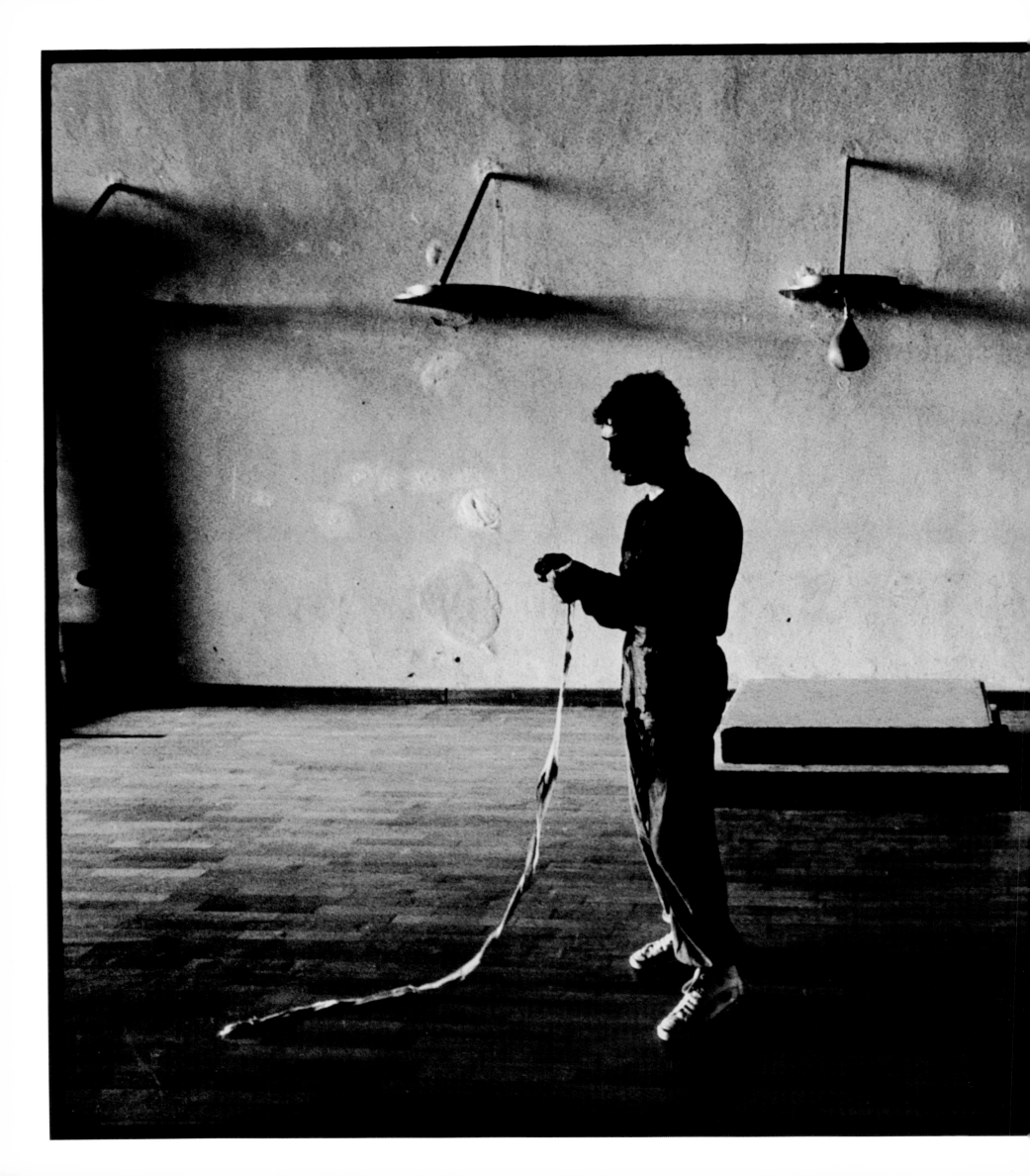

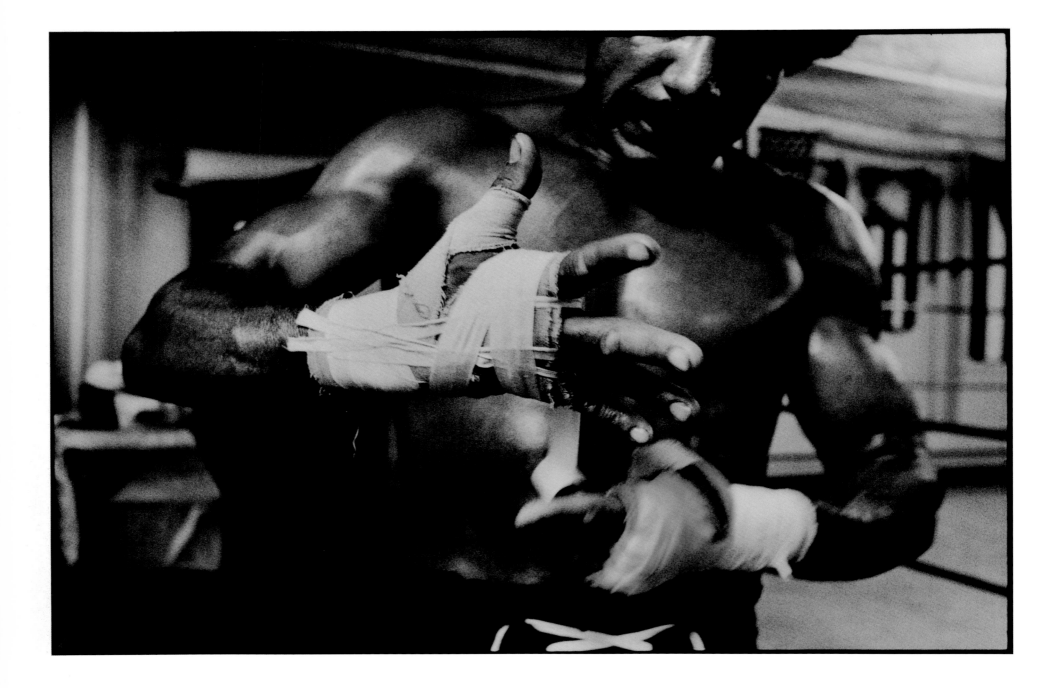

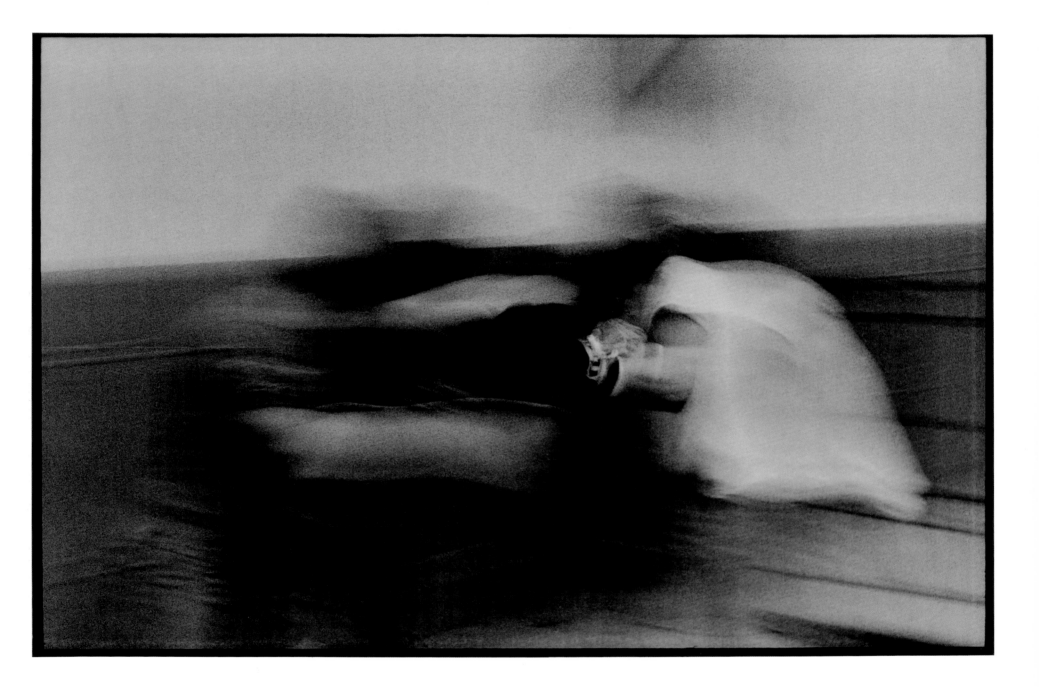

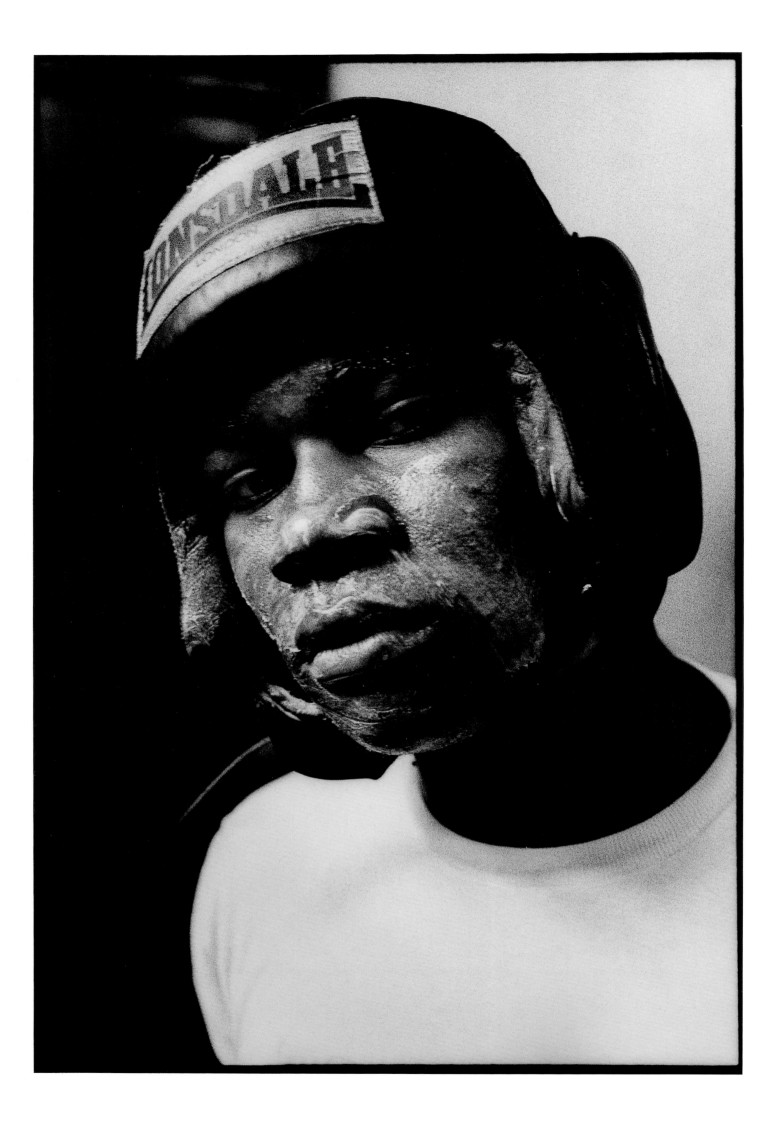

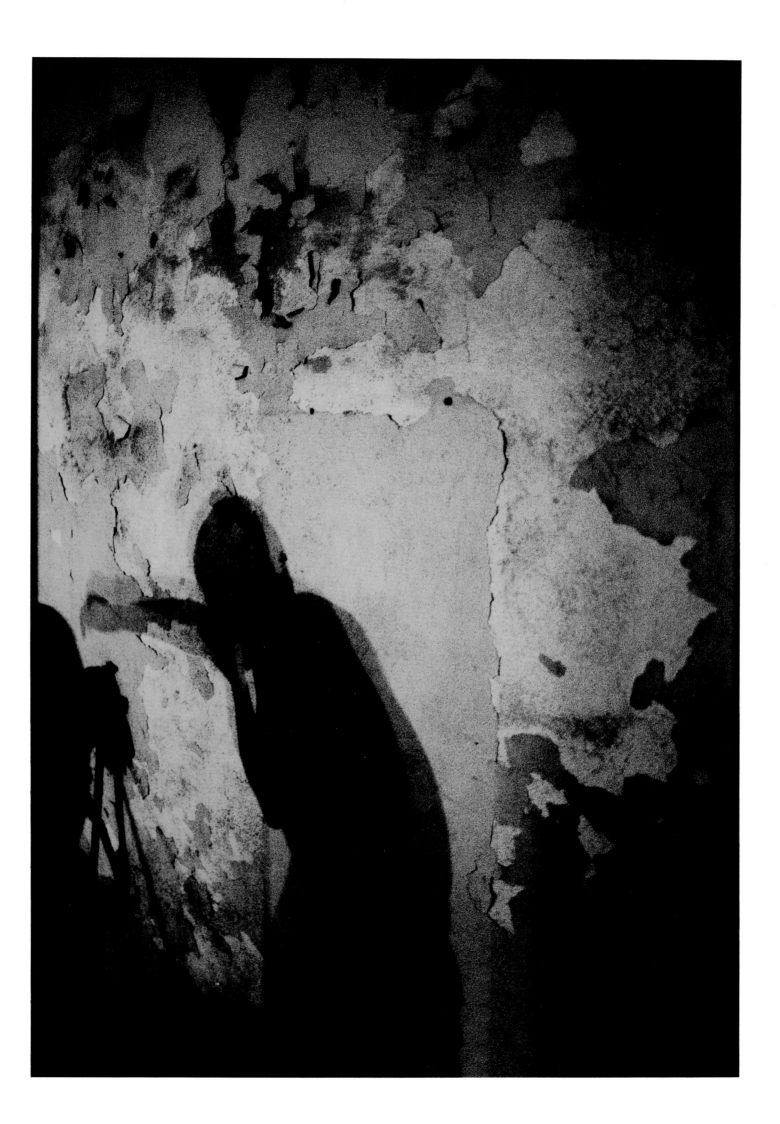

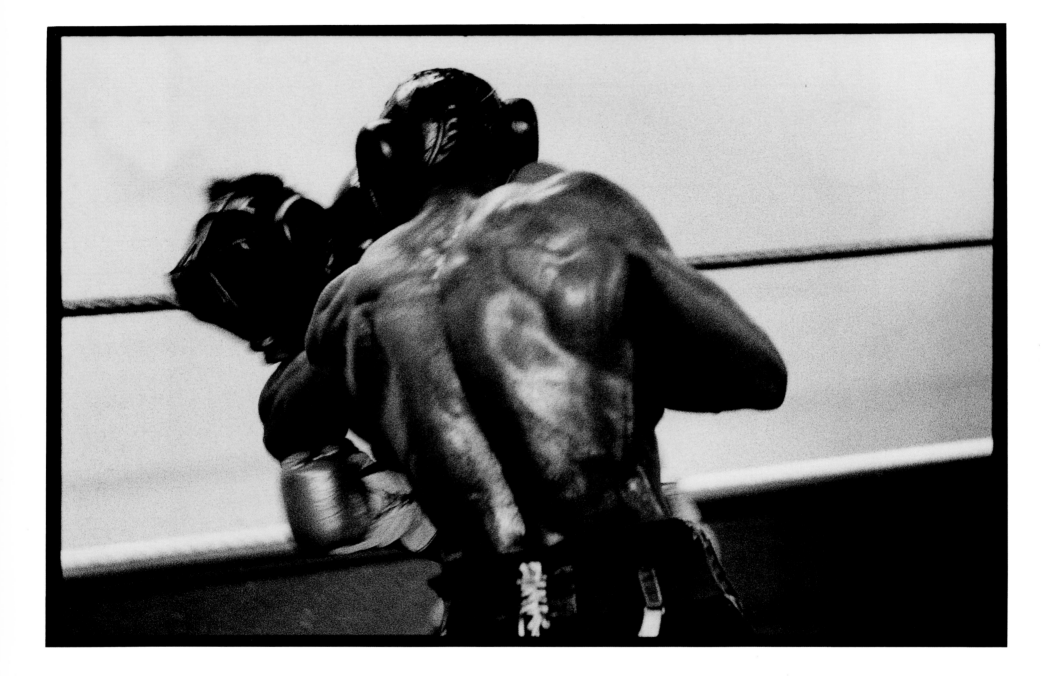

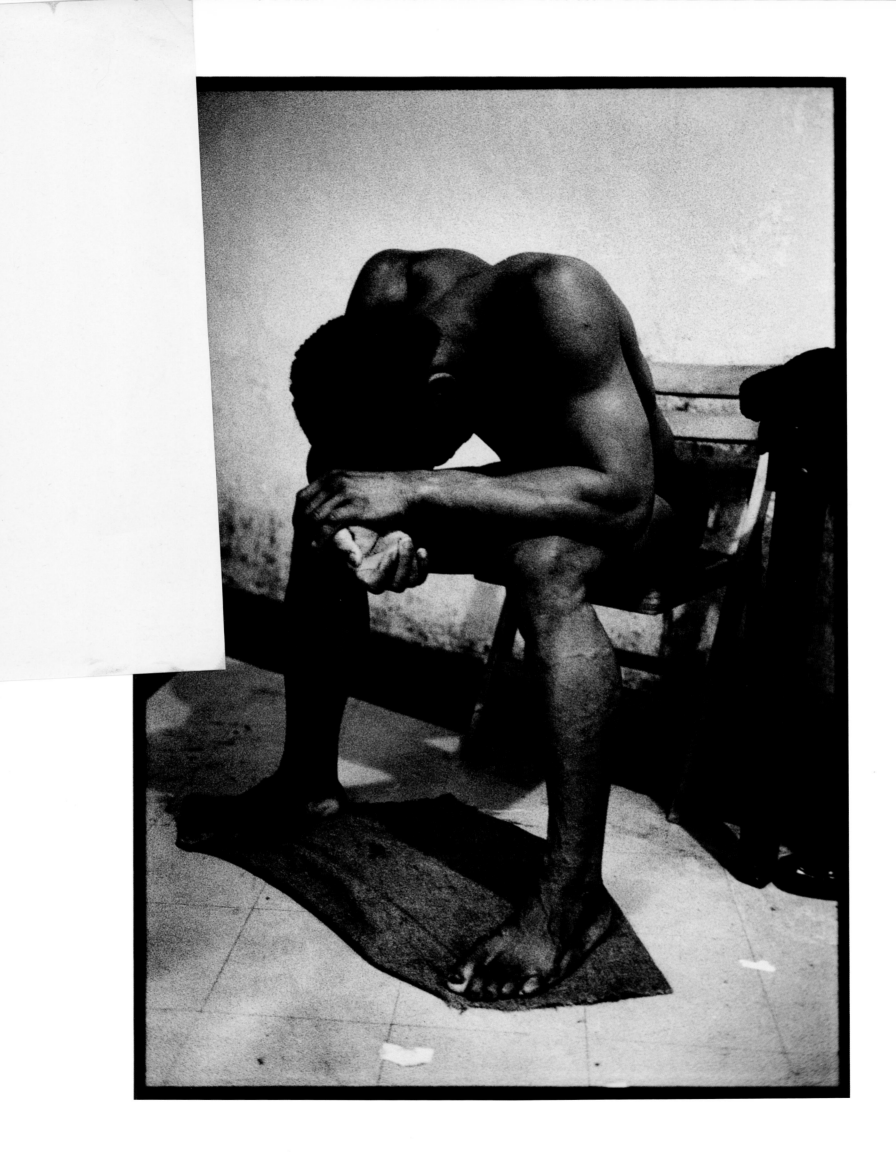

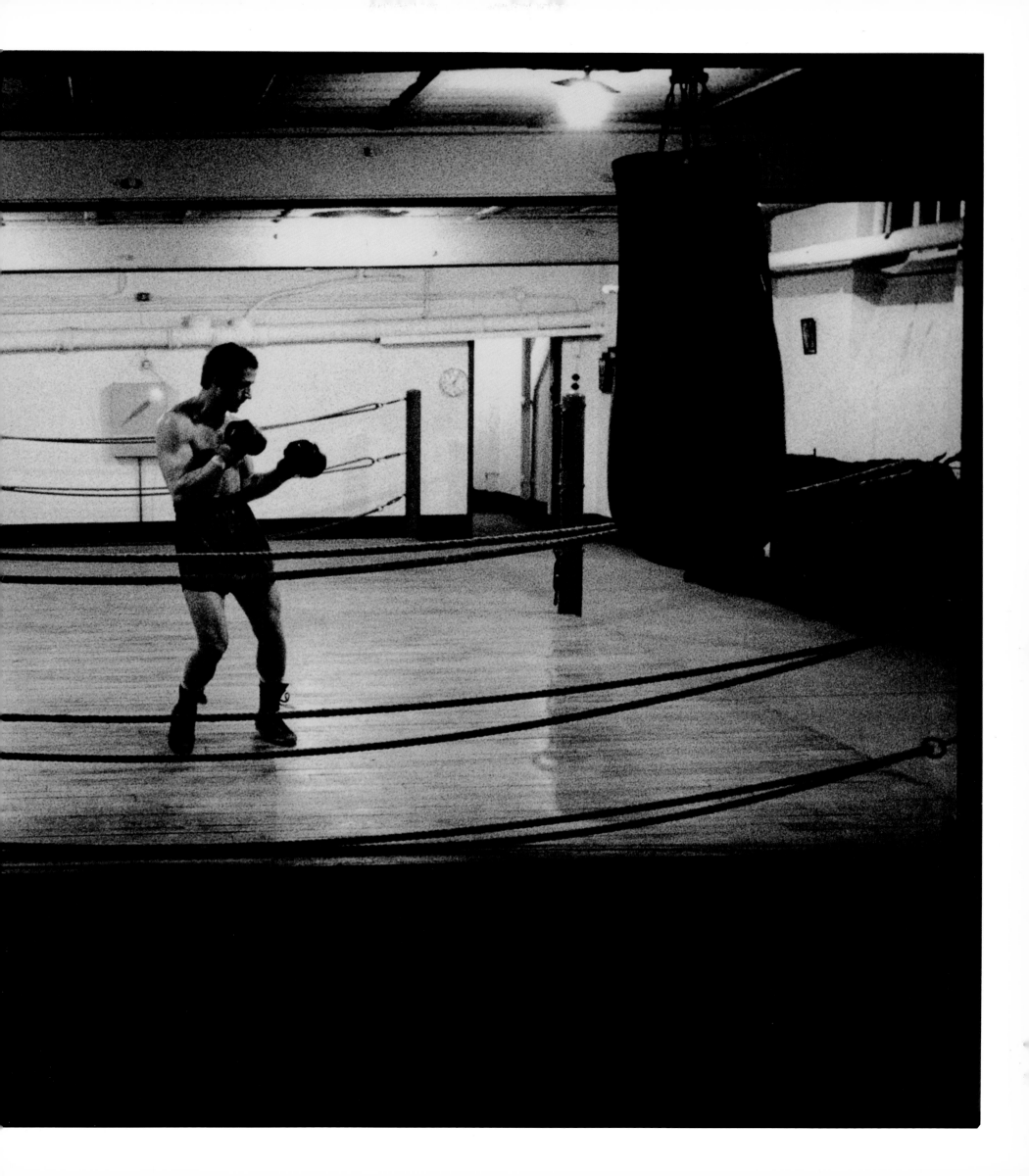

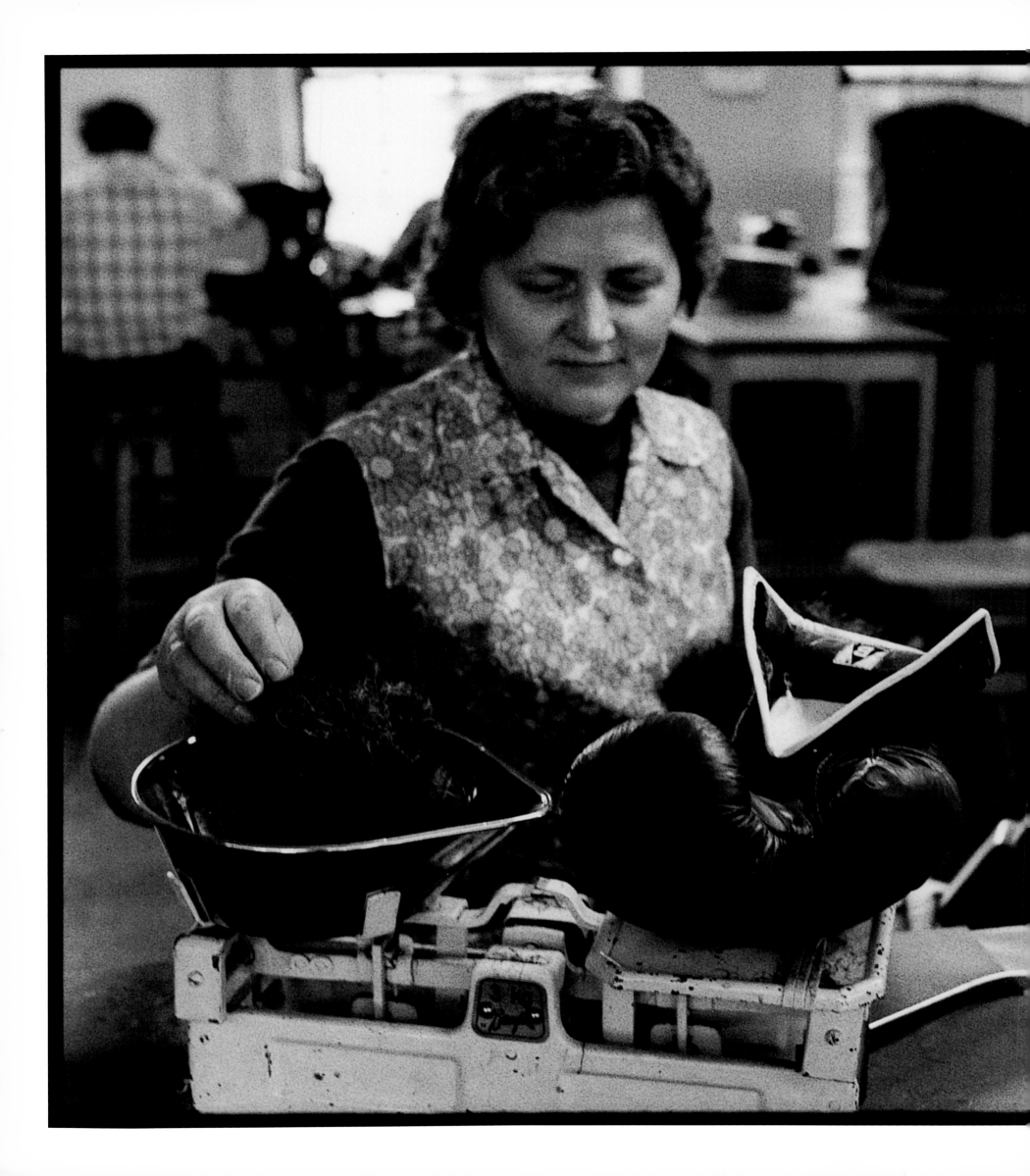

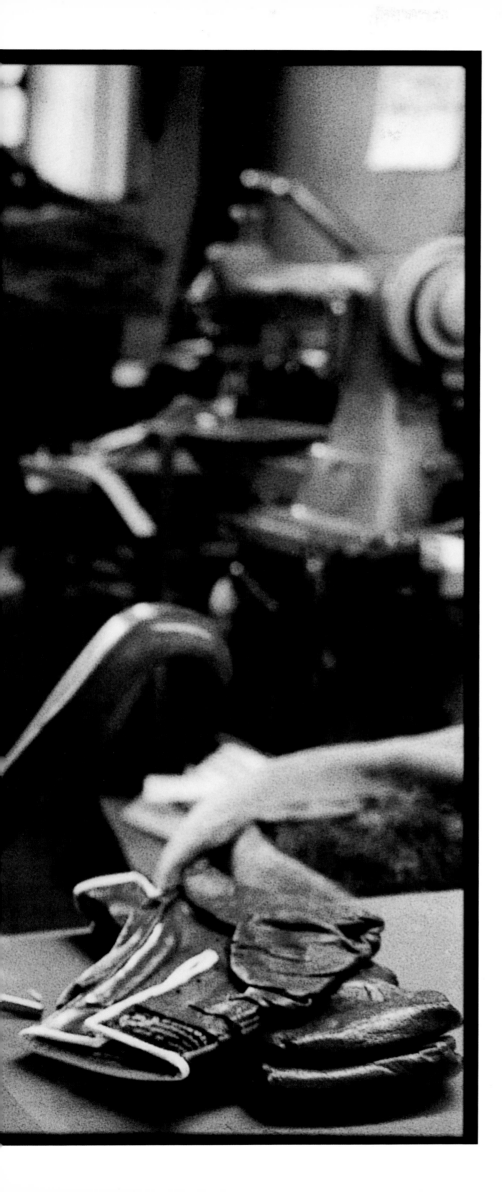

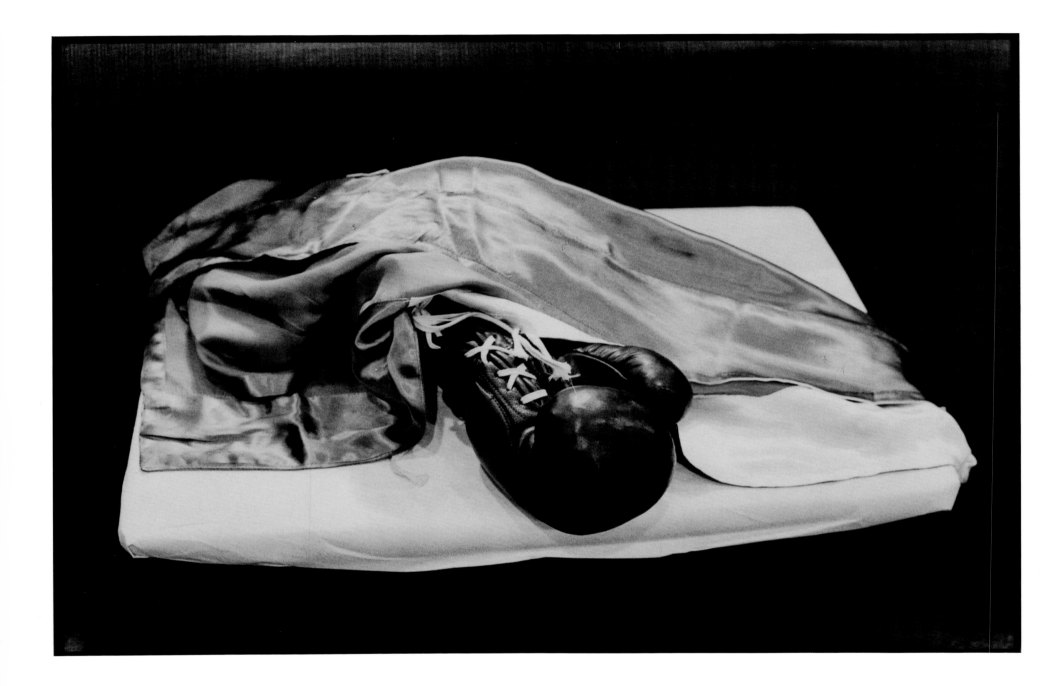

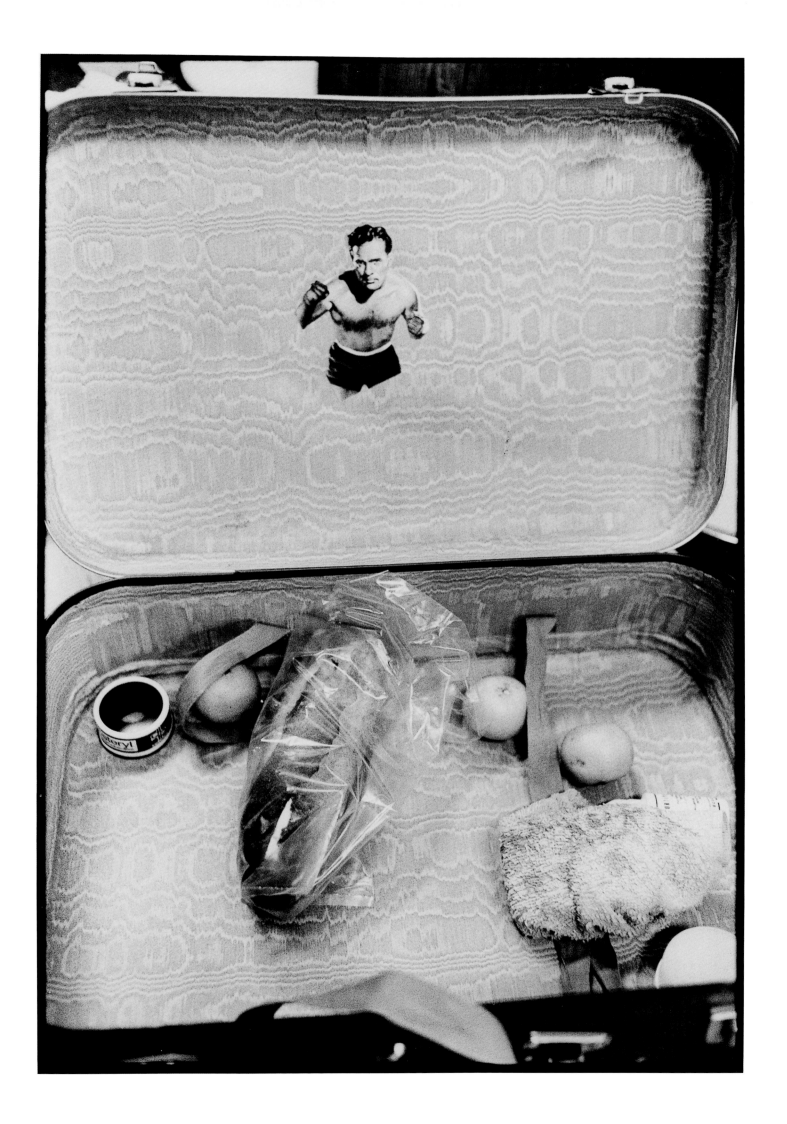

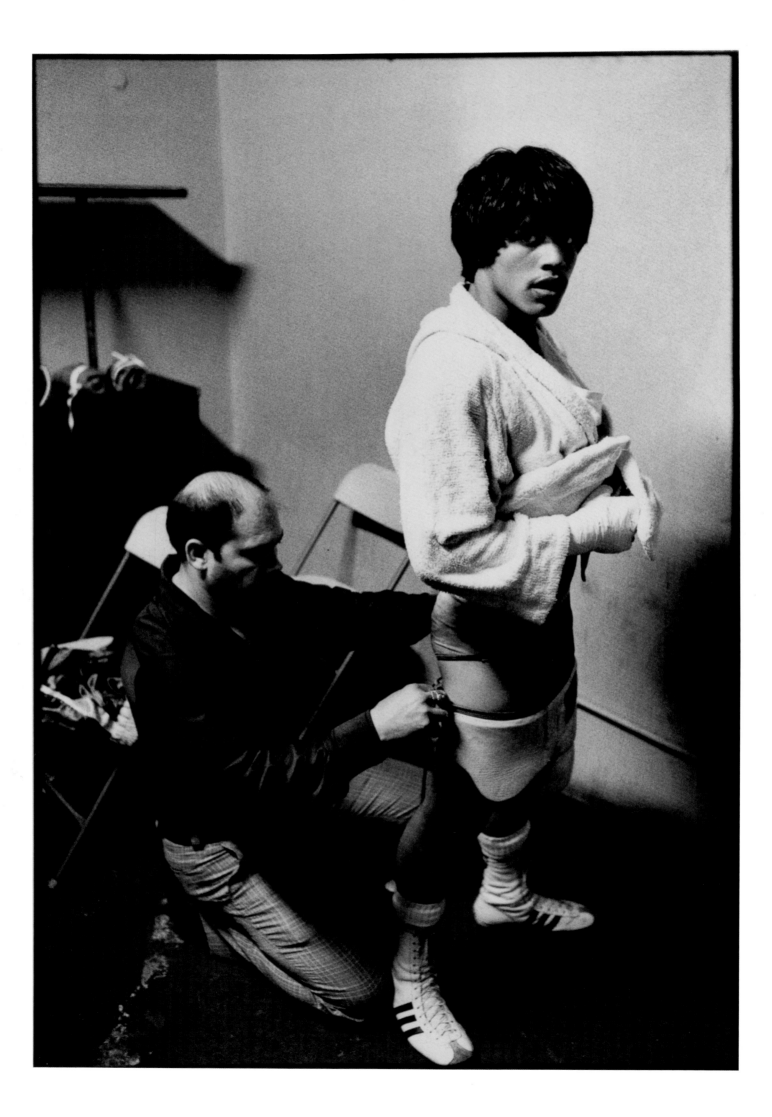

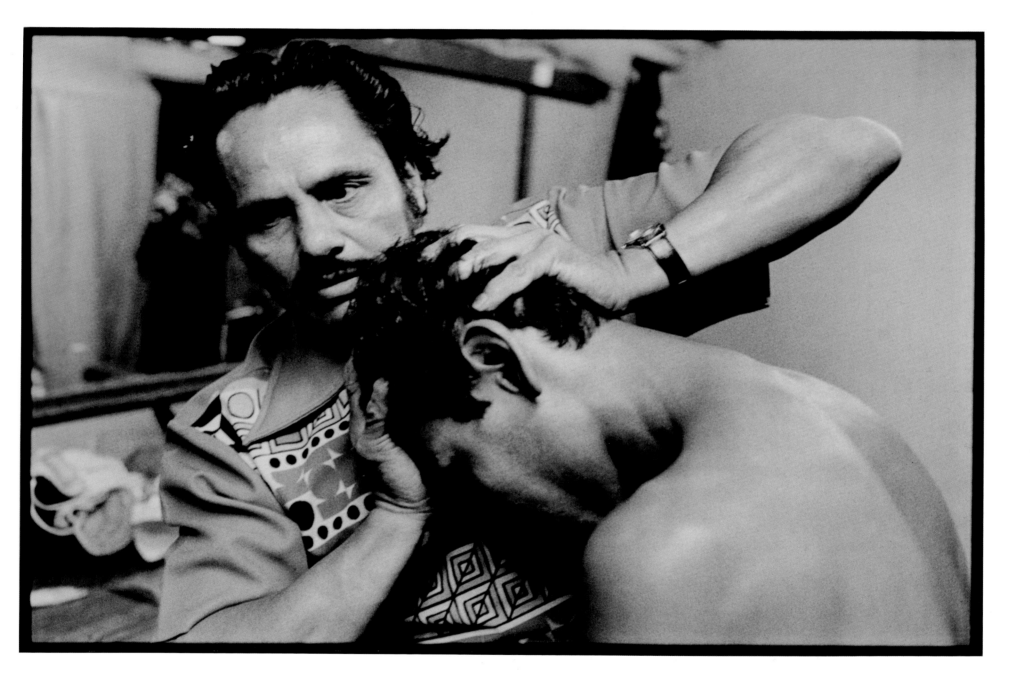

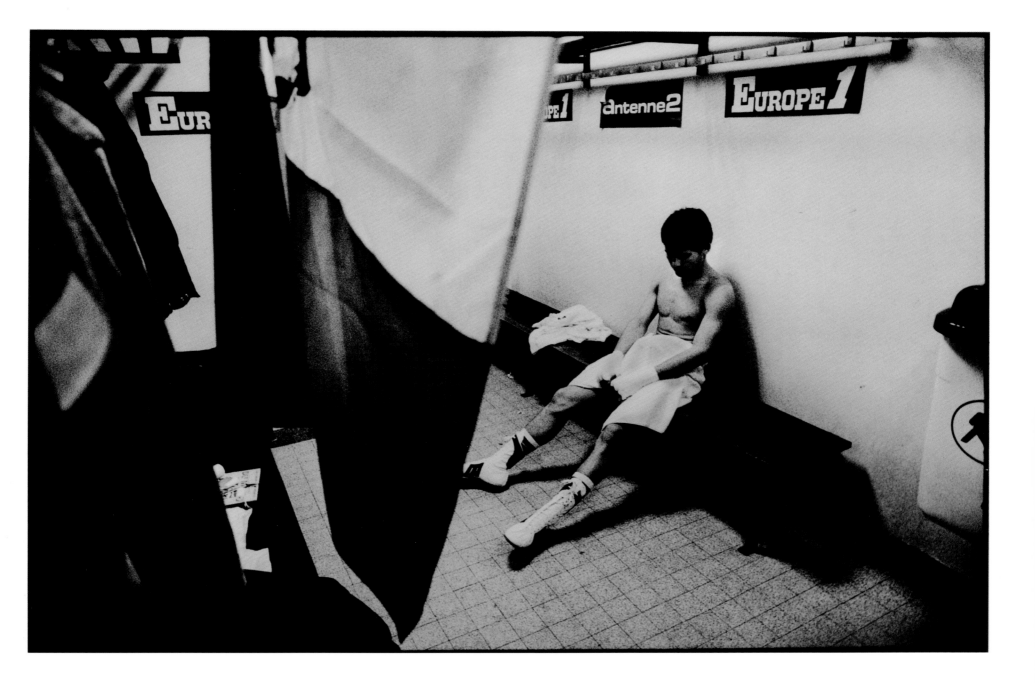

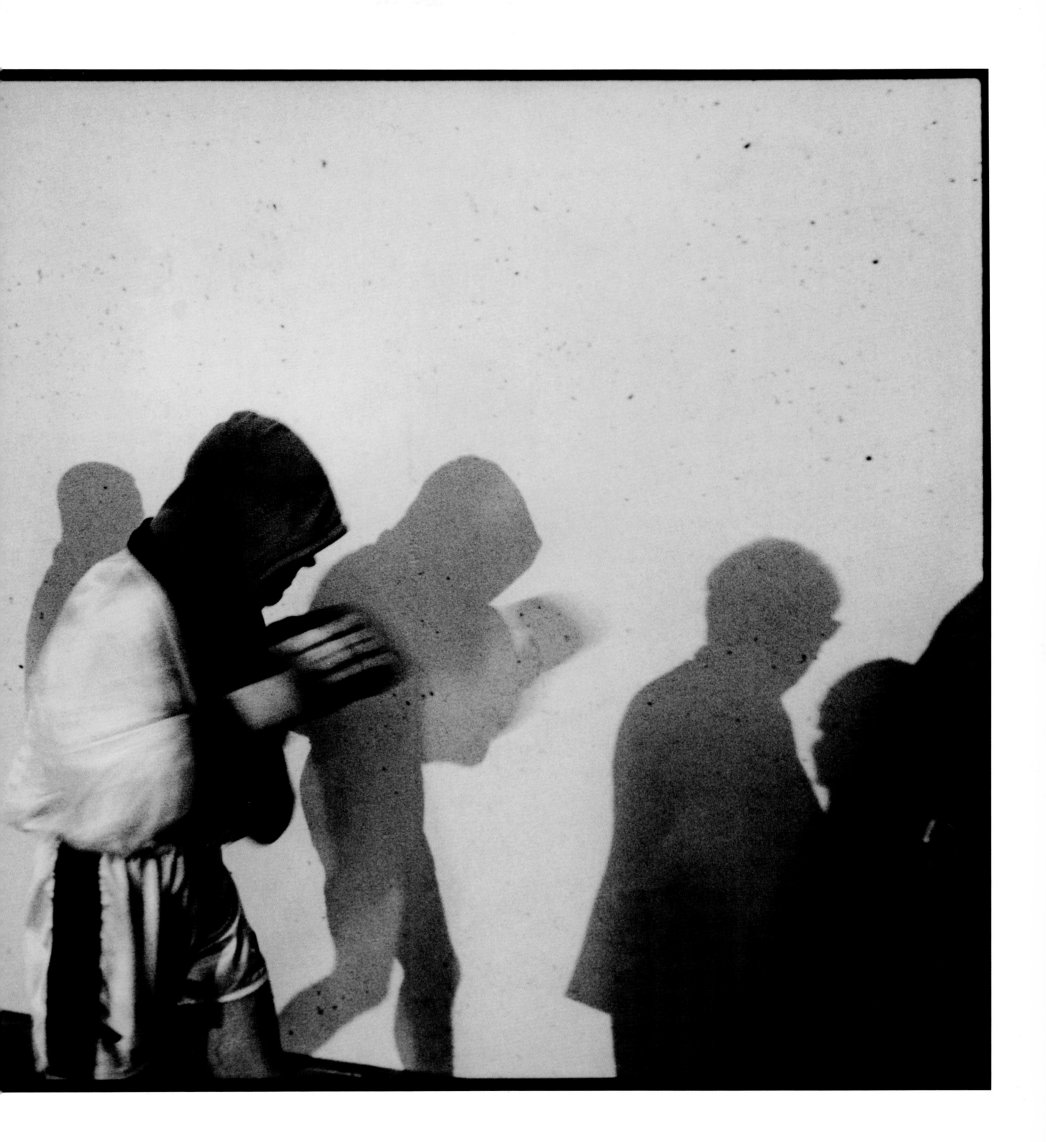

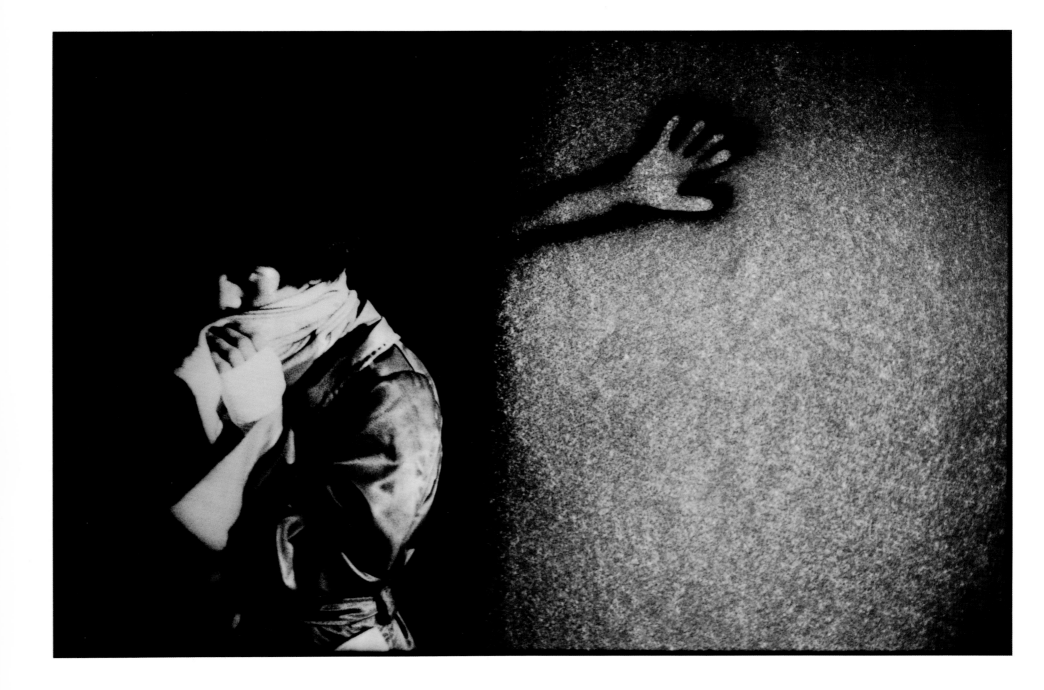

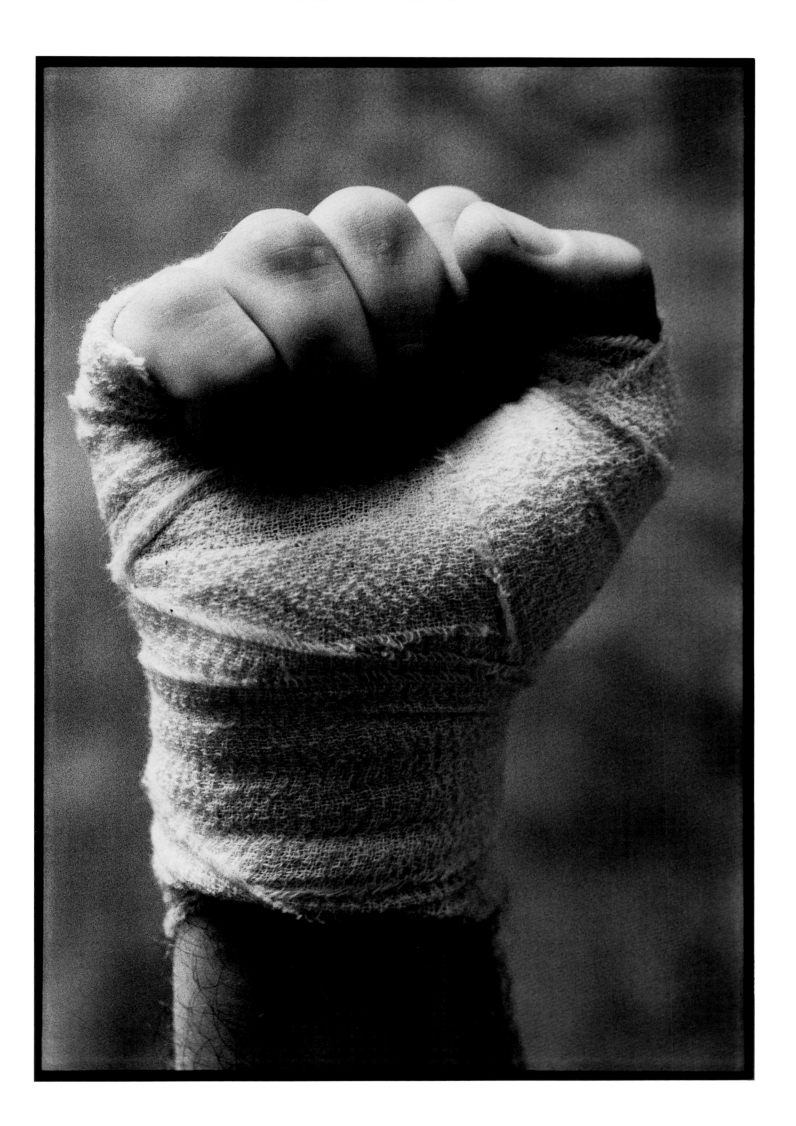

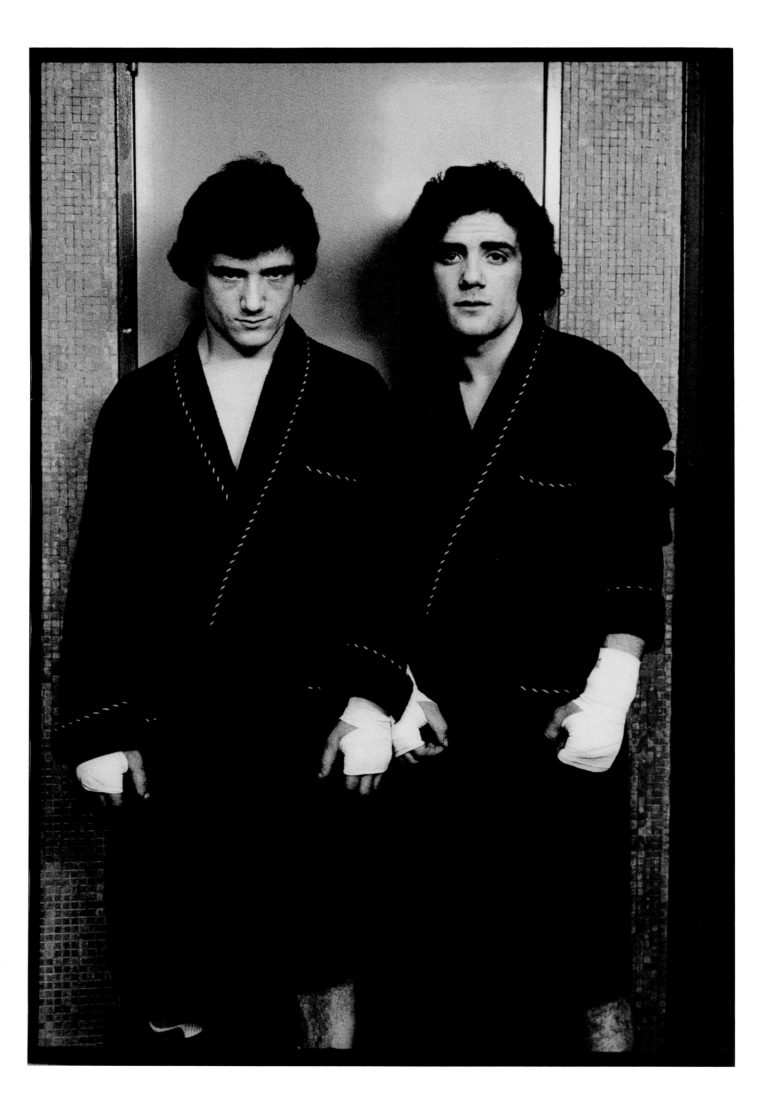

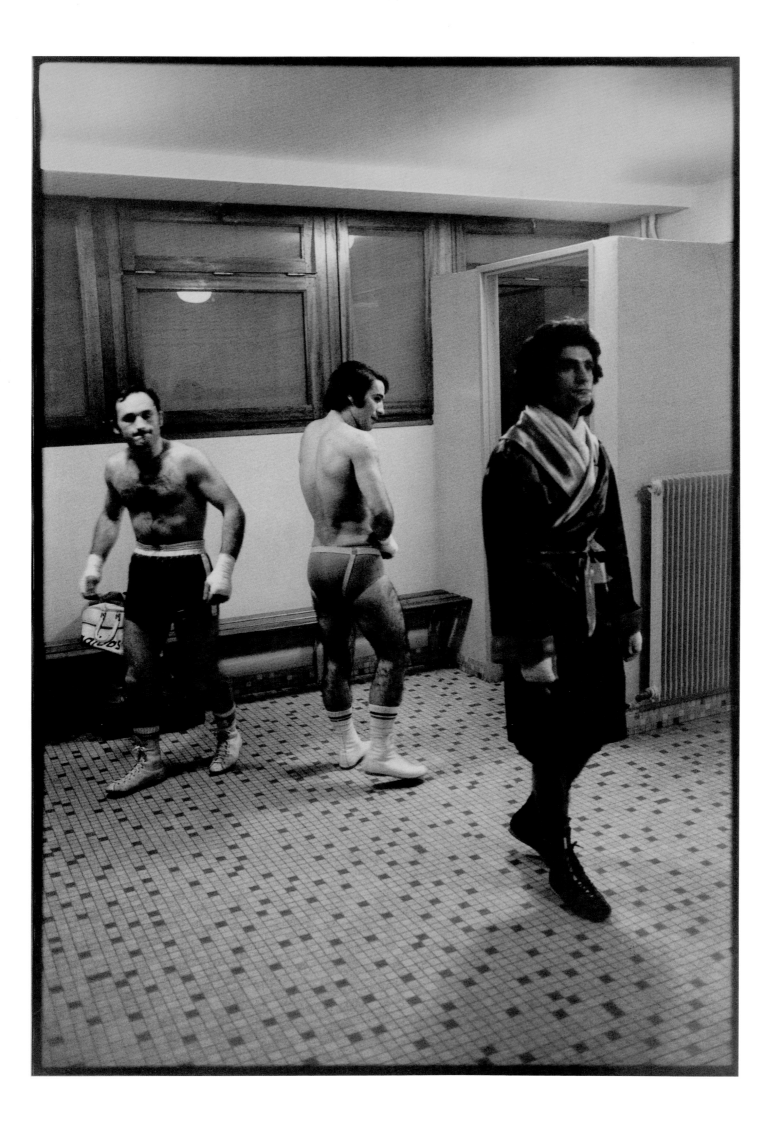

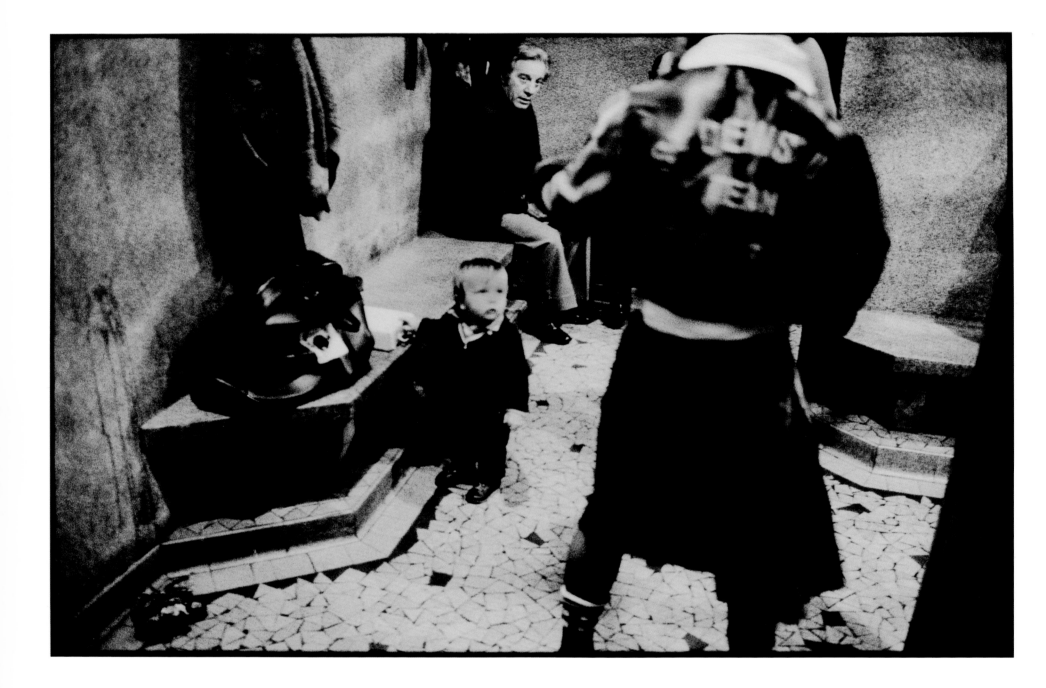

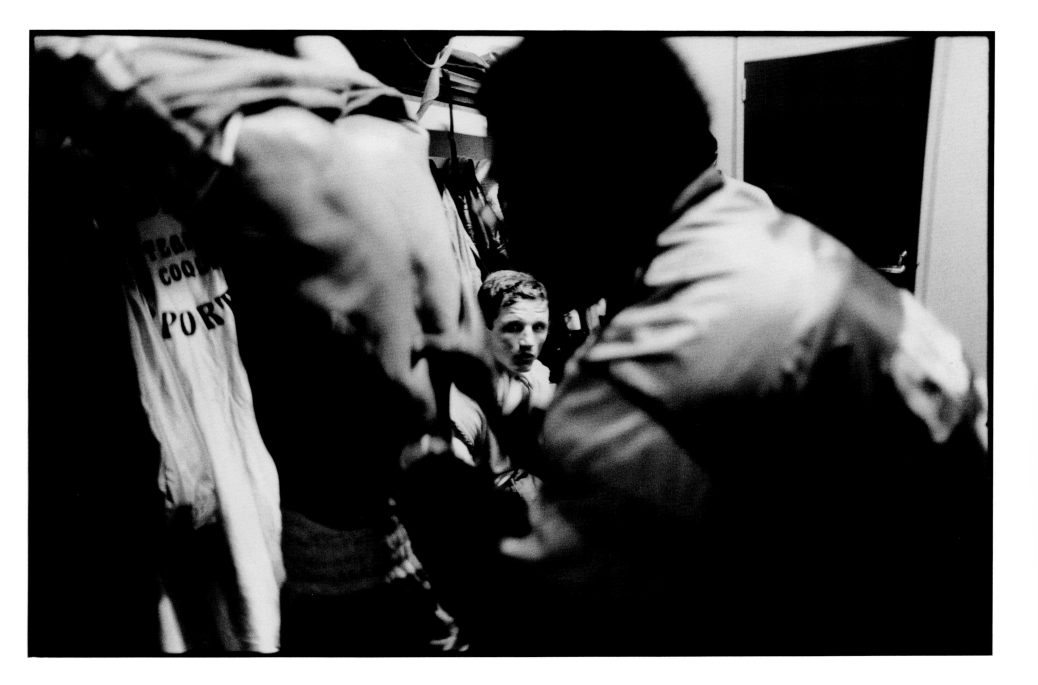

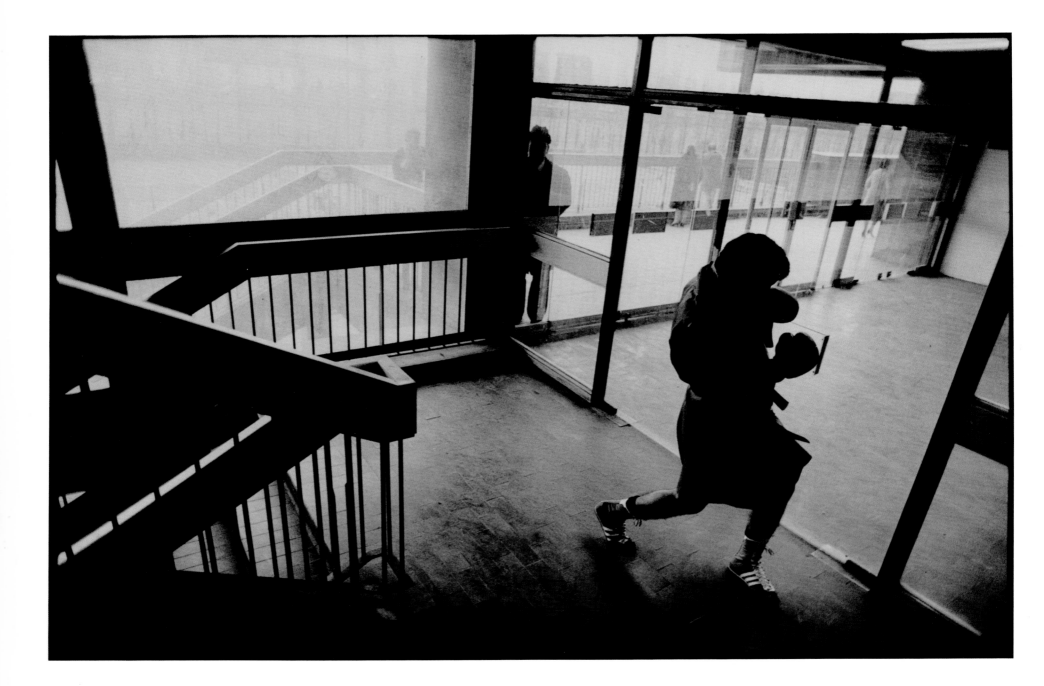

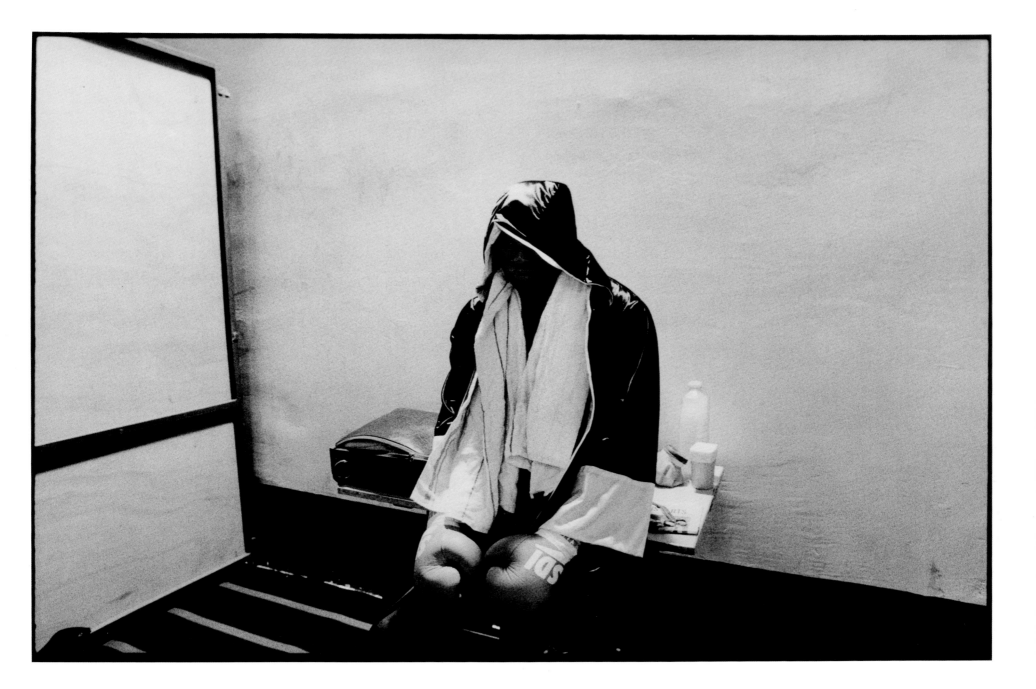

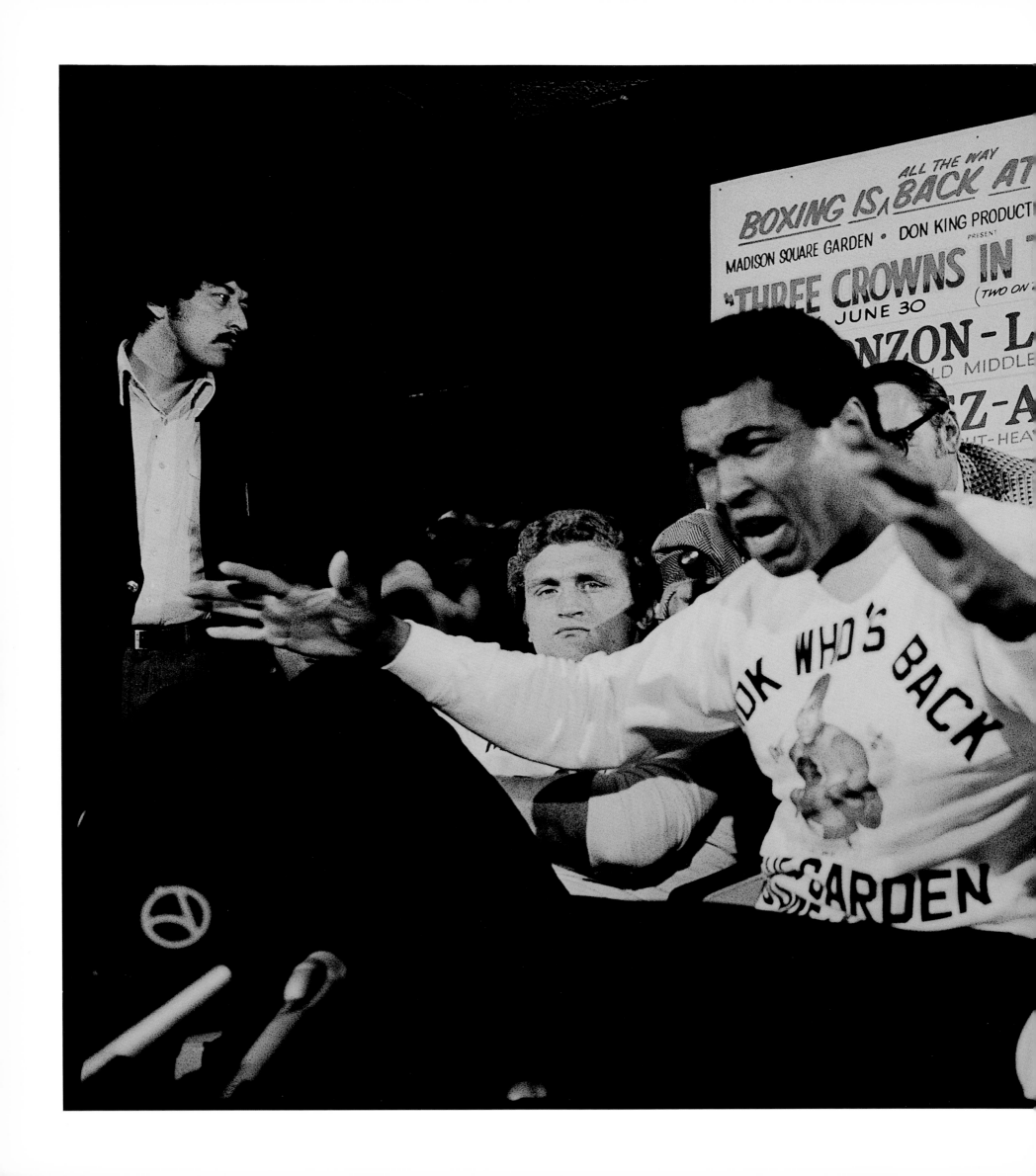

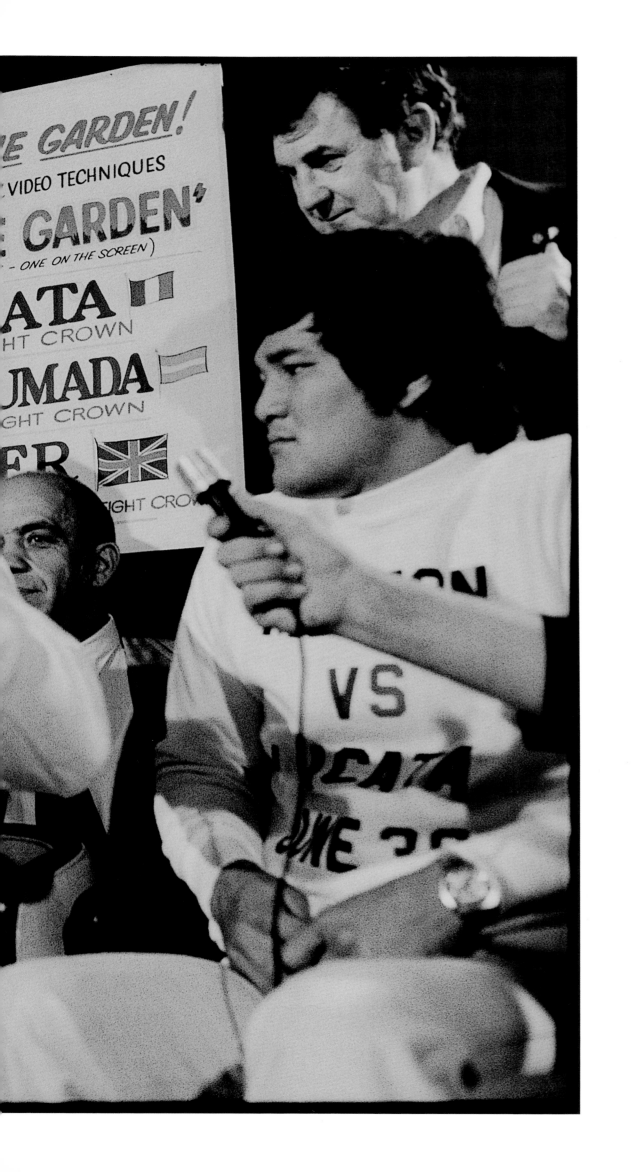

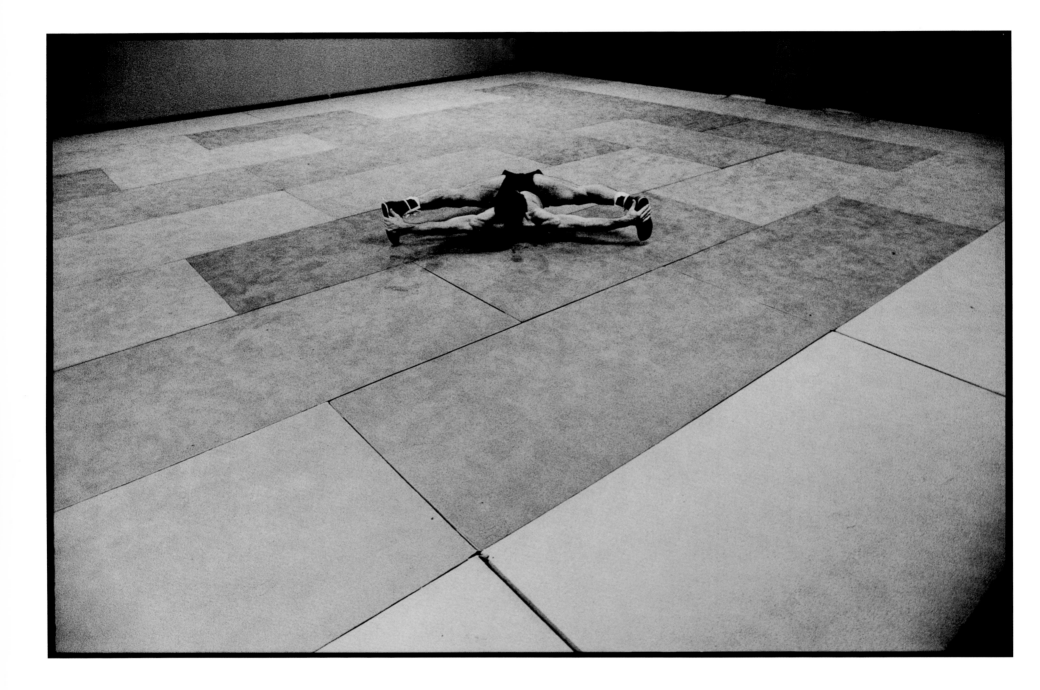

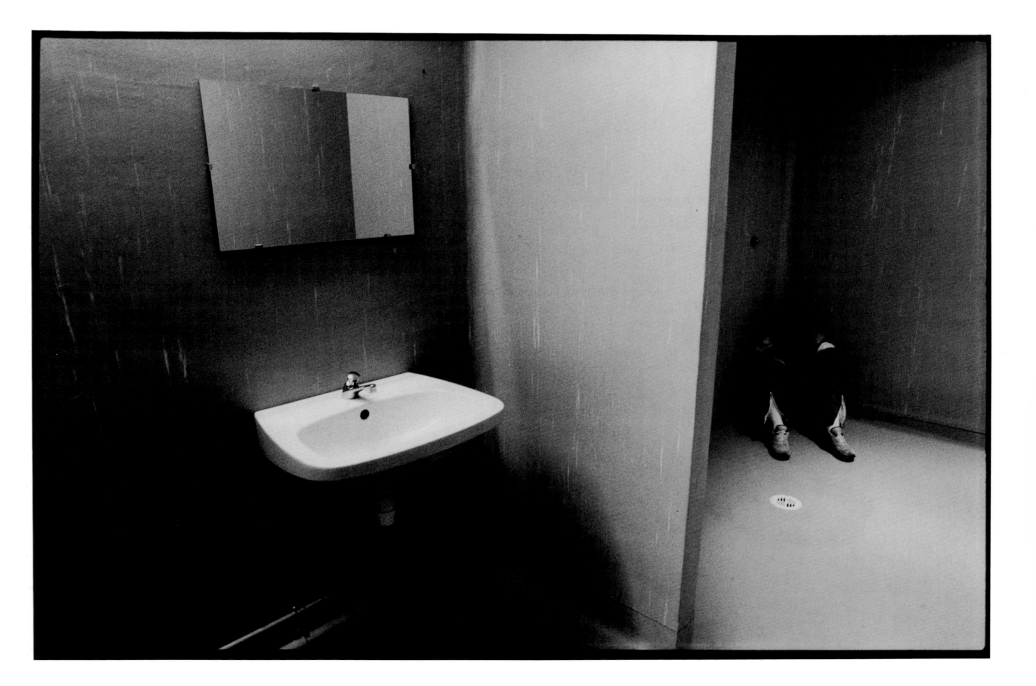

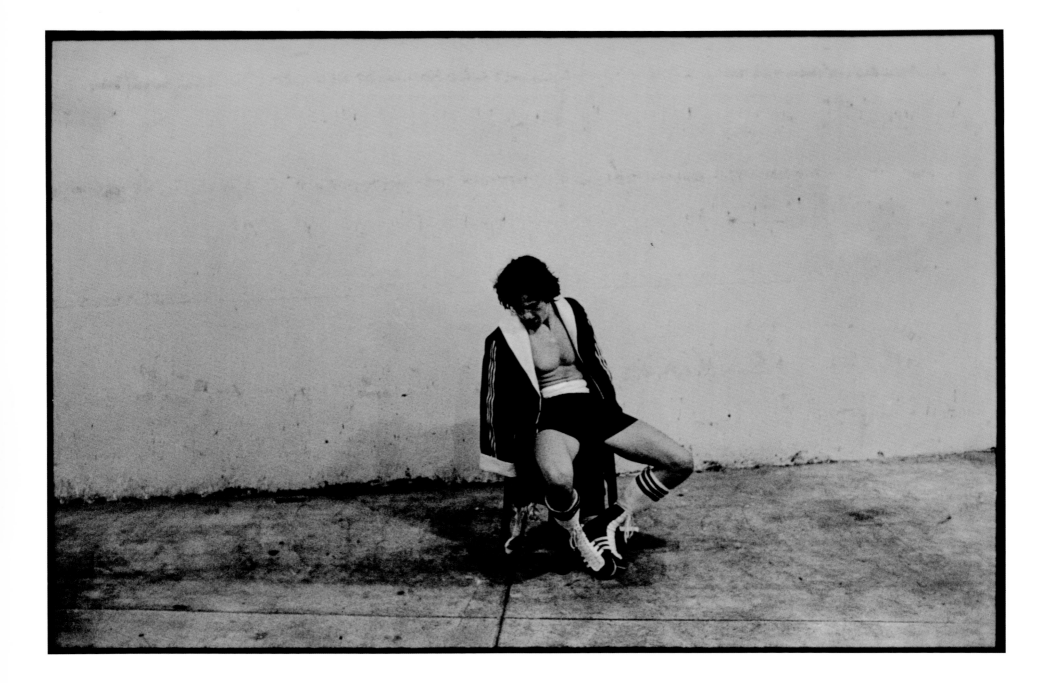

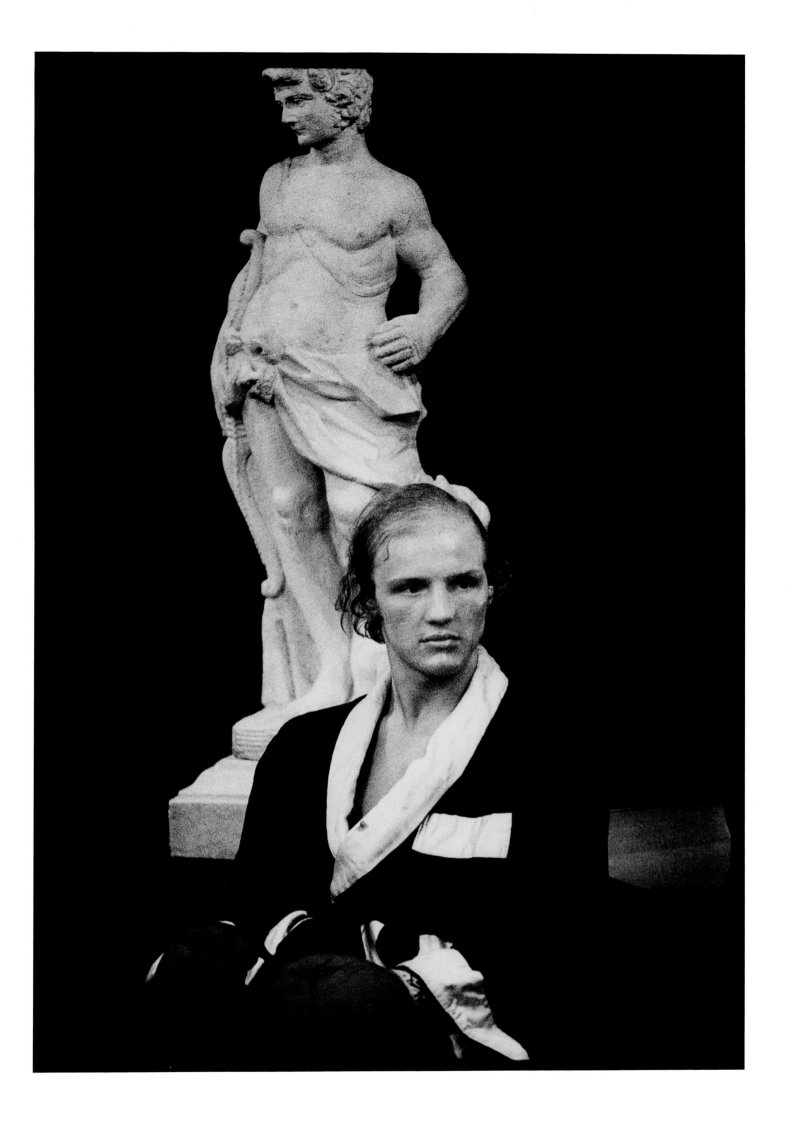

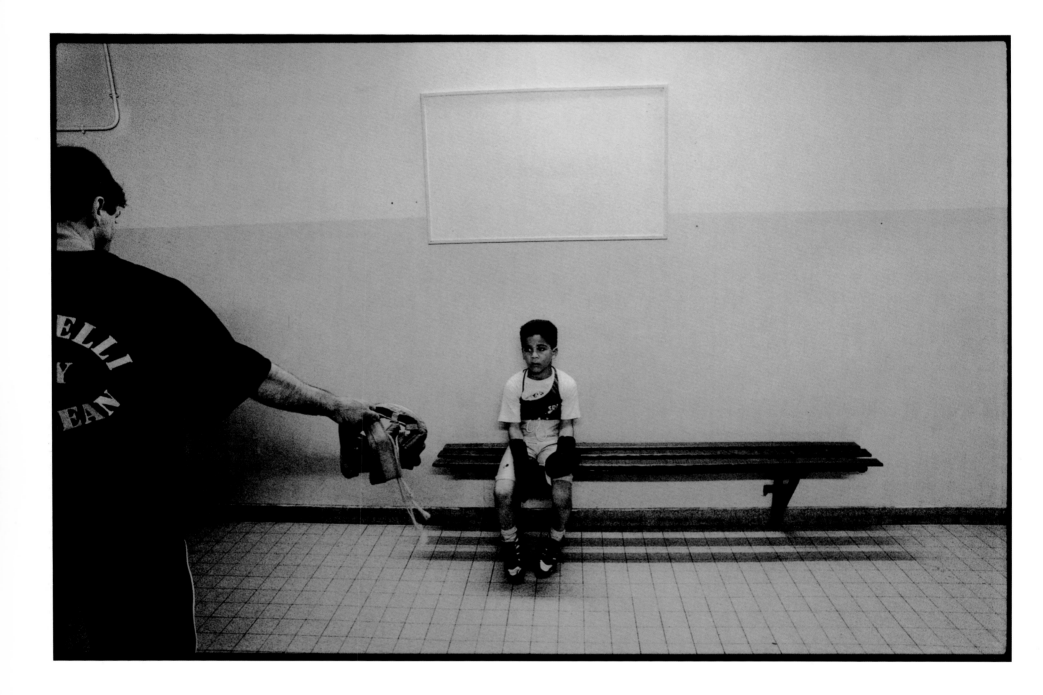

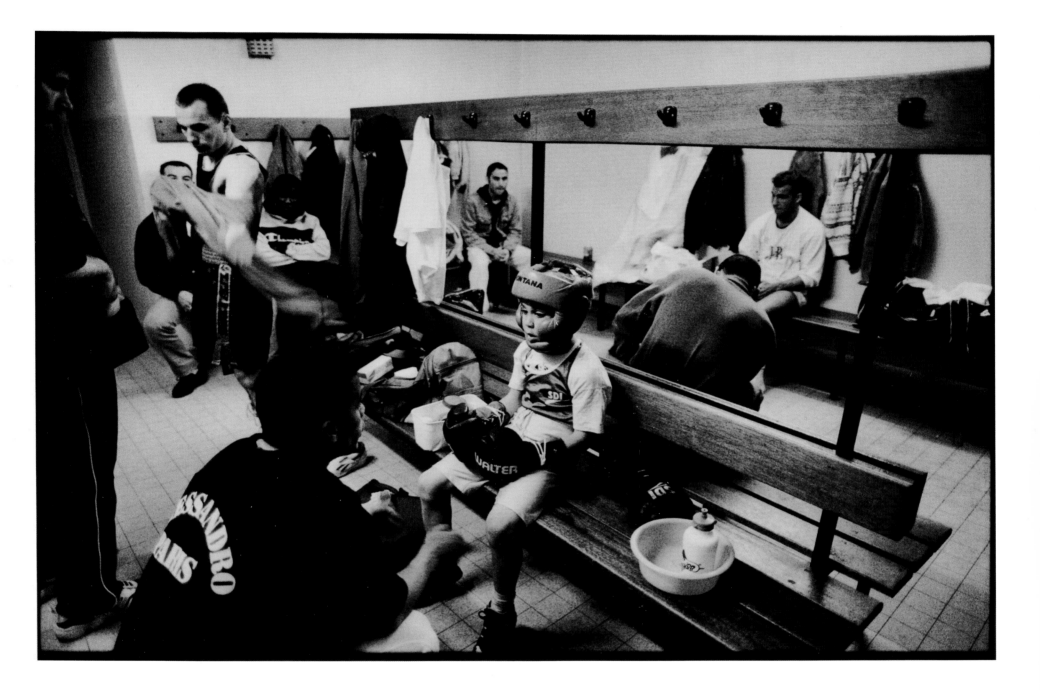

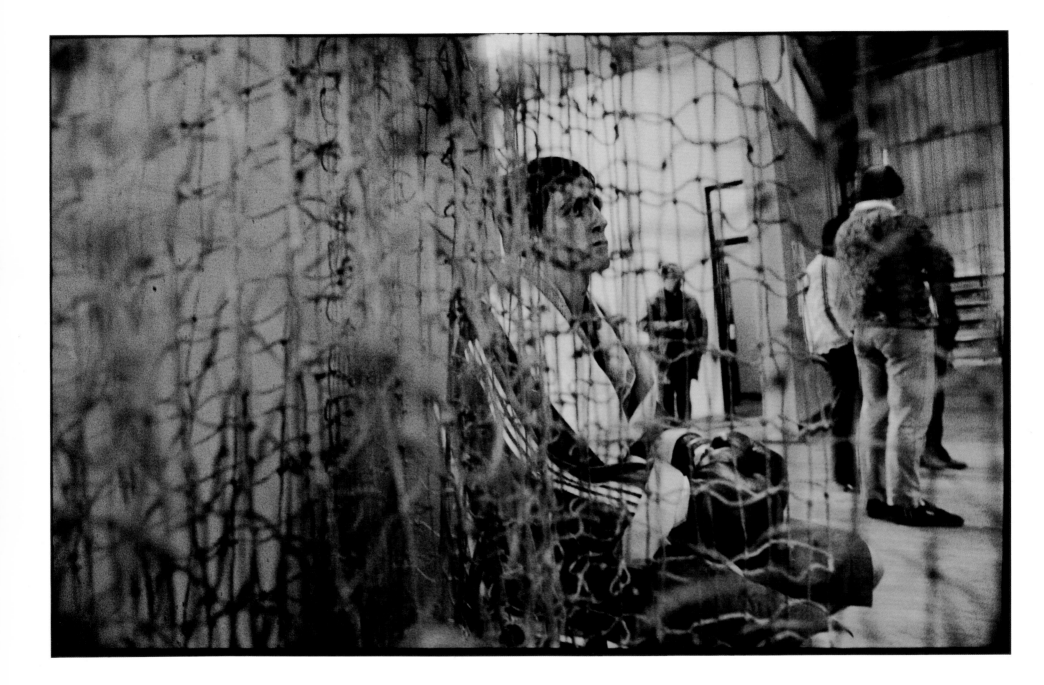

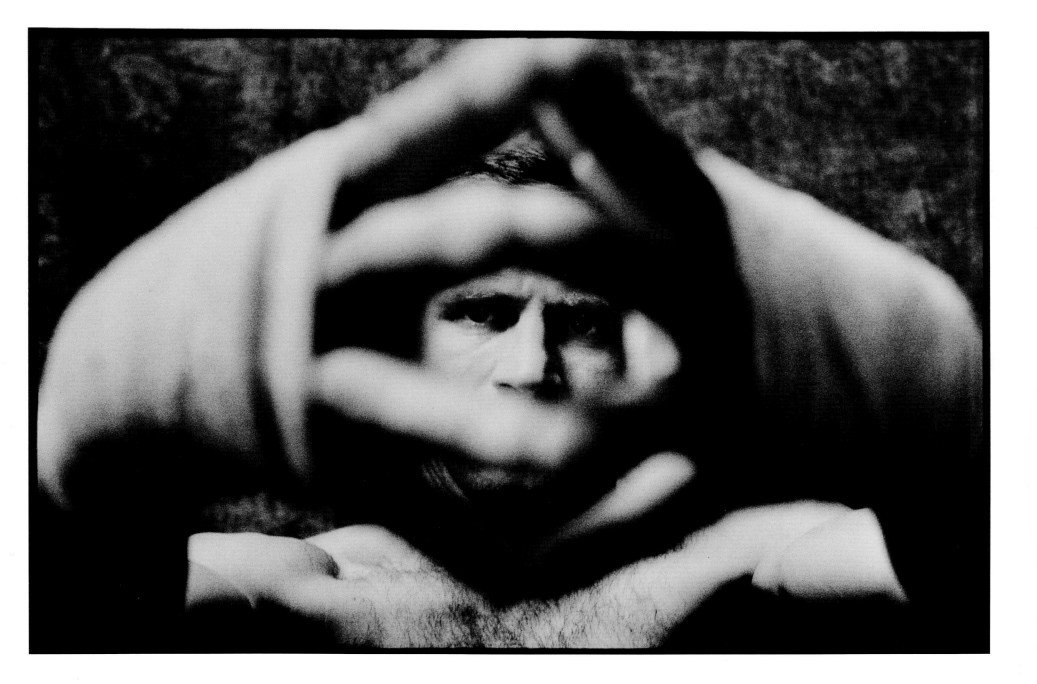

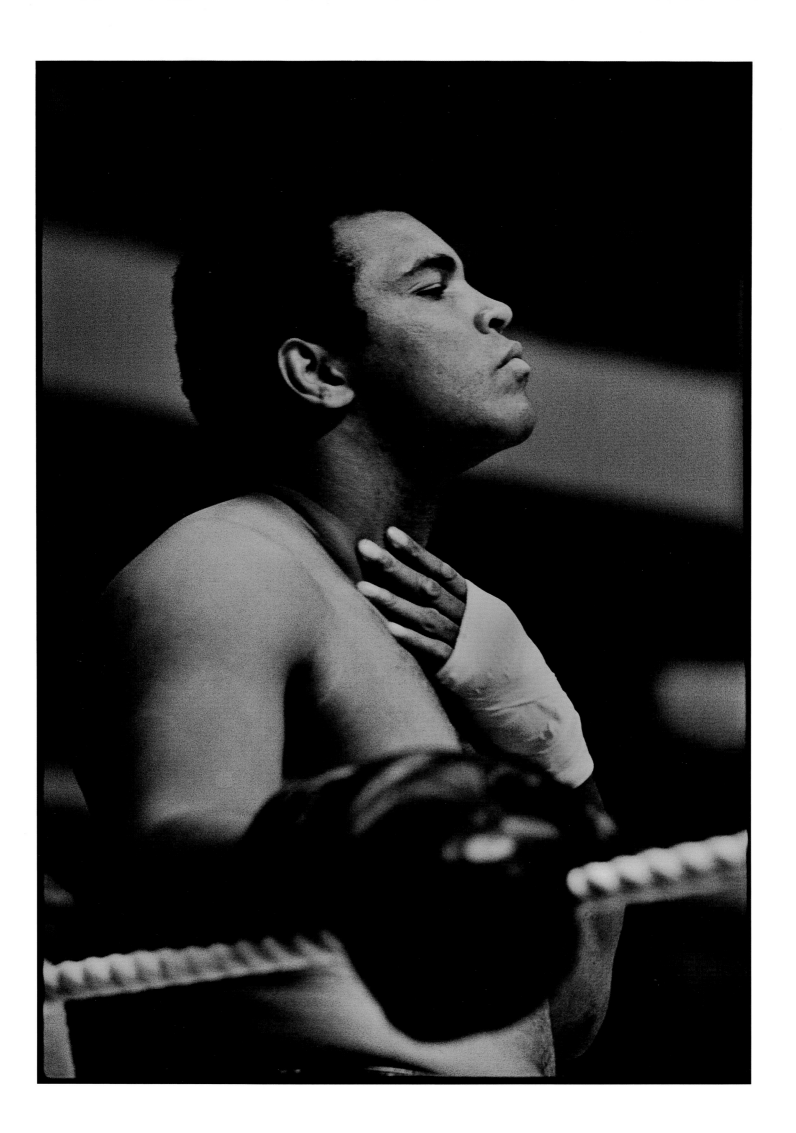

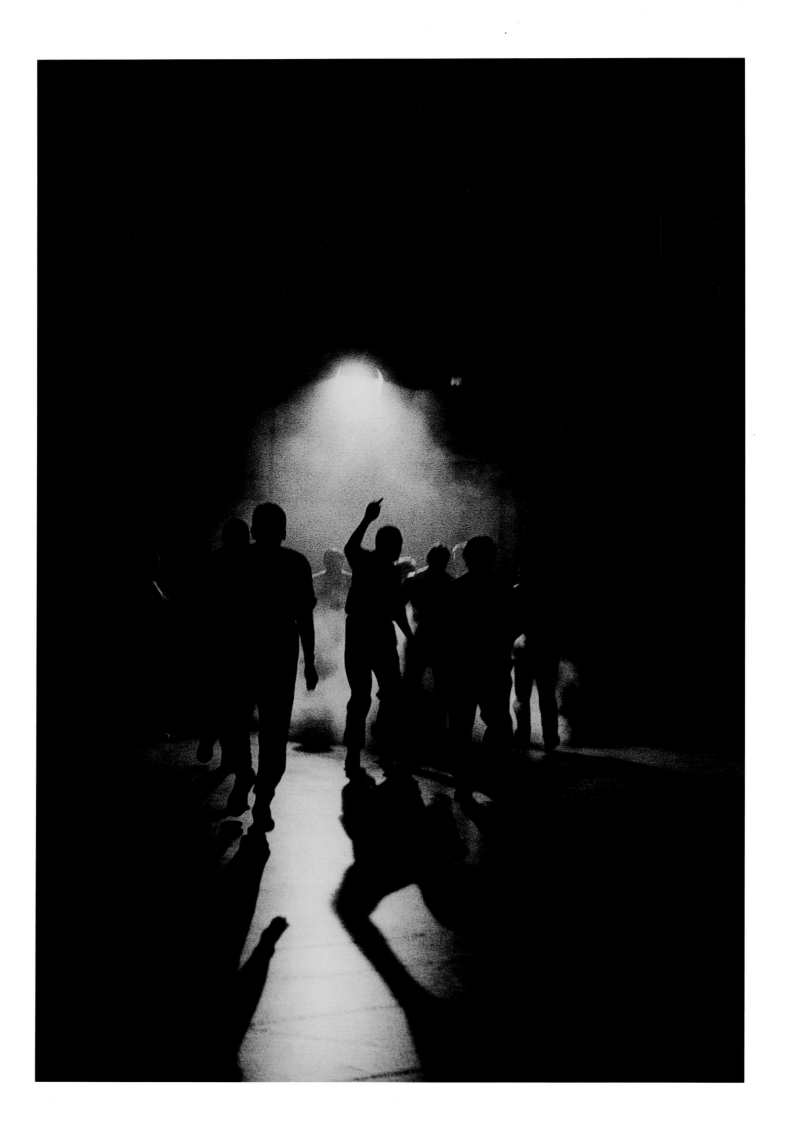

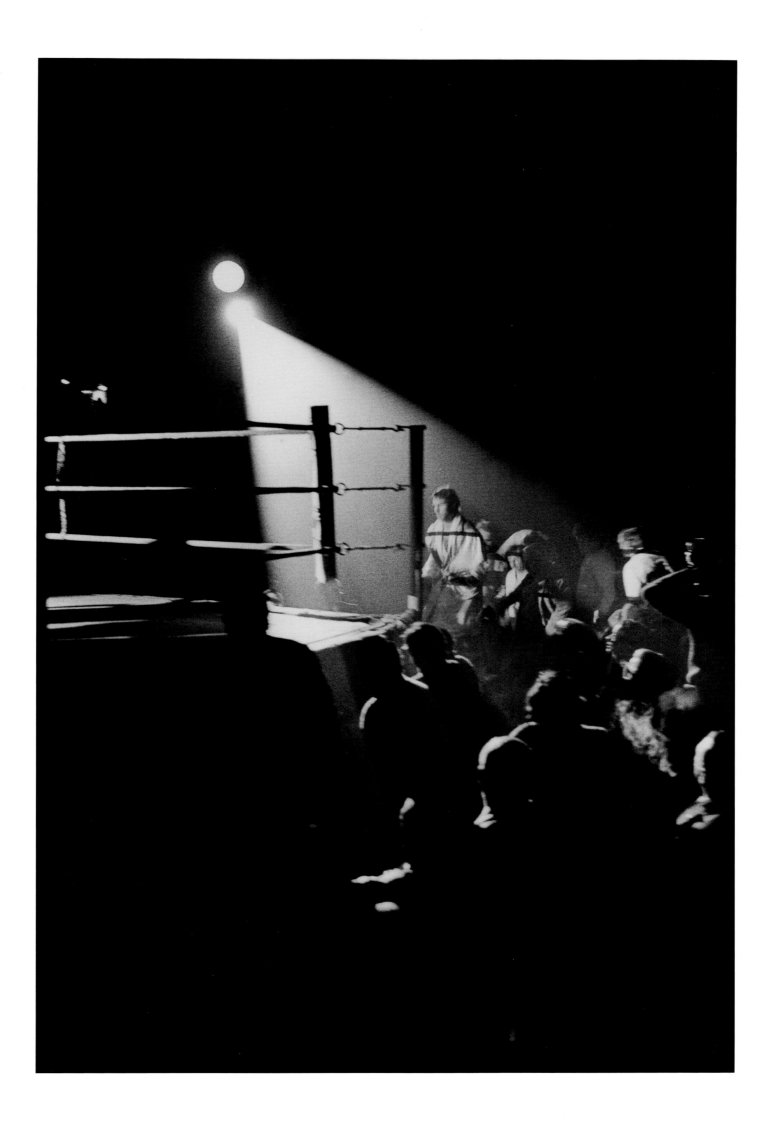

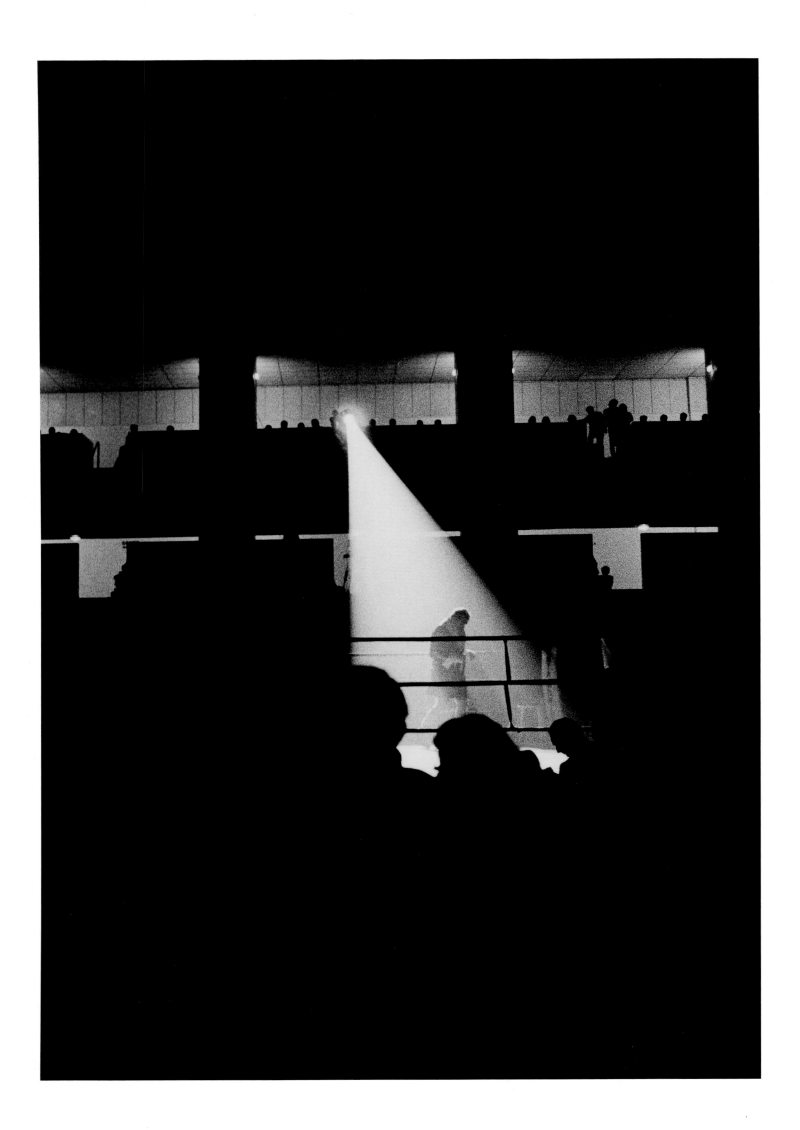

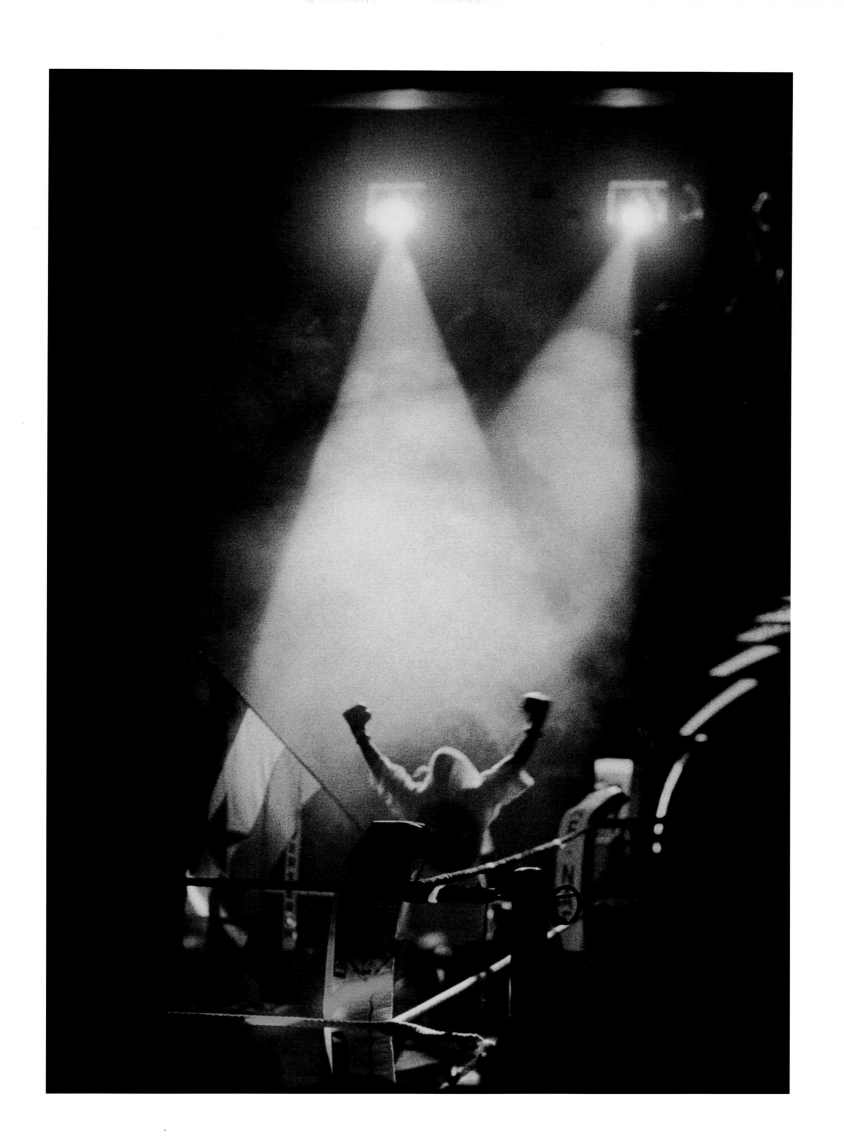

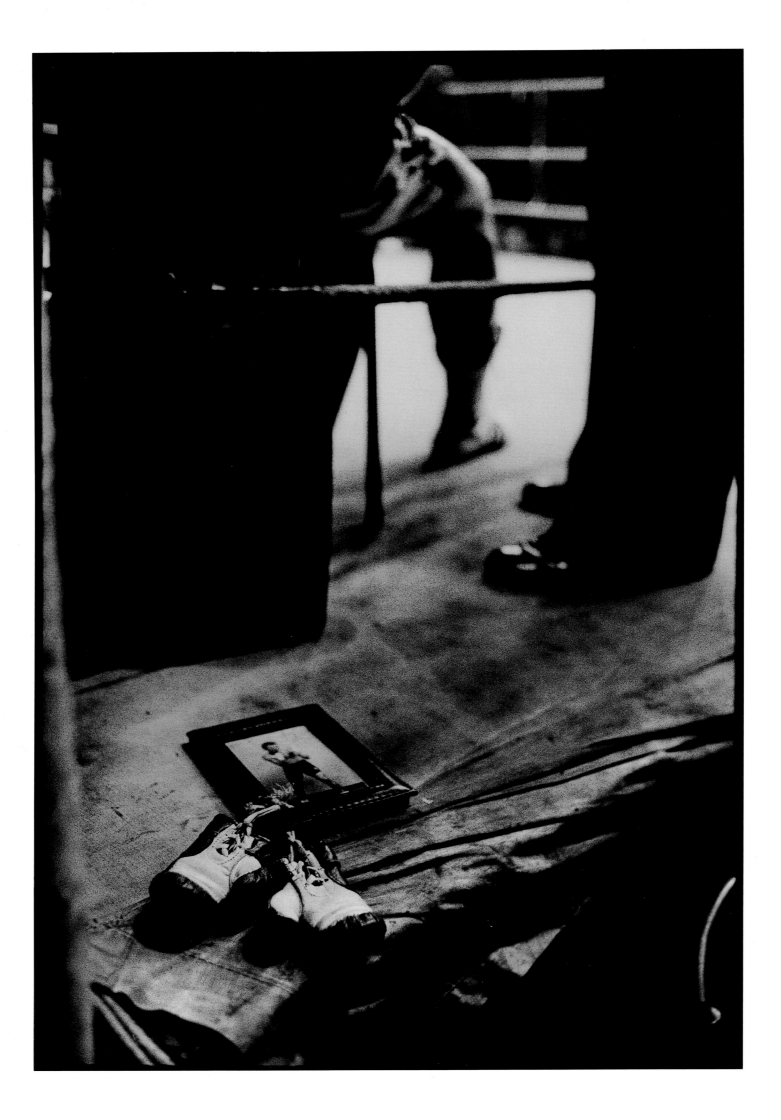

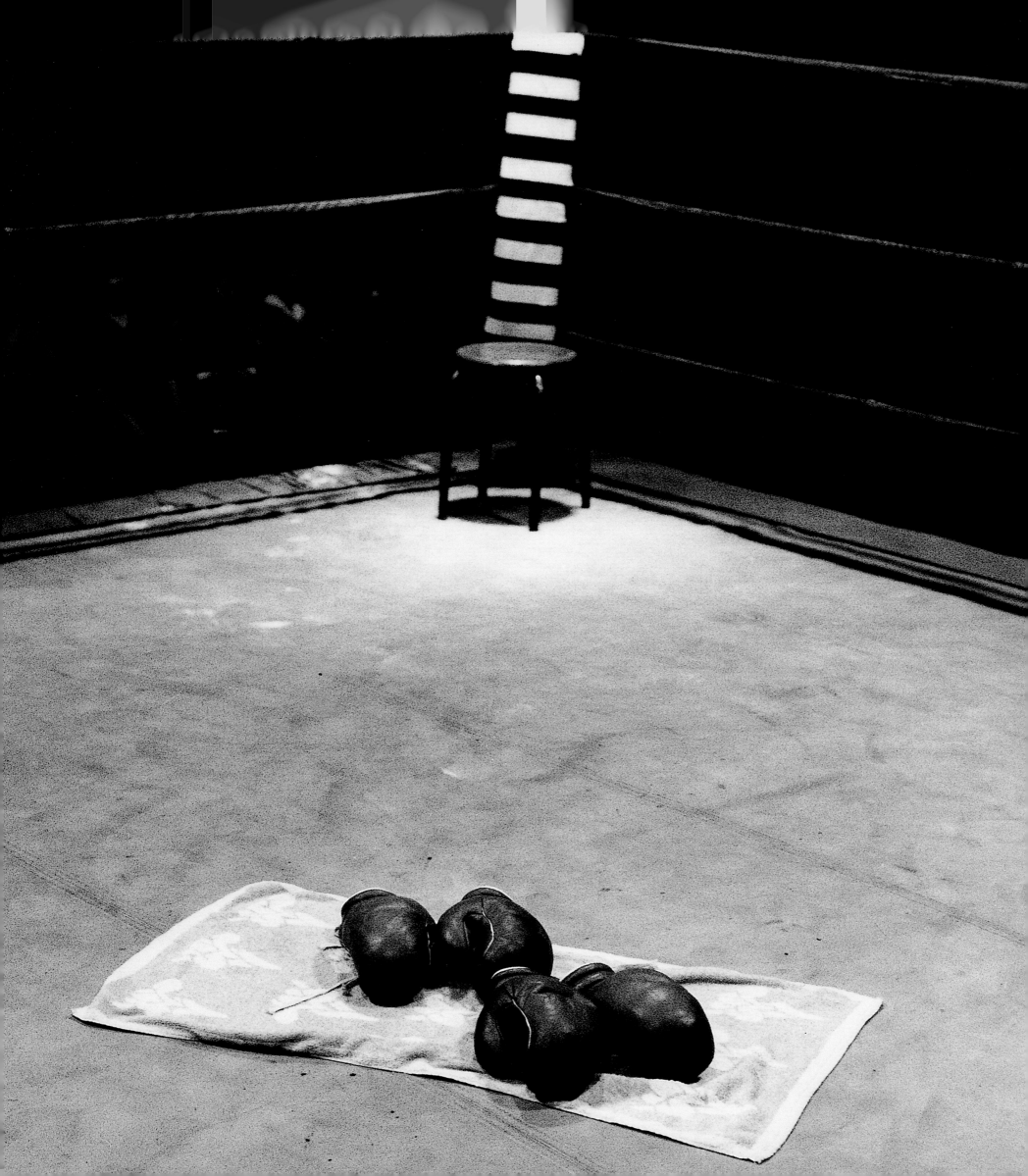

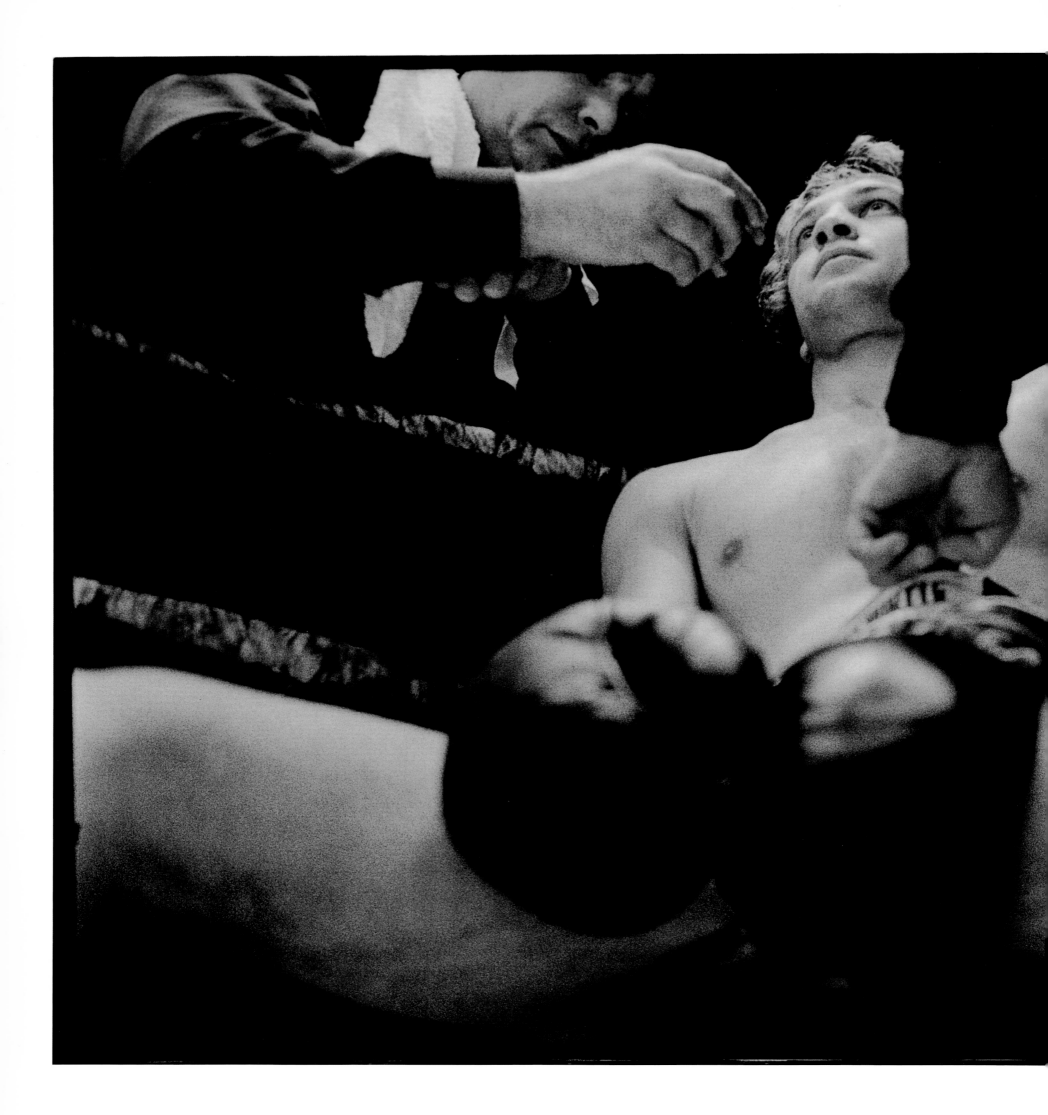

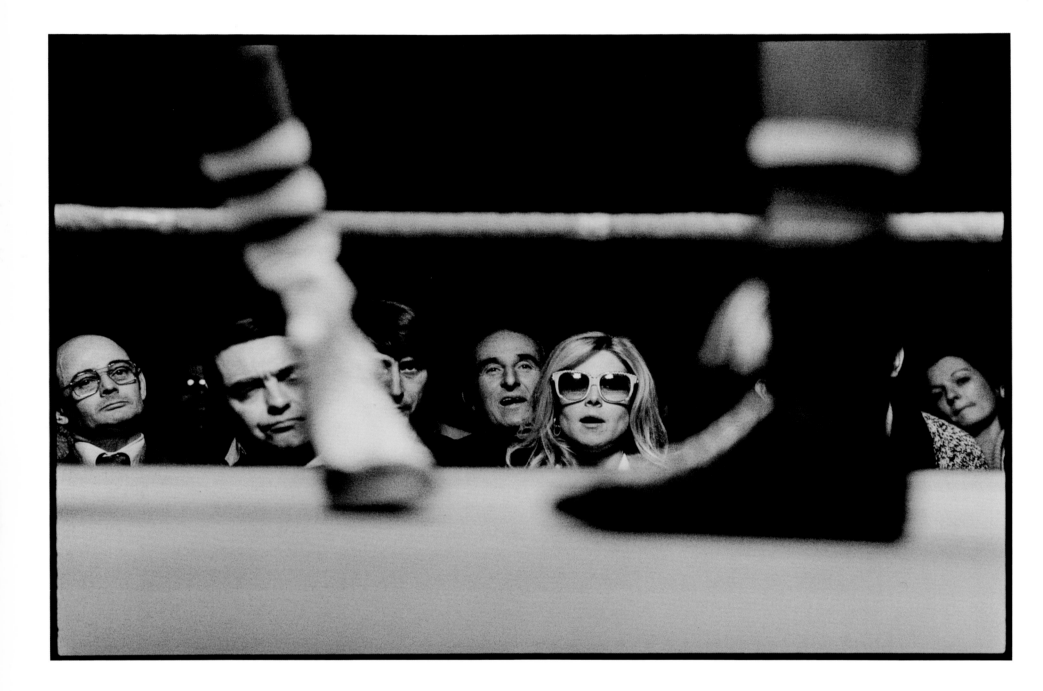

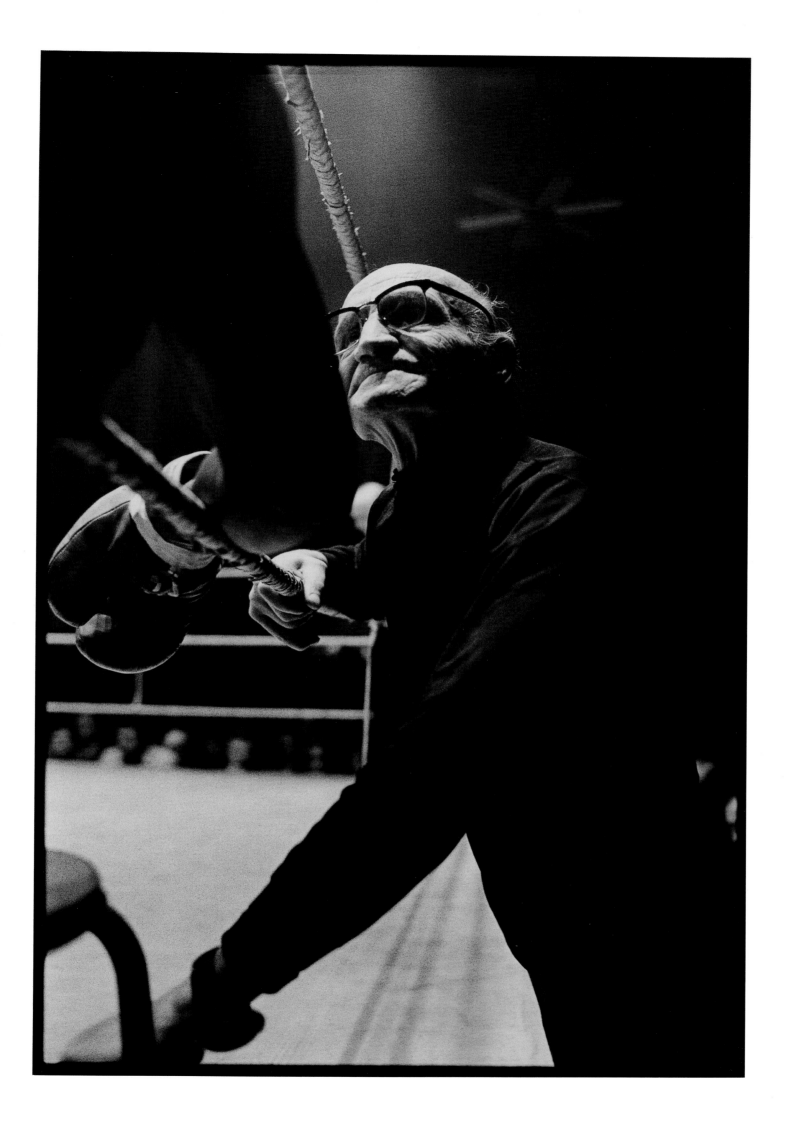

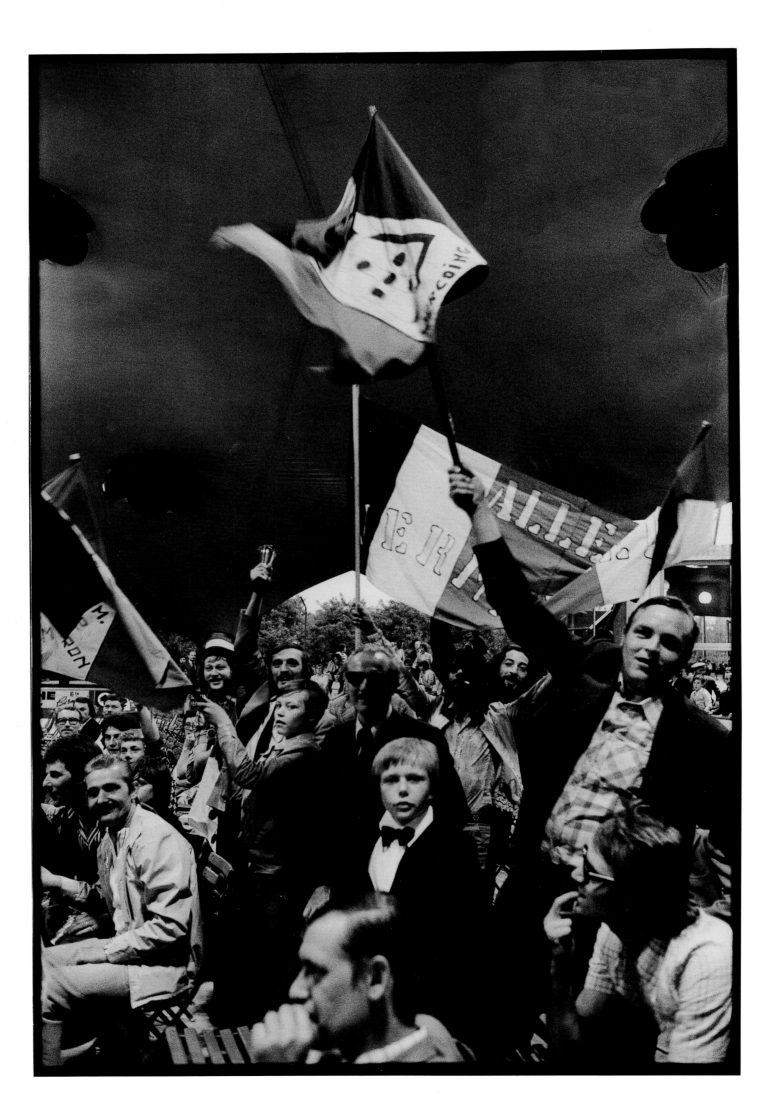

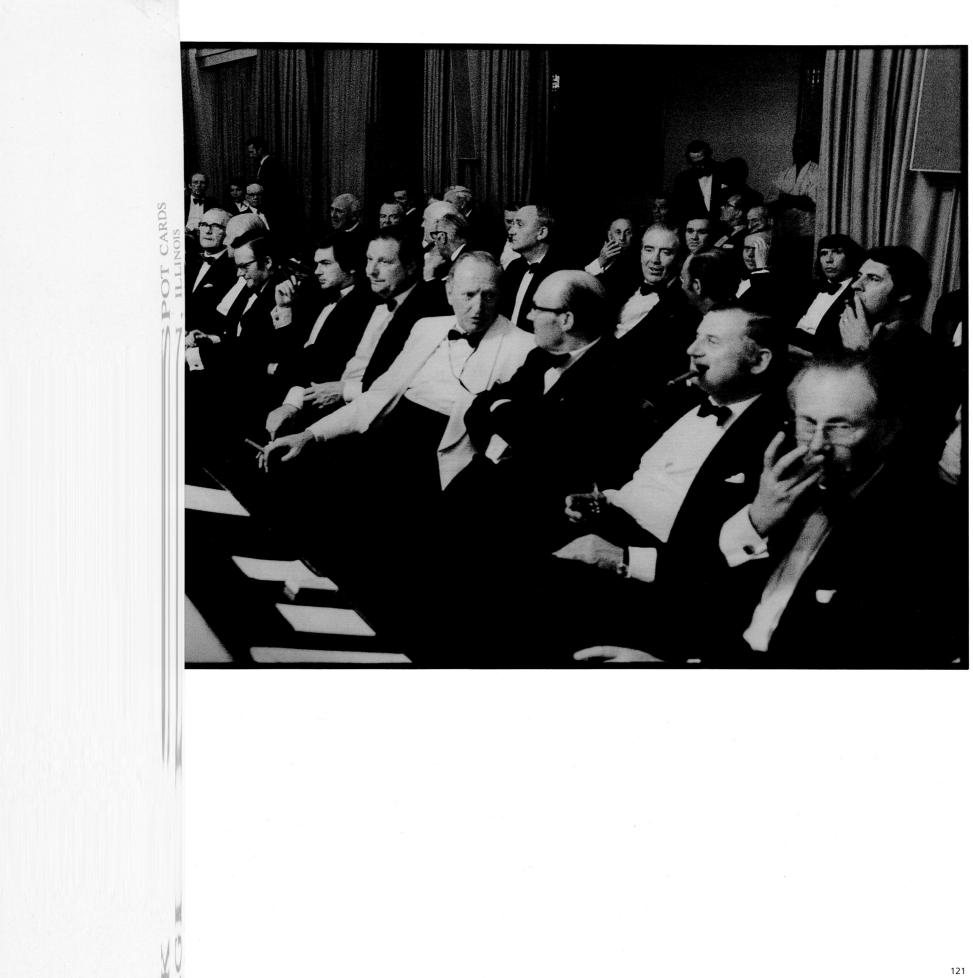

CK
ELG

POT CARDS
N, ILLINOIS

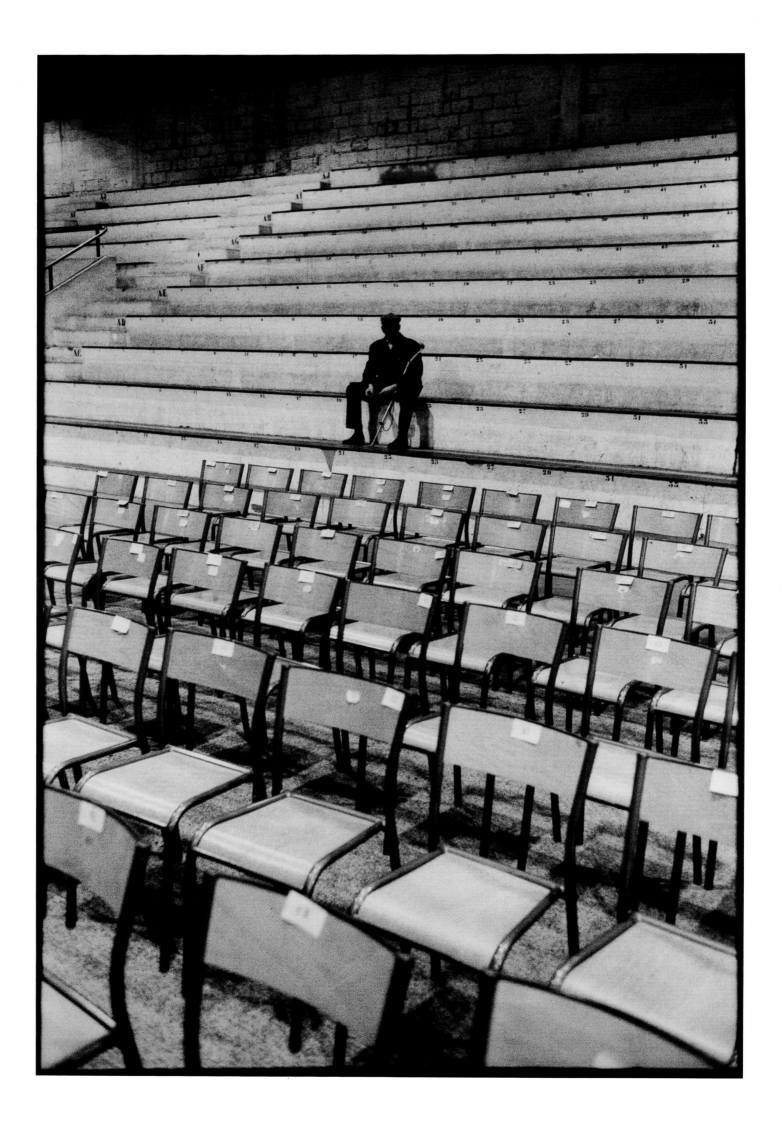

BLACK SPOT CARDS
ELGIN. ILLINOIS

123

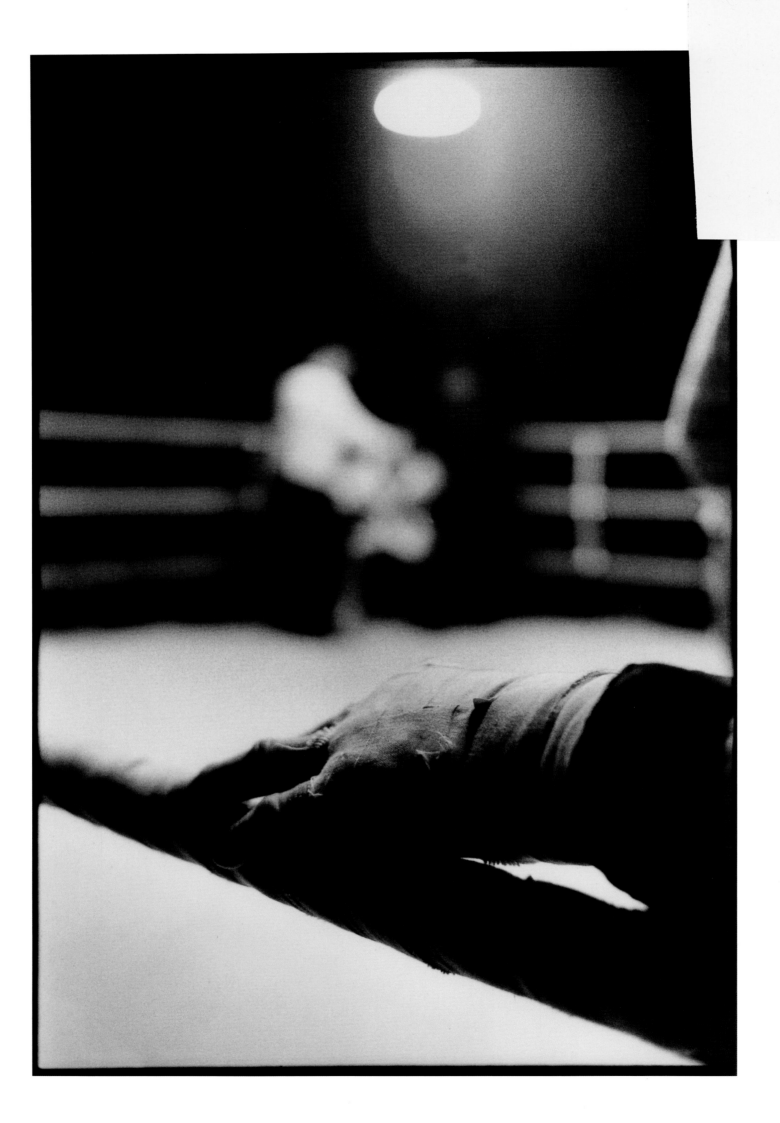

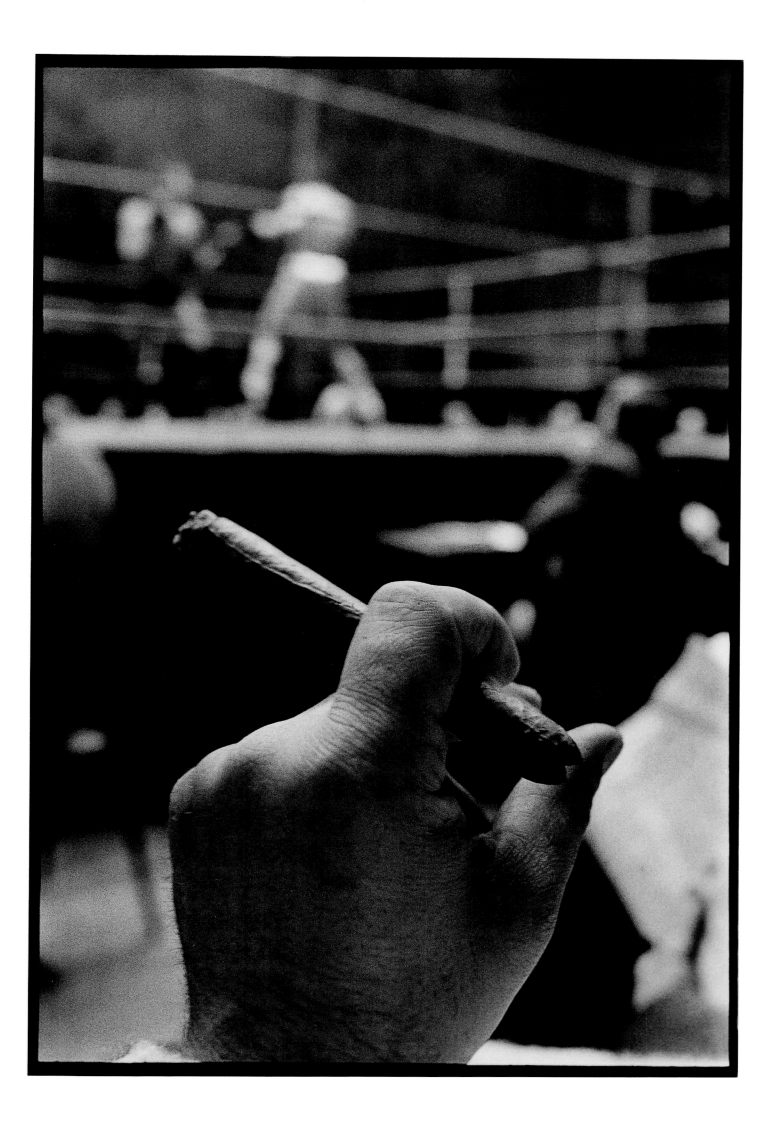

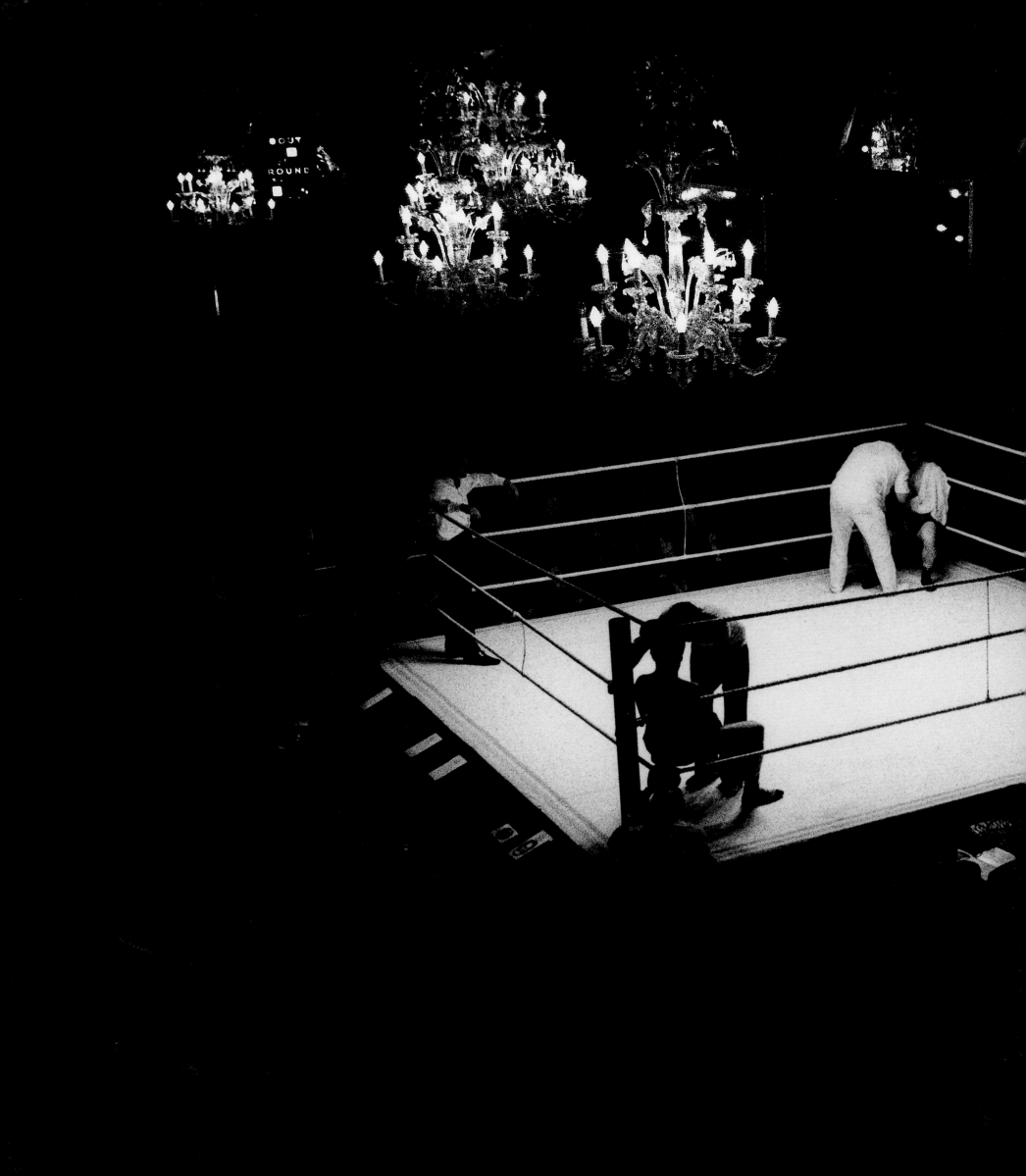

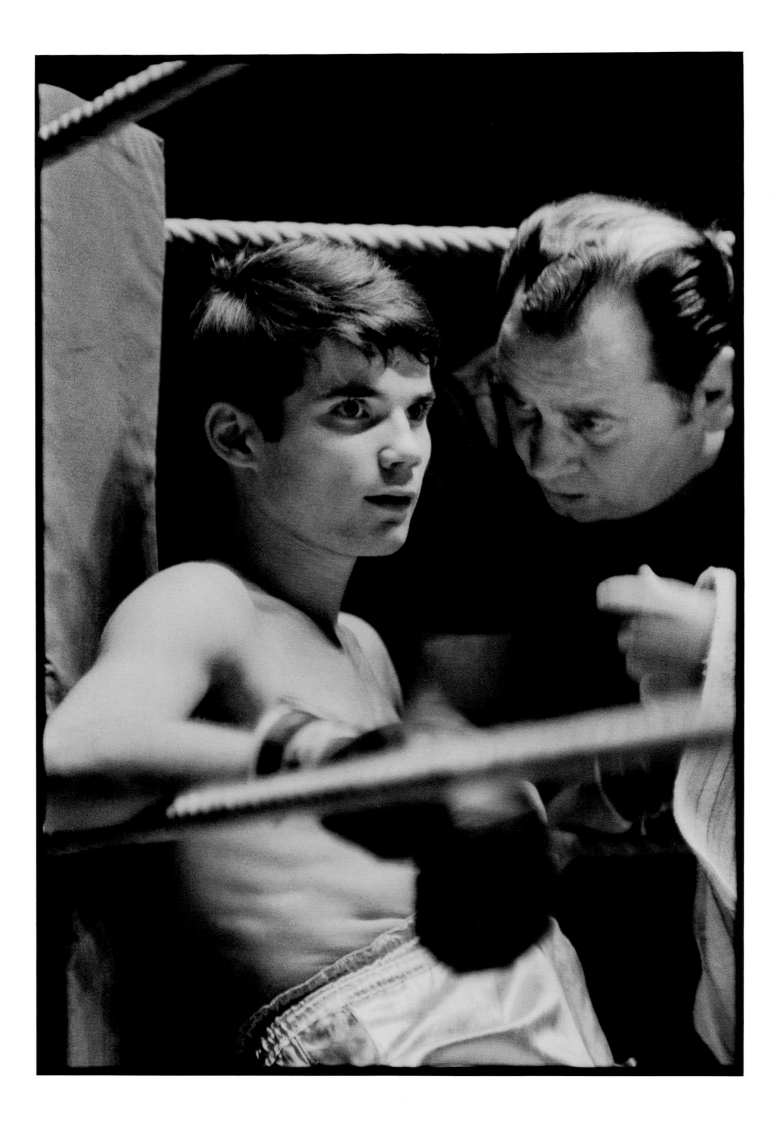

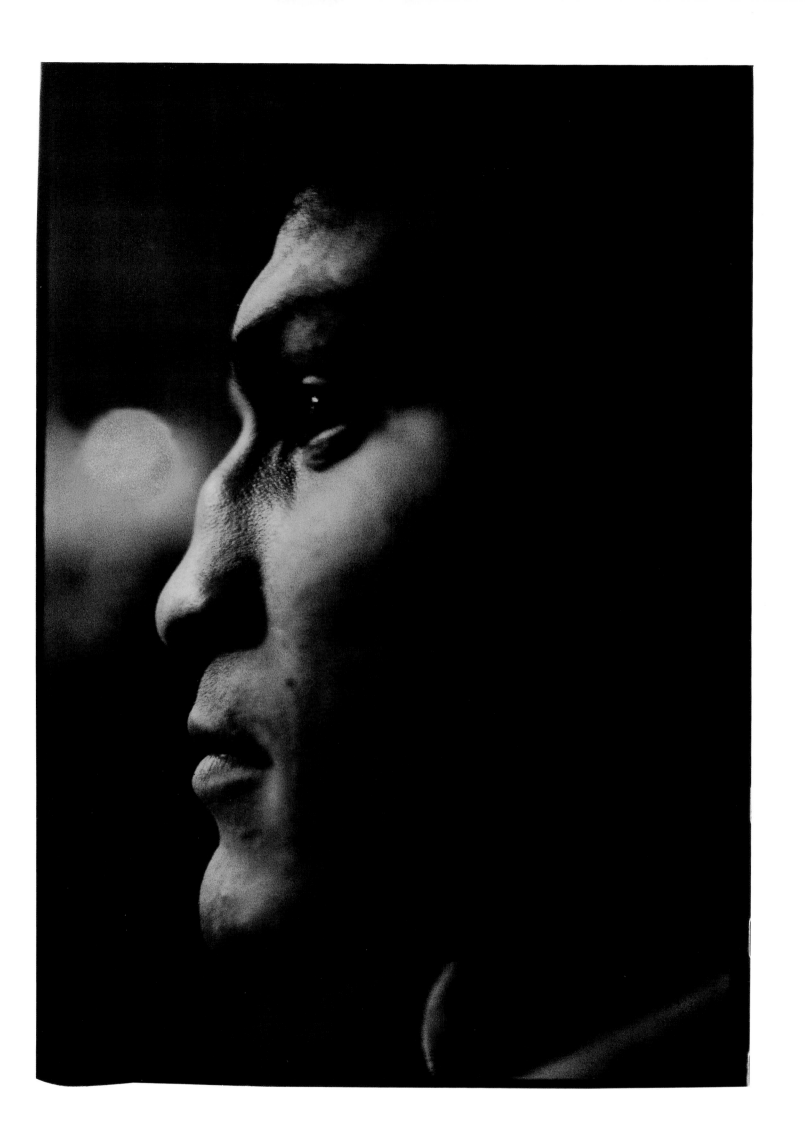

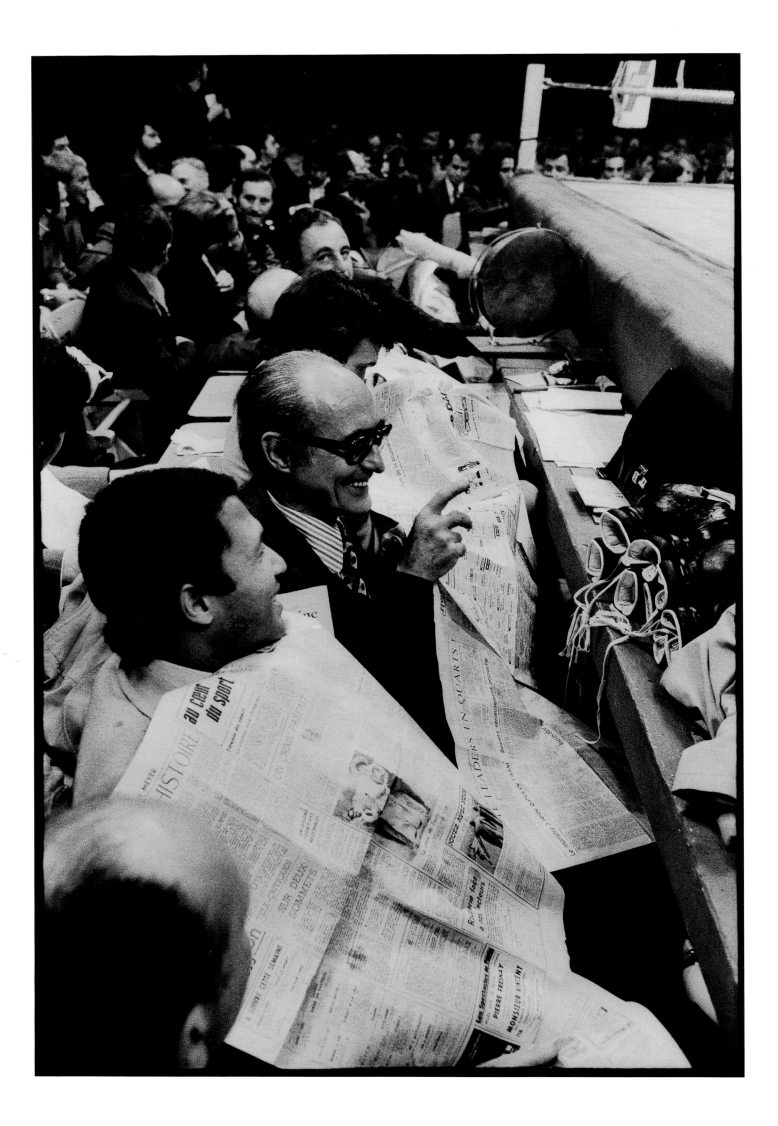

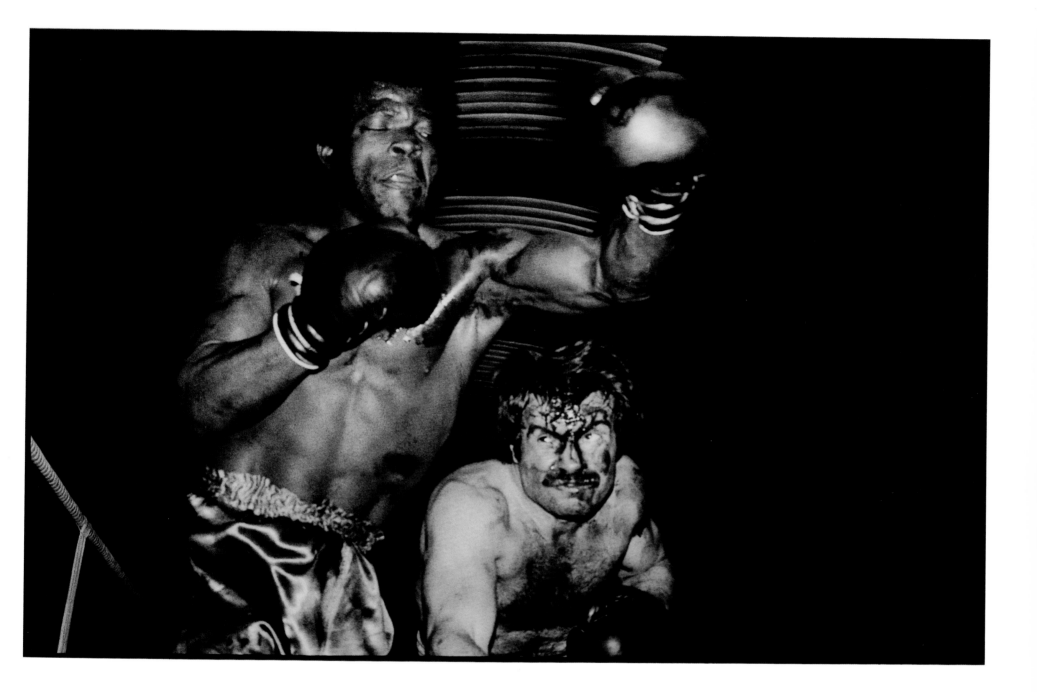

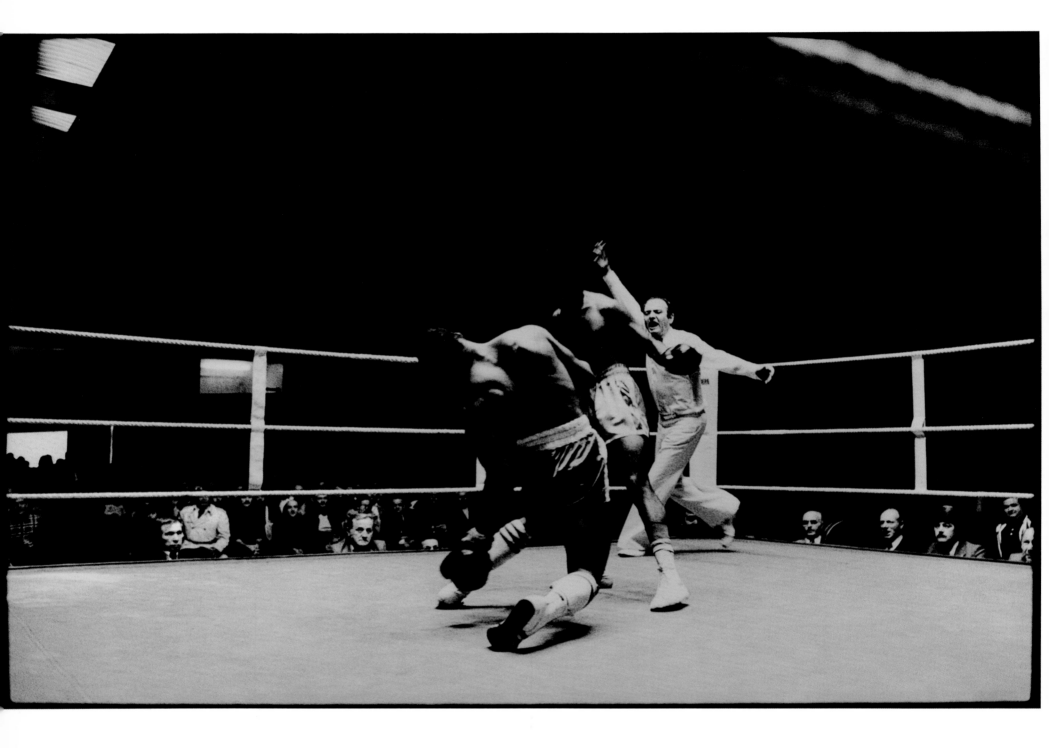

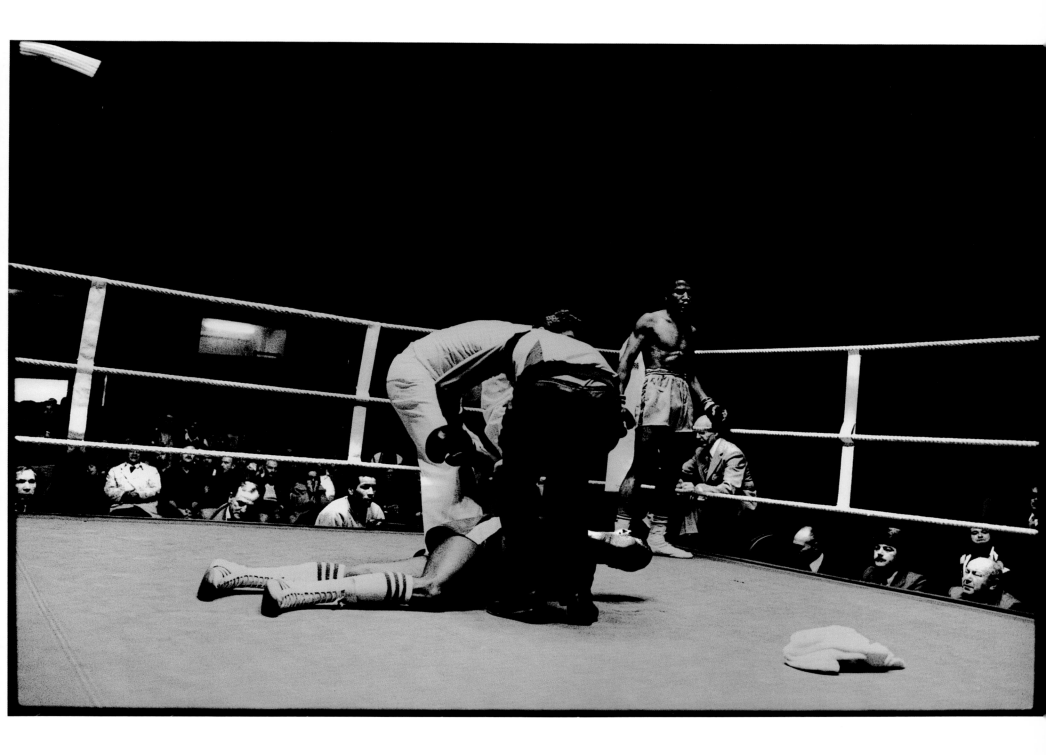

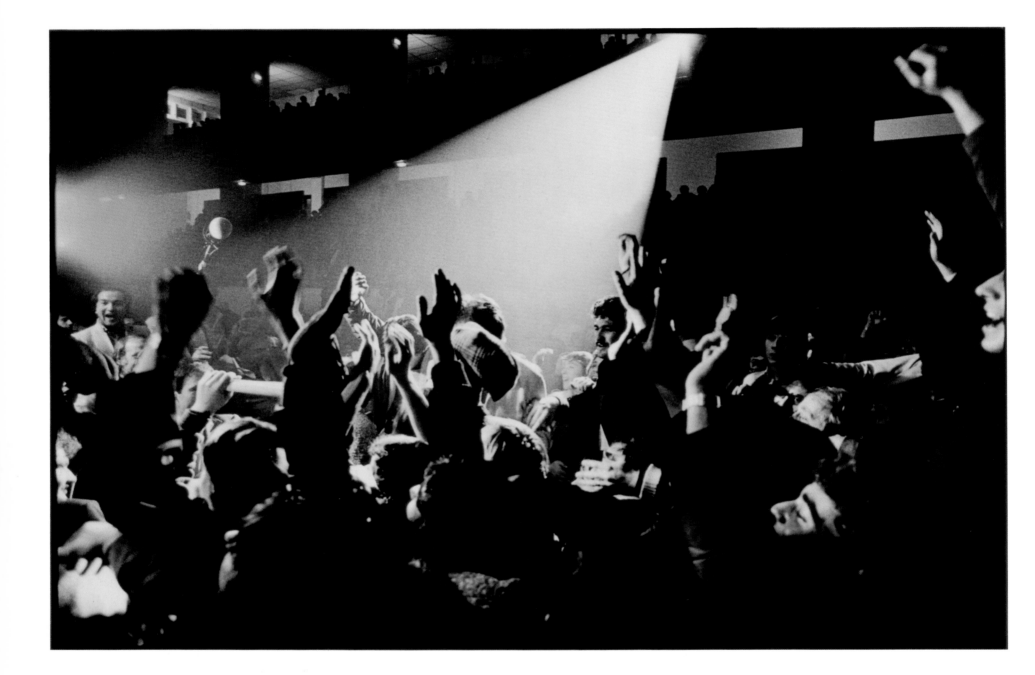

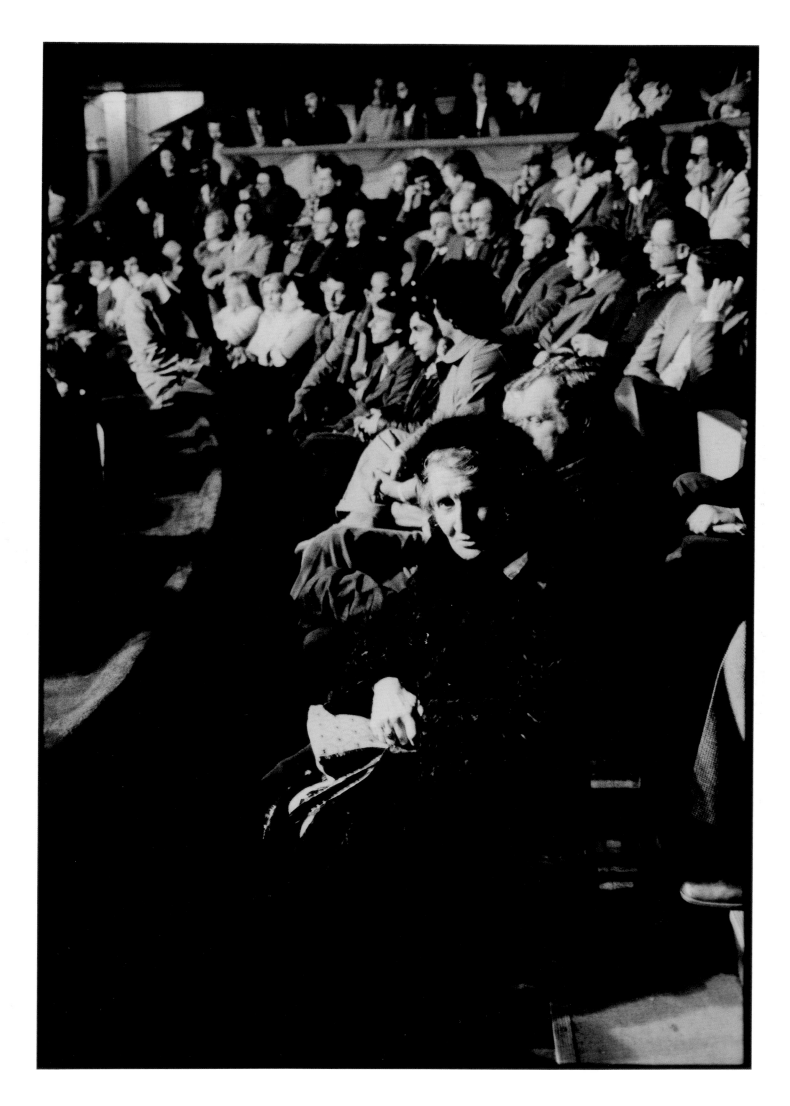

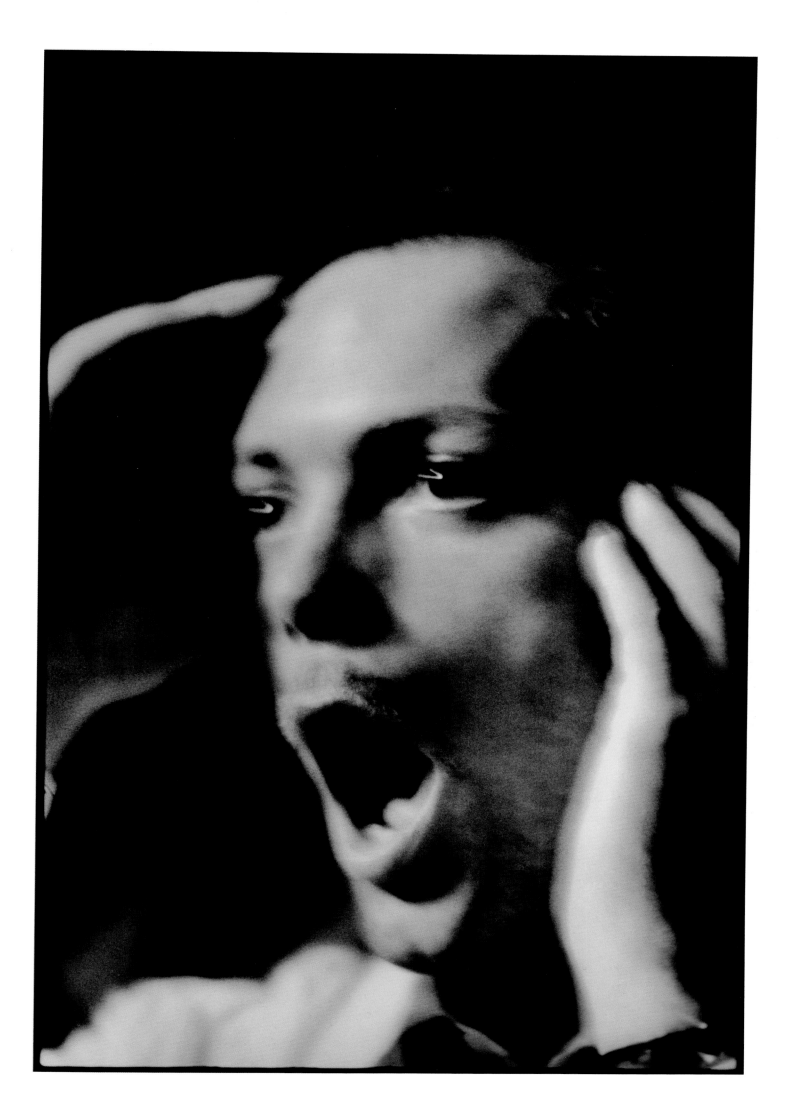

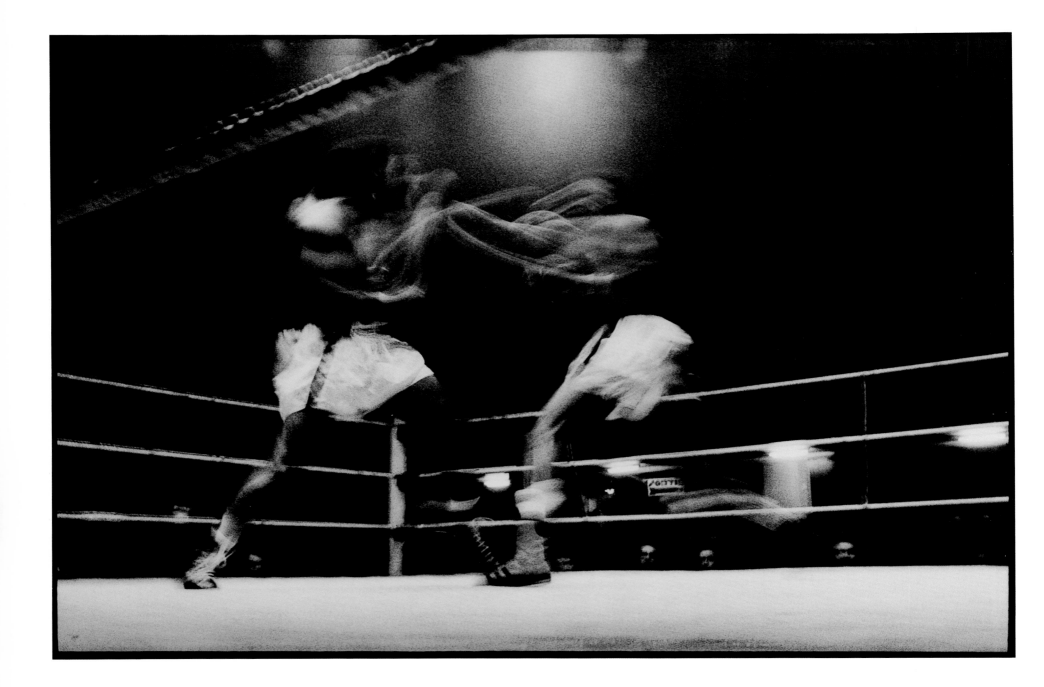

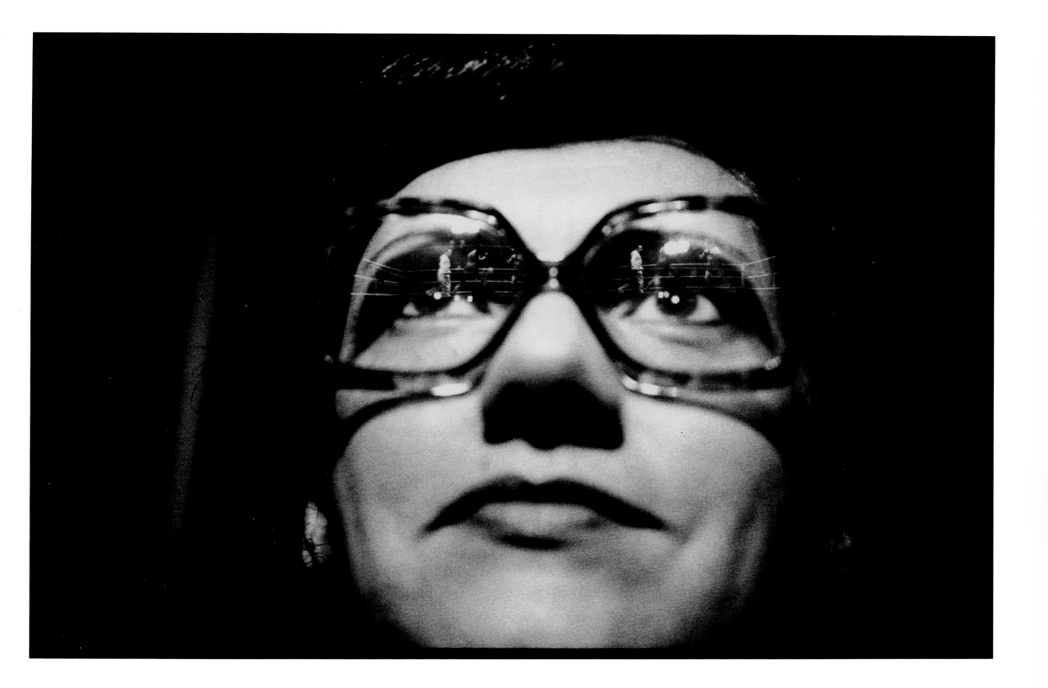

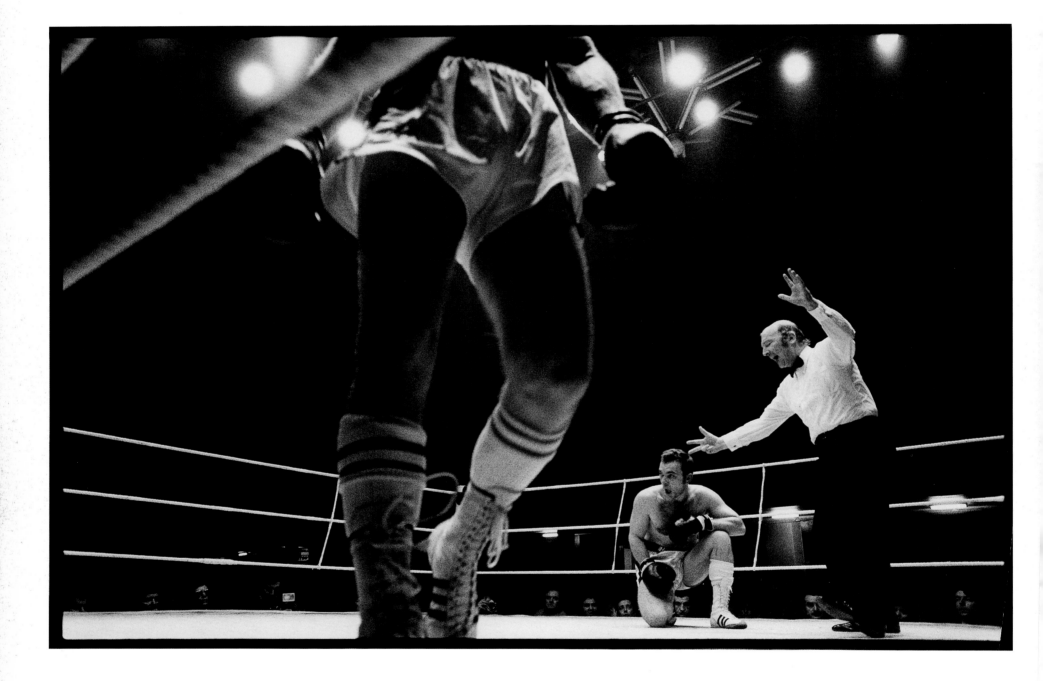

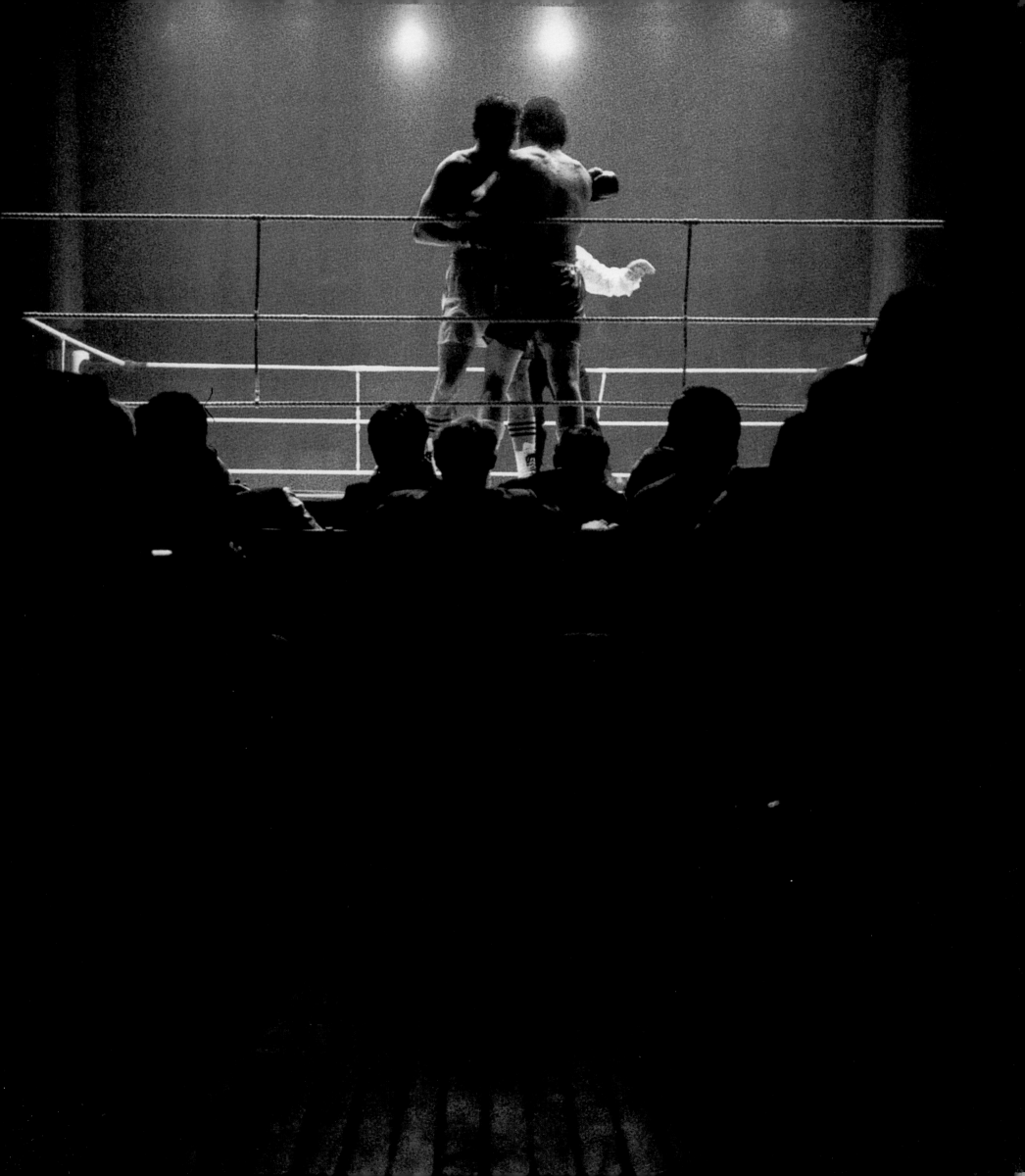

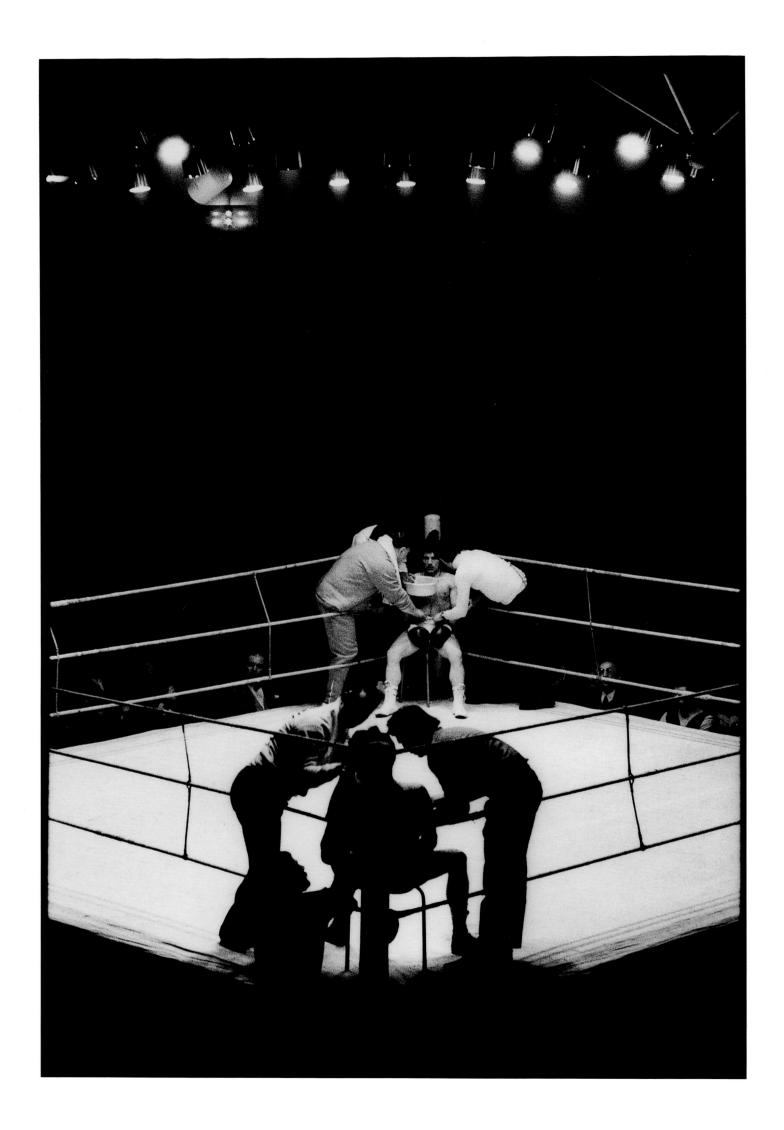

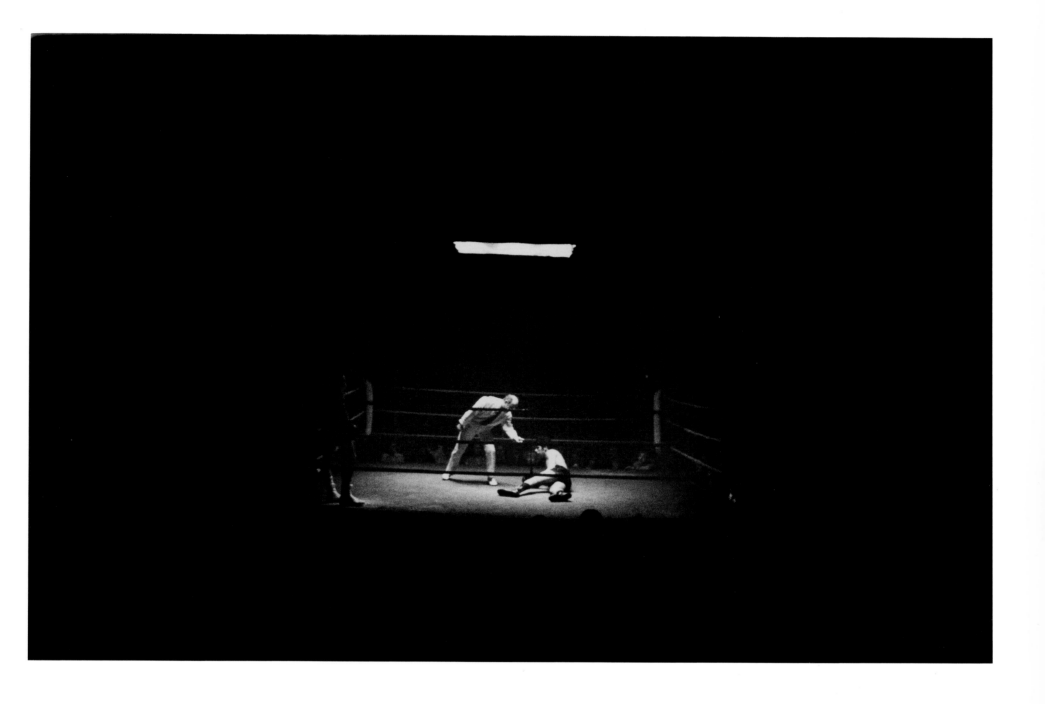

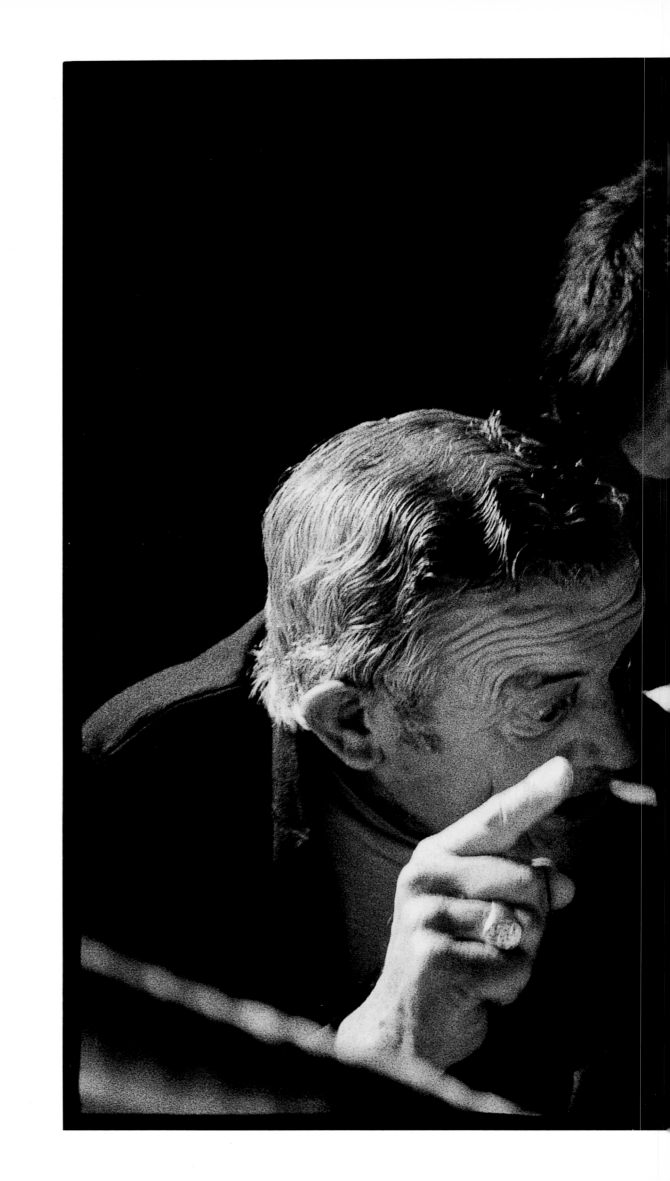

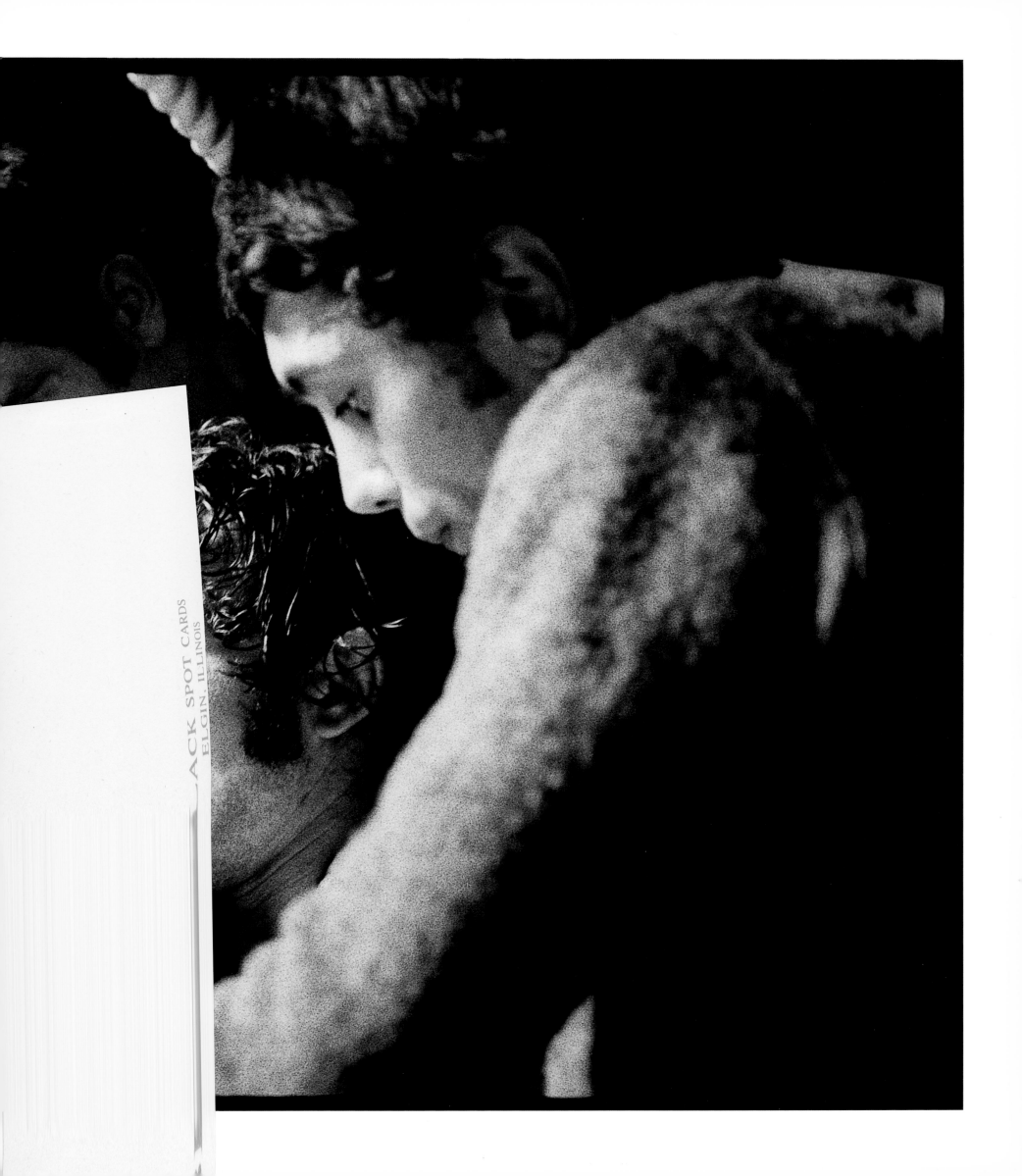

BLACK SPOT CARDS
ELGIN, ILLINOIS

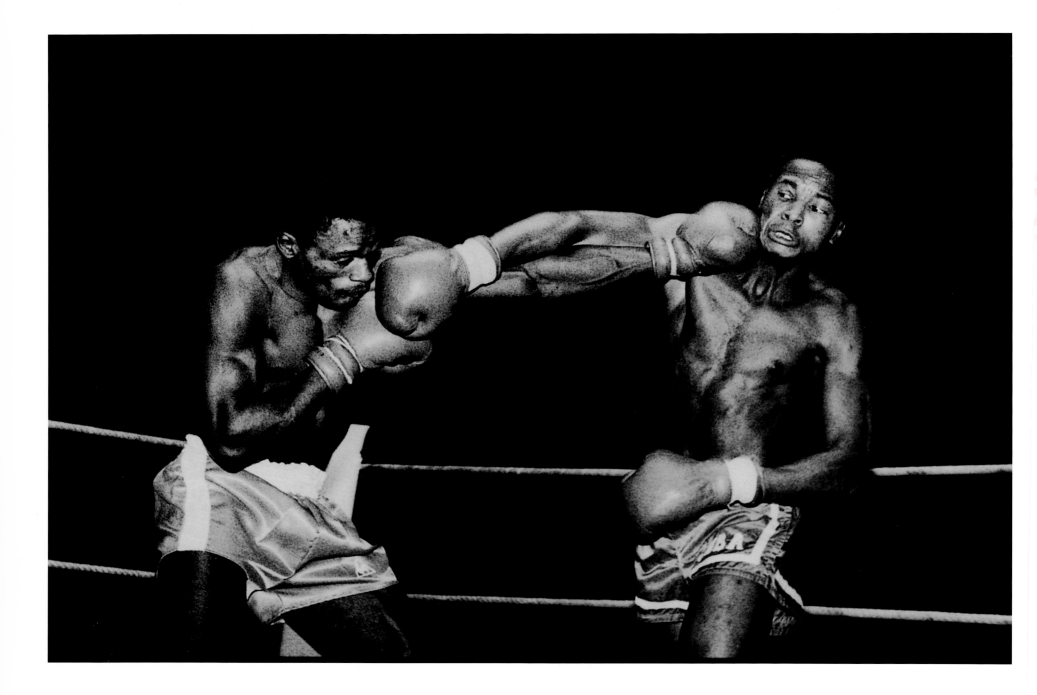

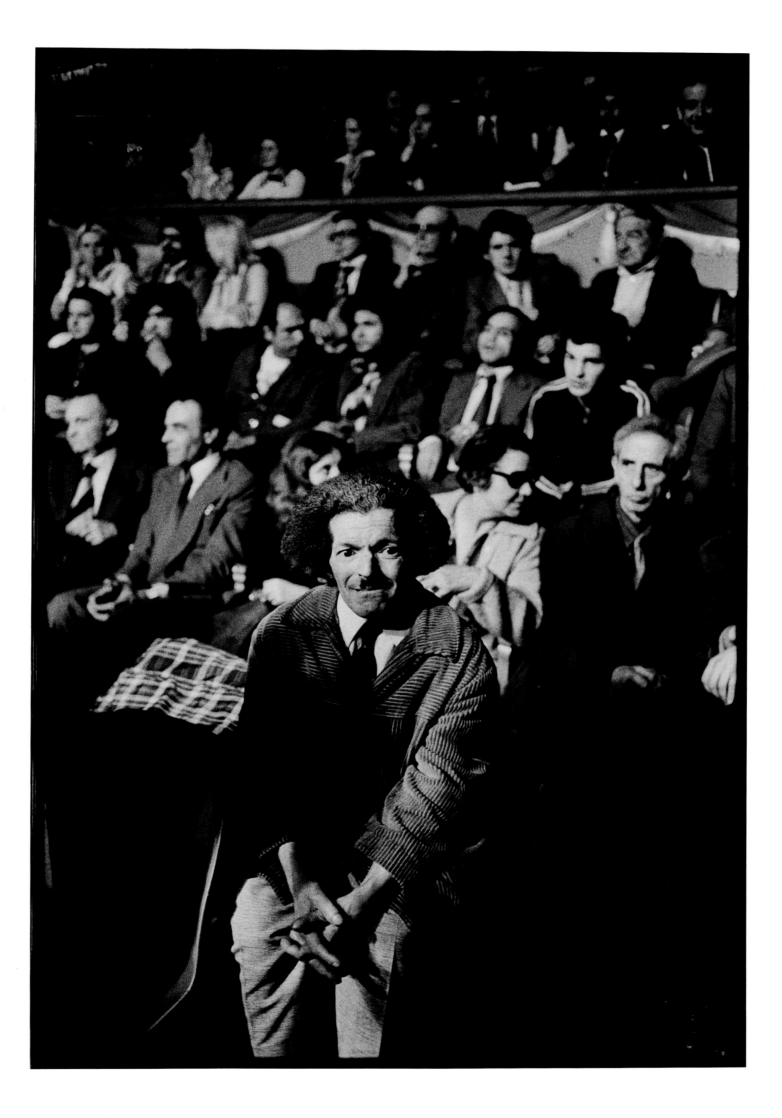

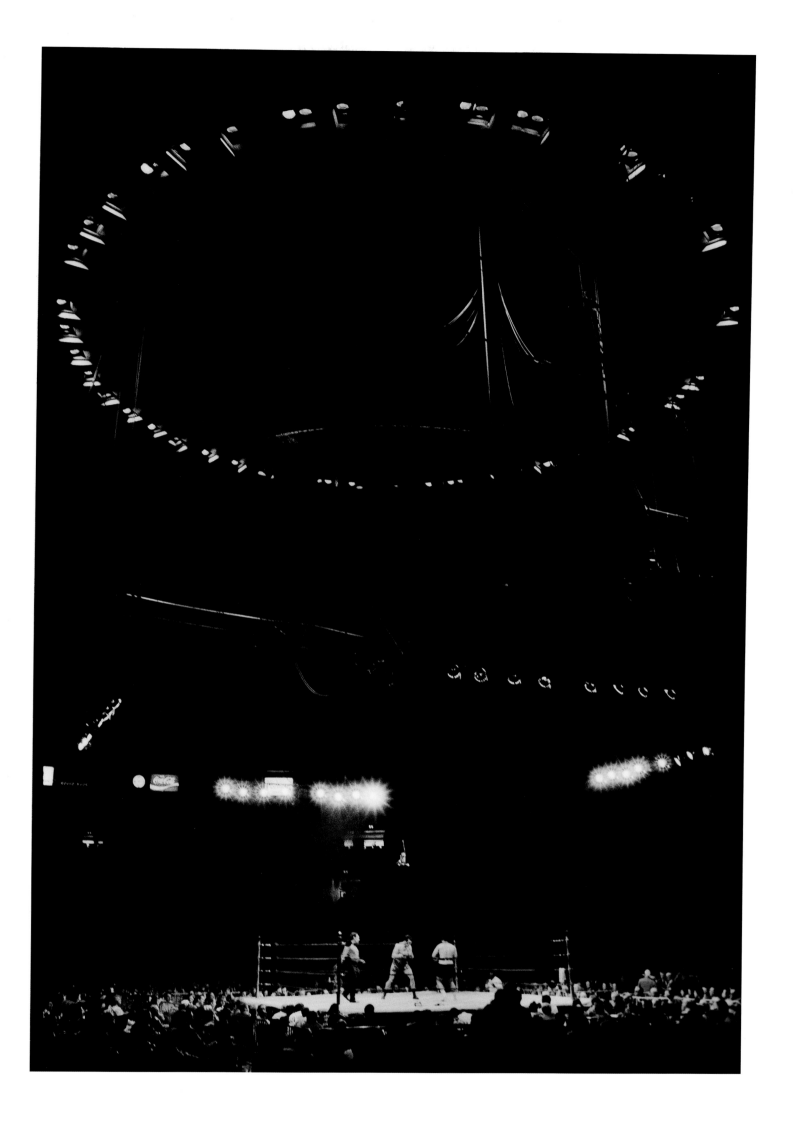

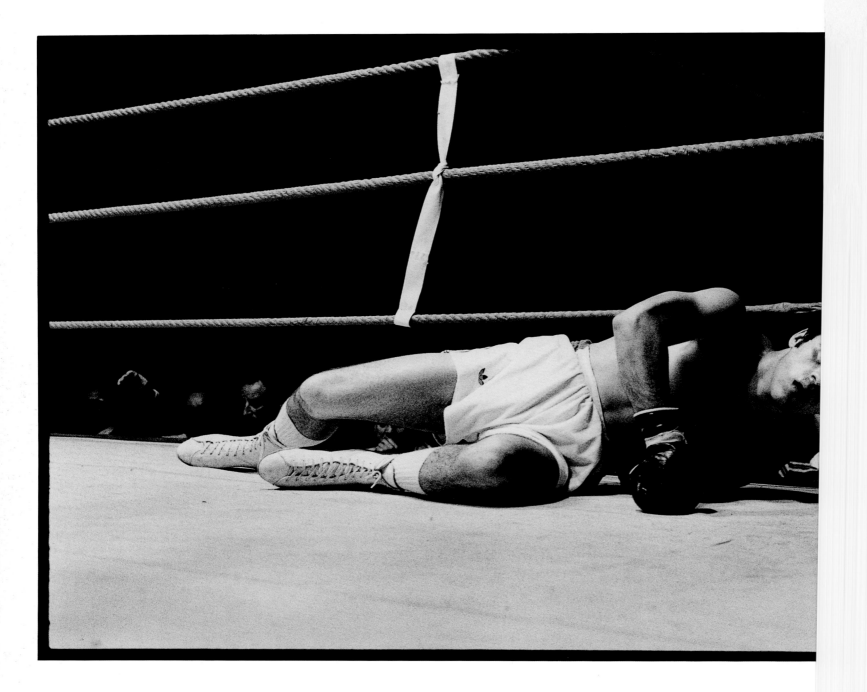

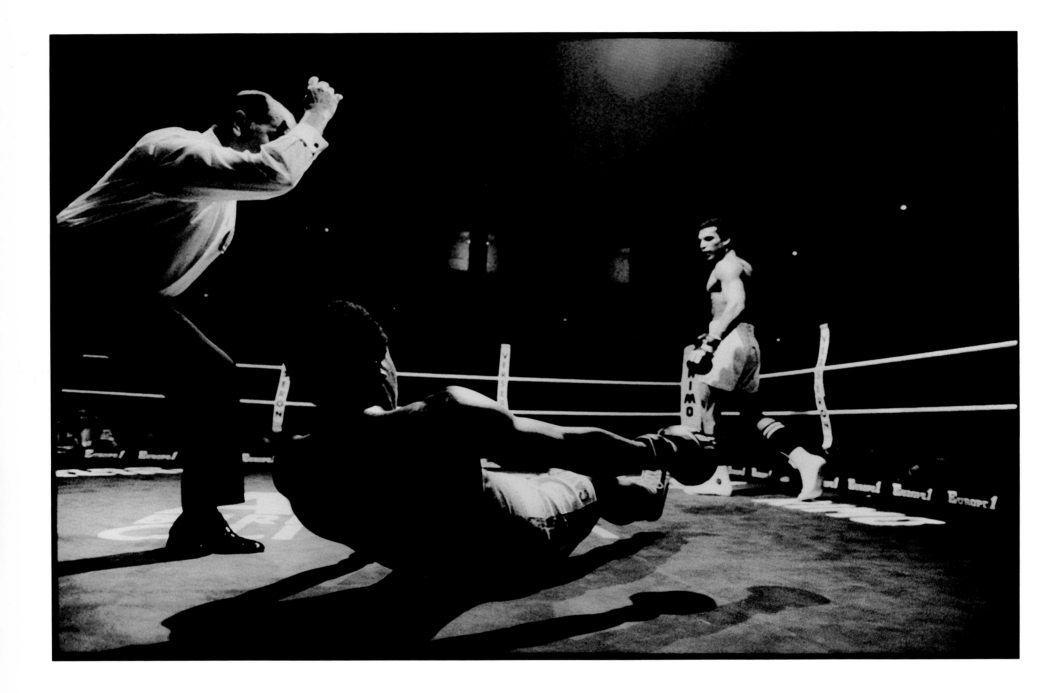

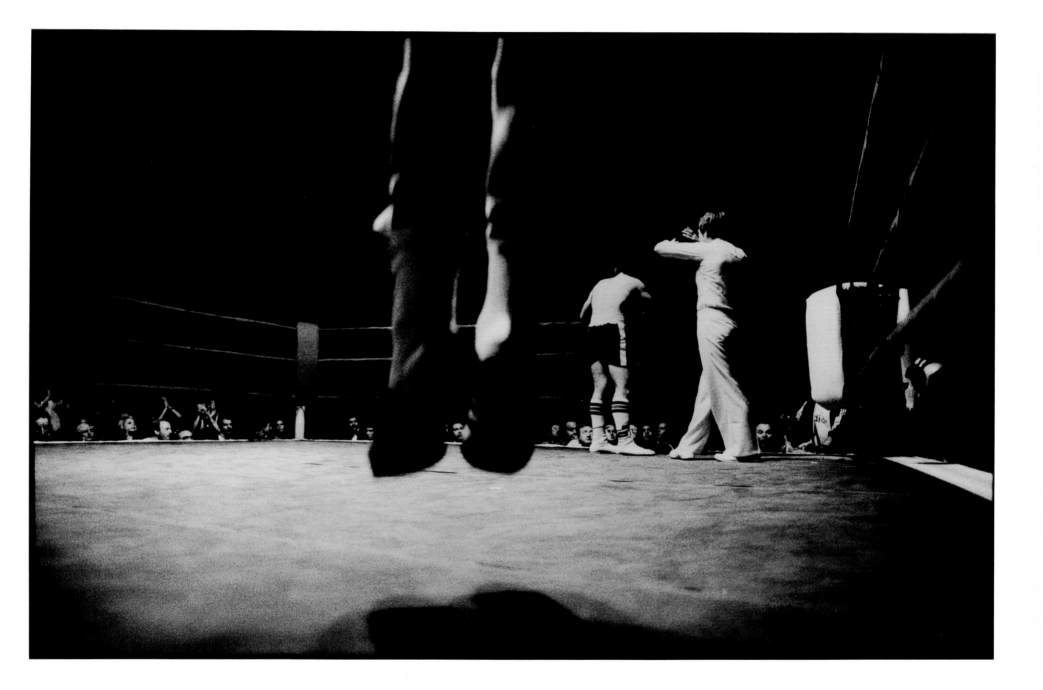

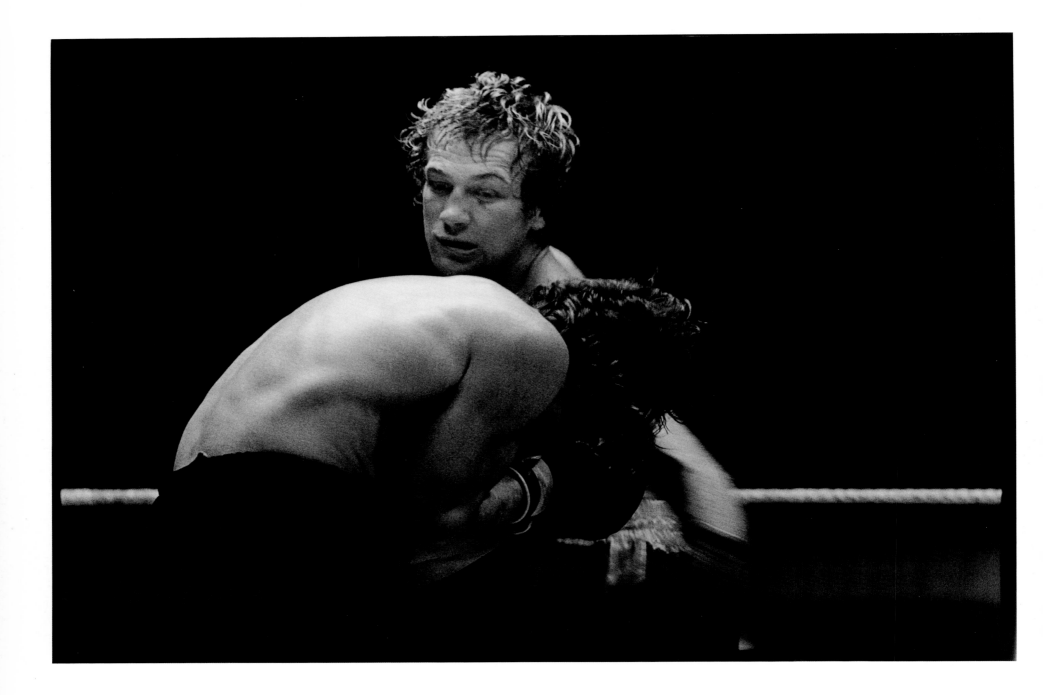

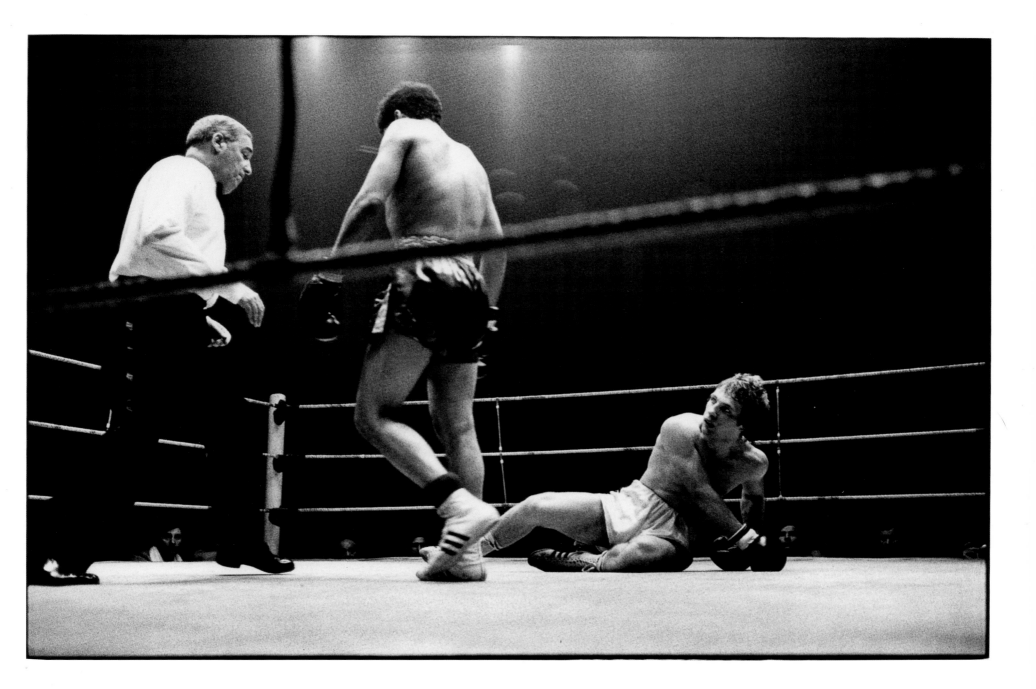

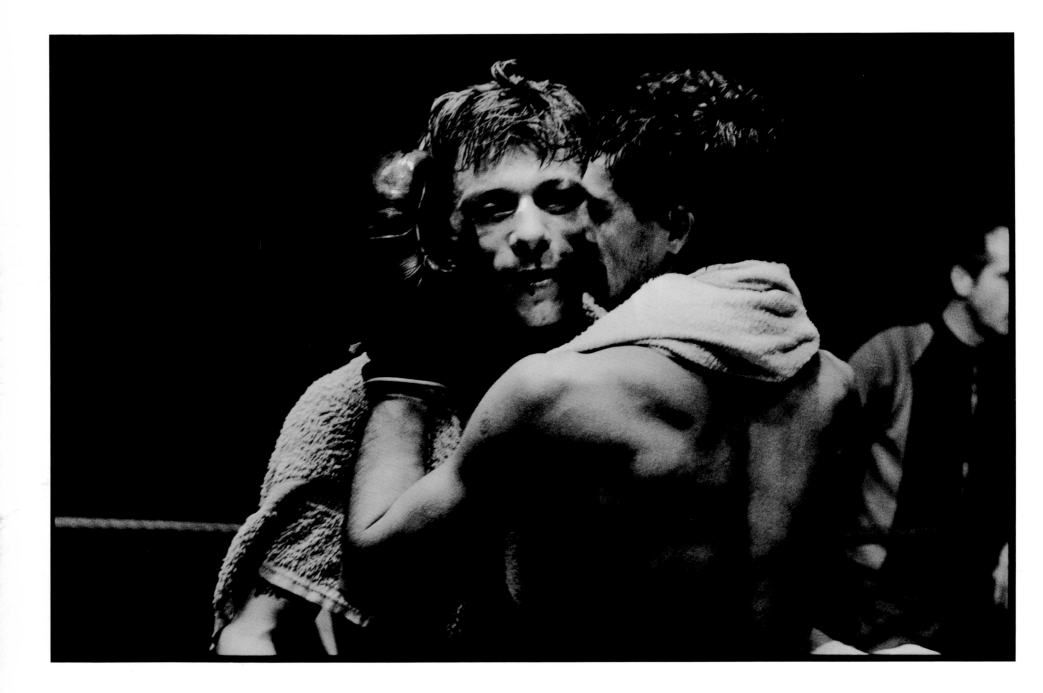

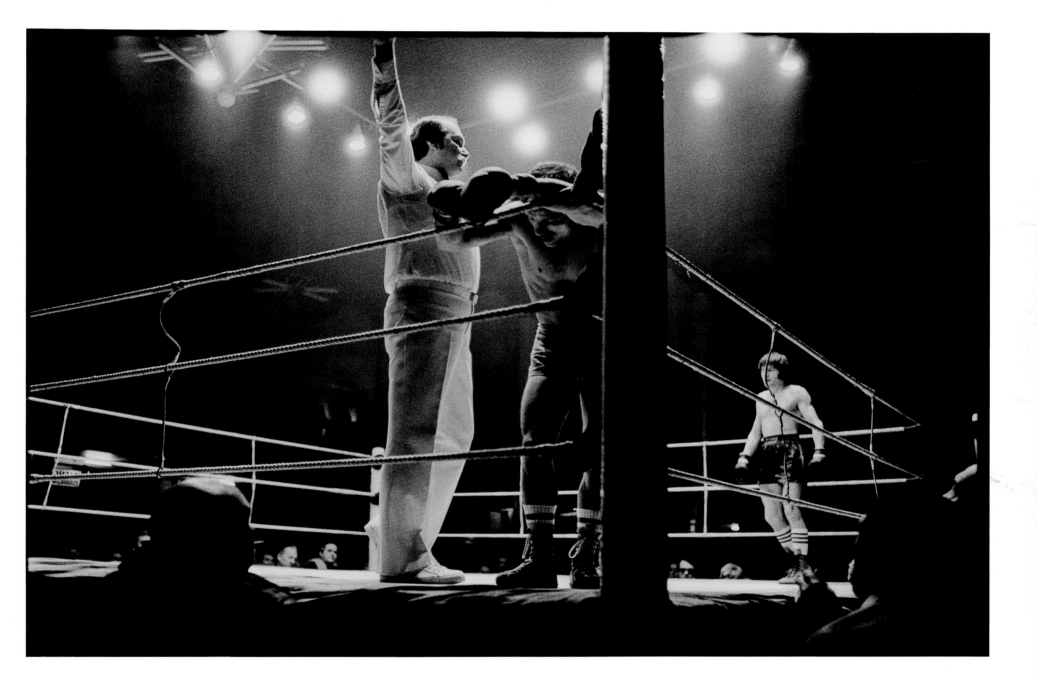

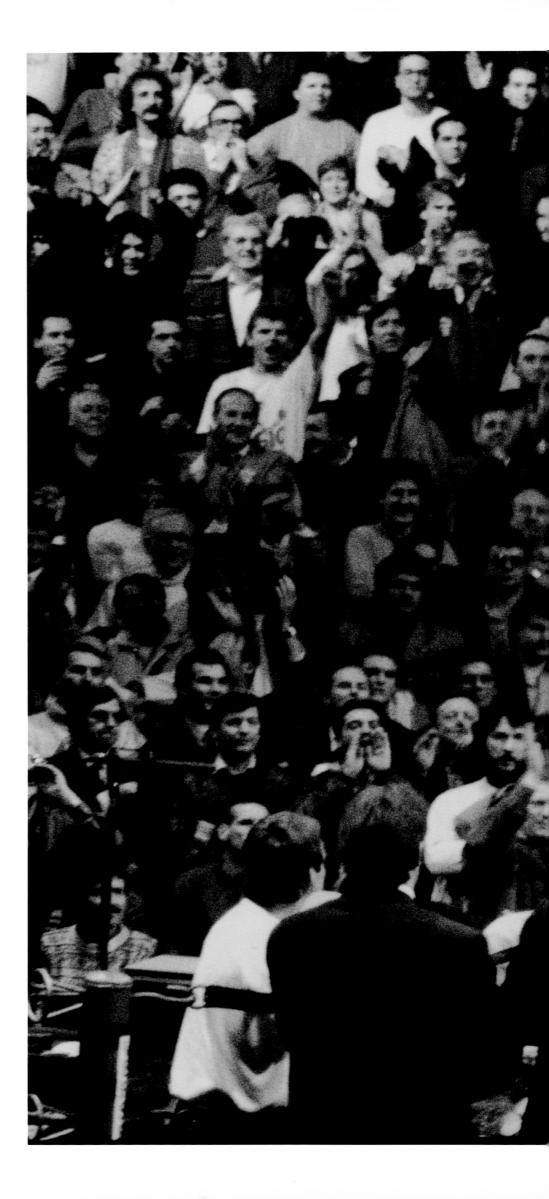

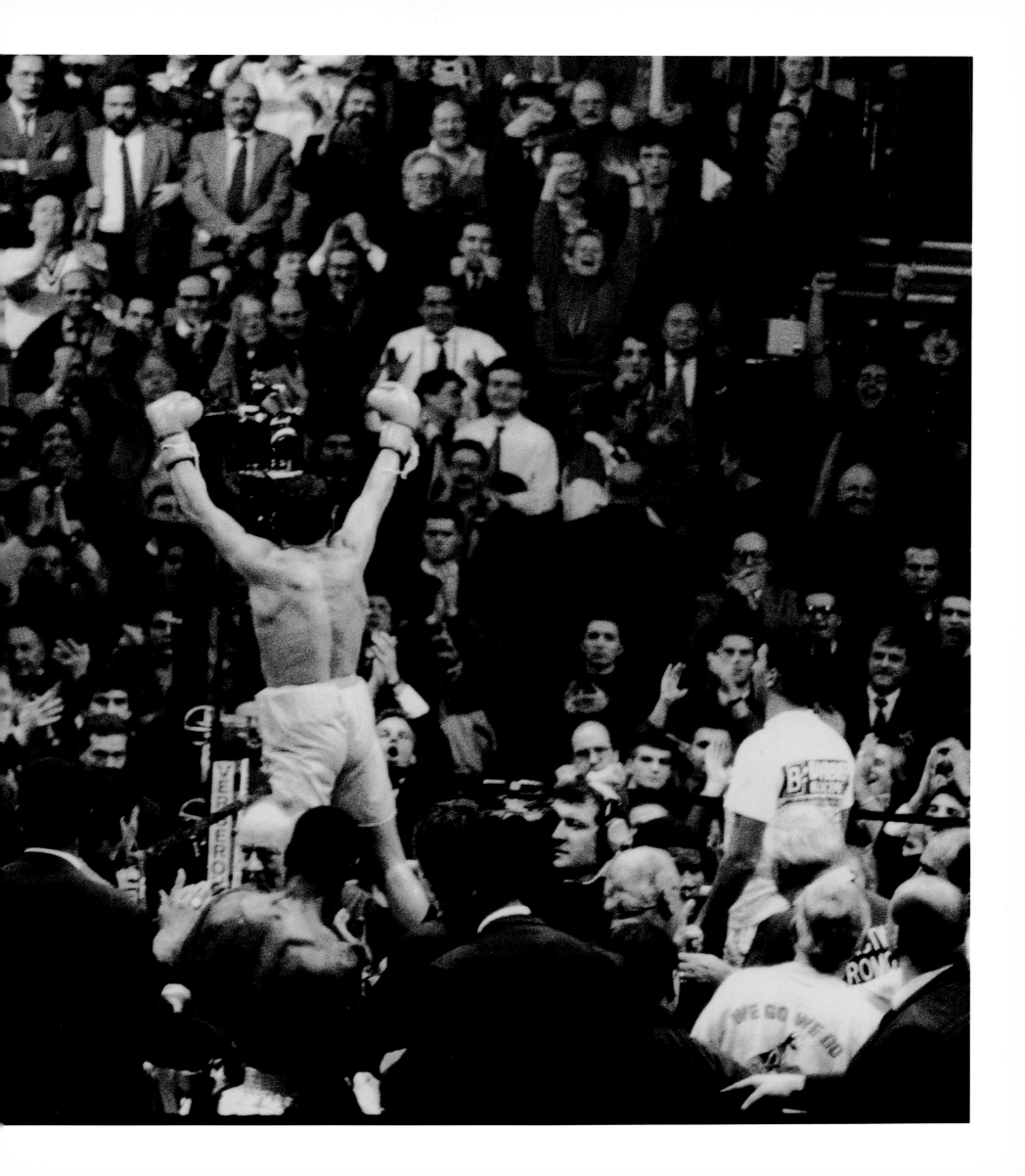

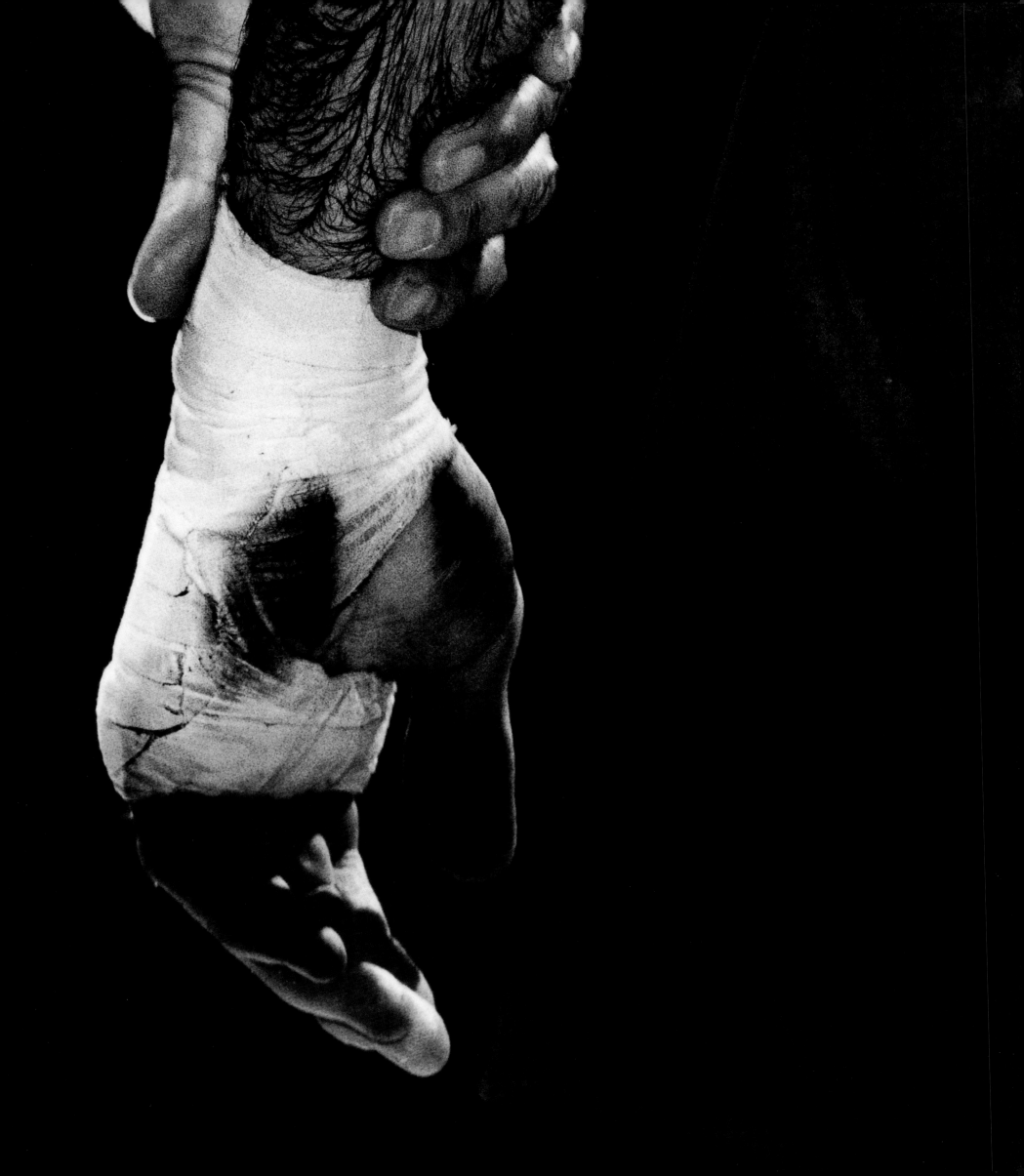

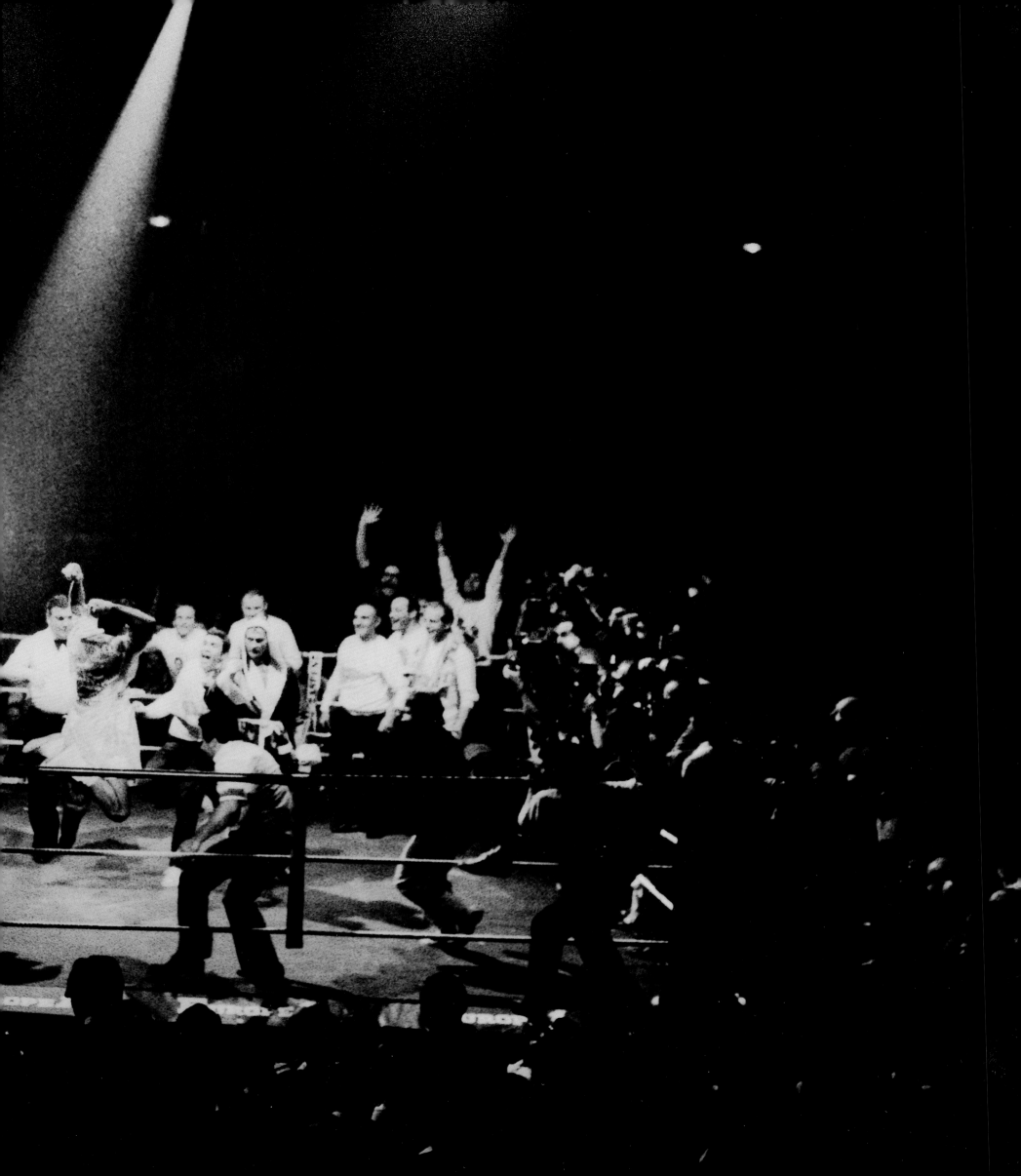

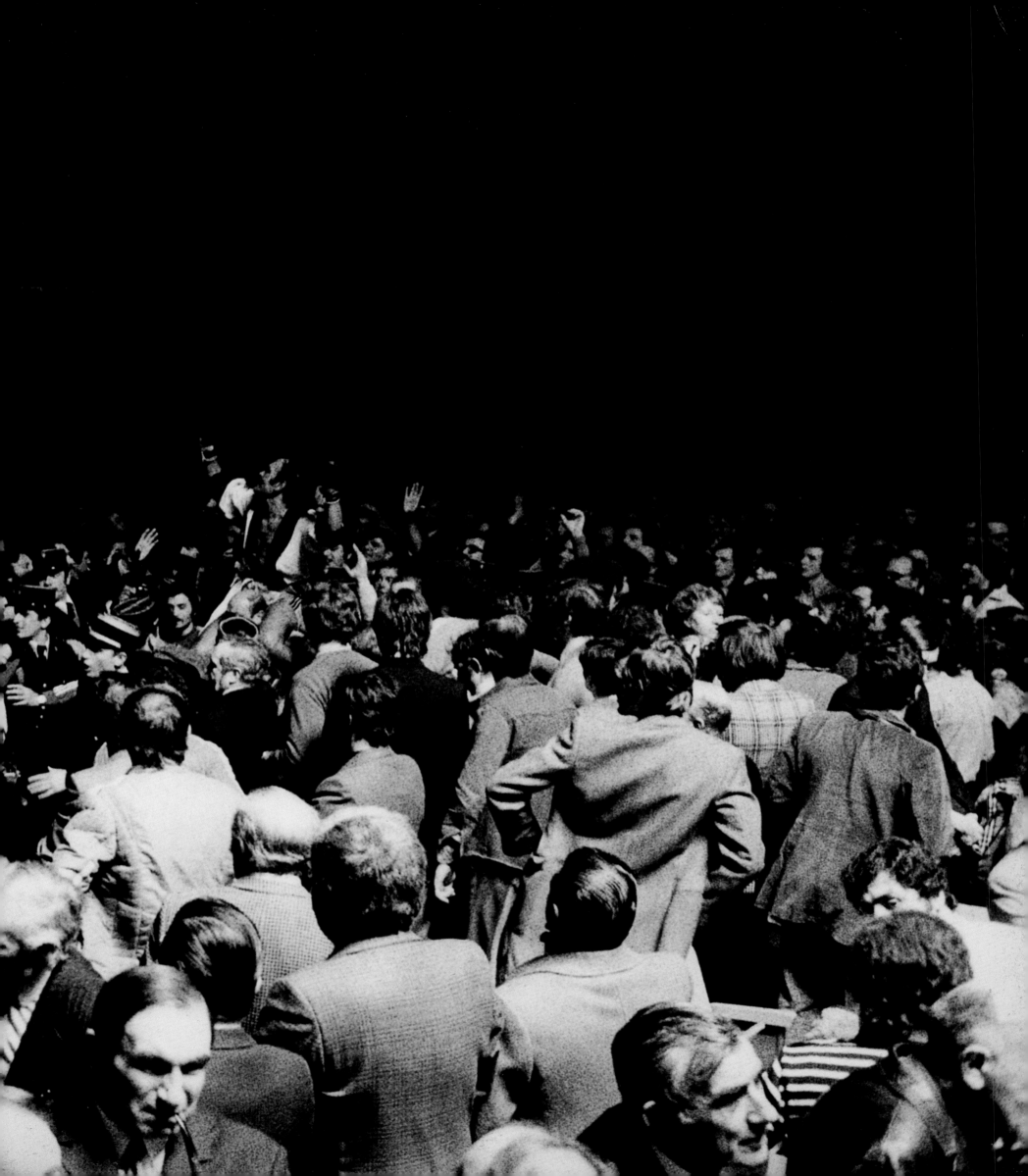

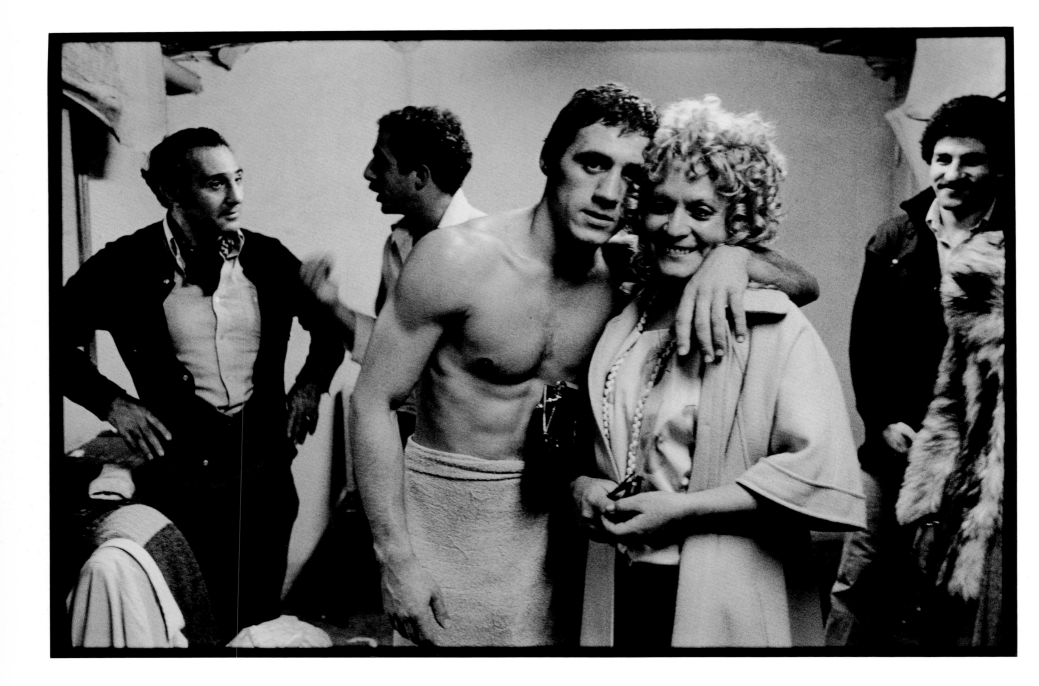

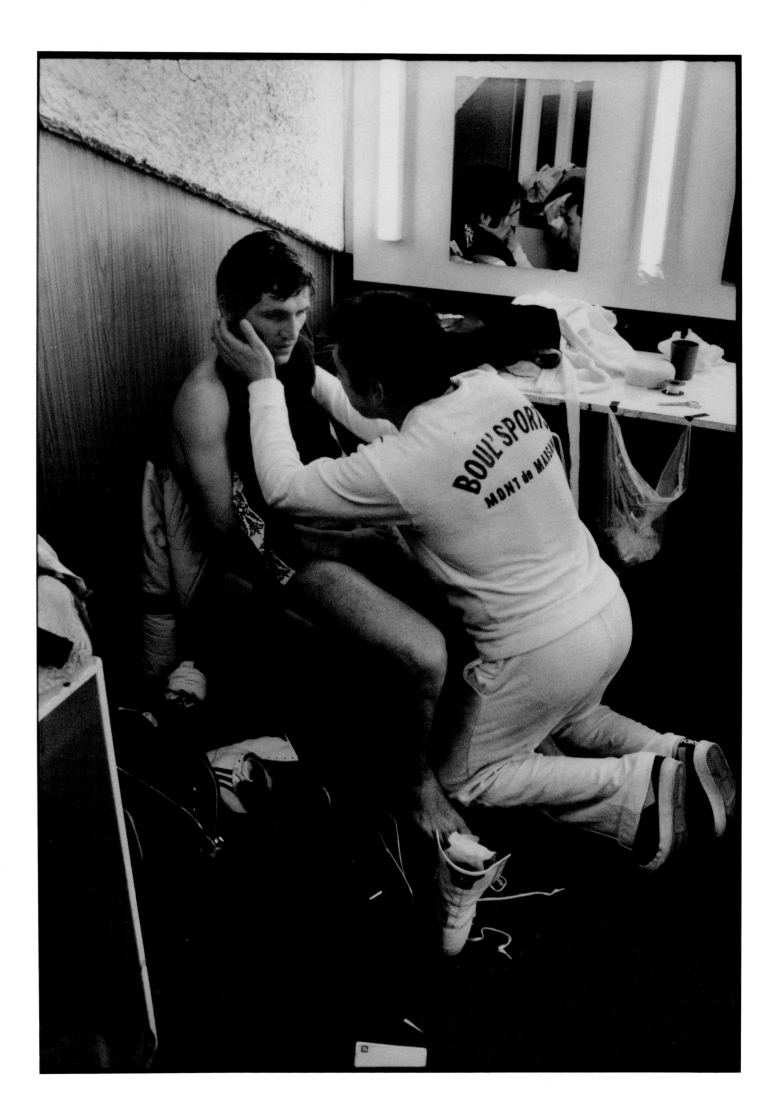

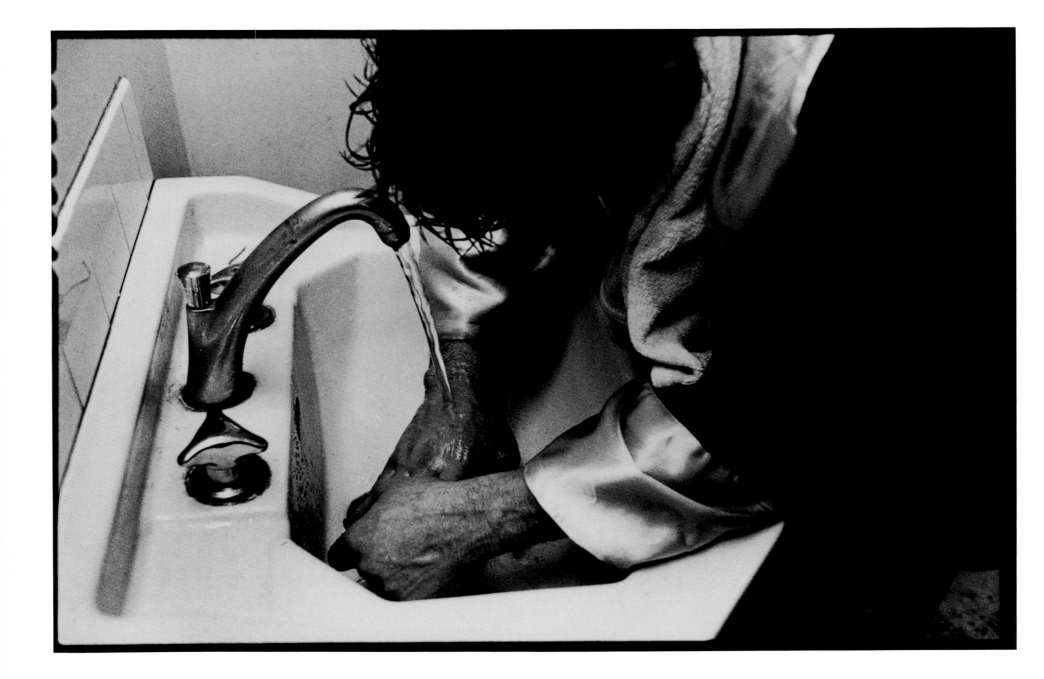

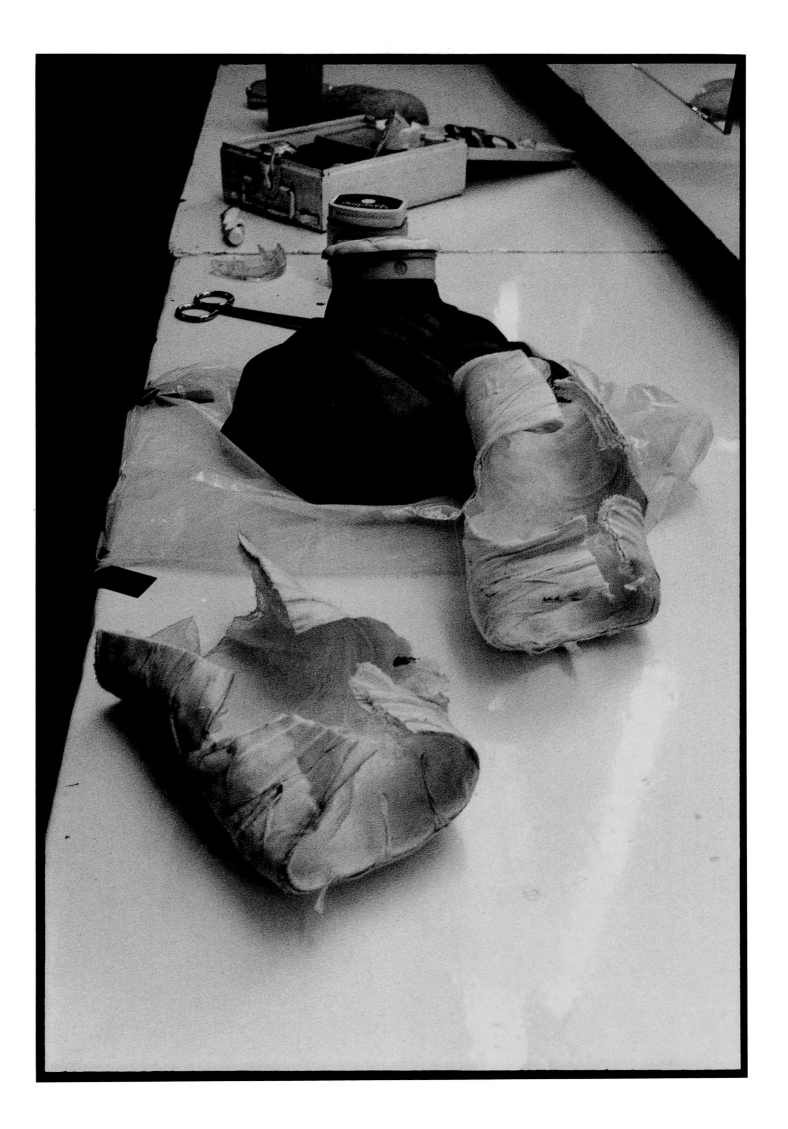

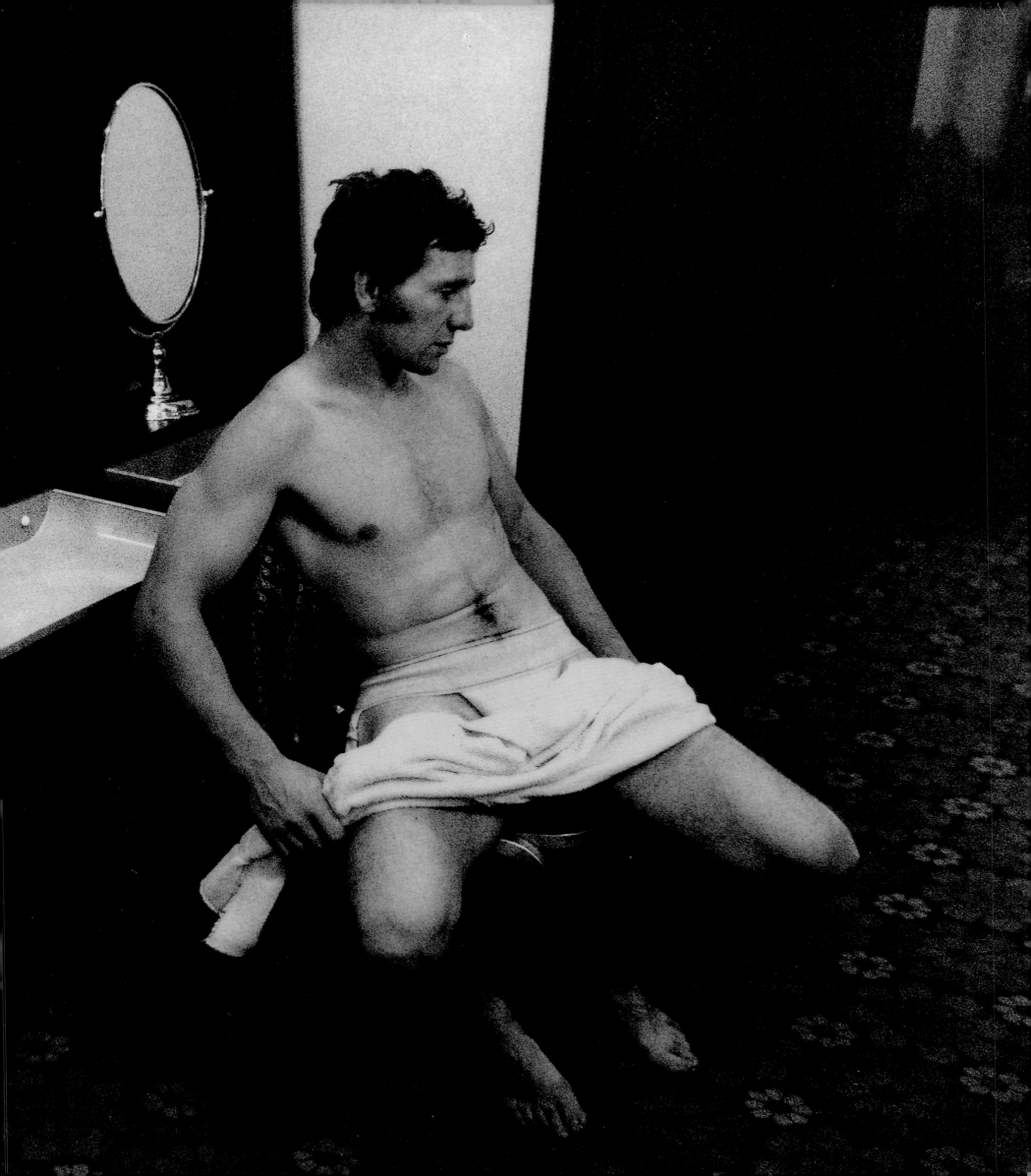

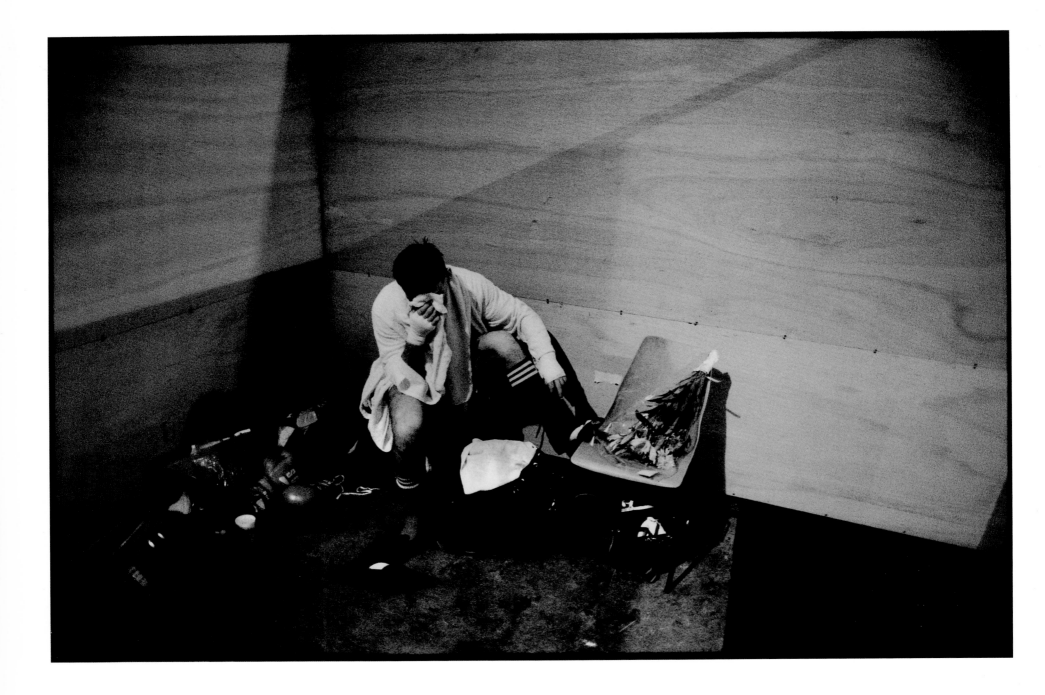

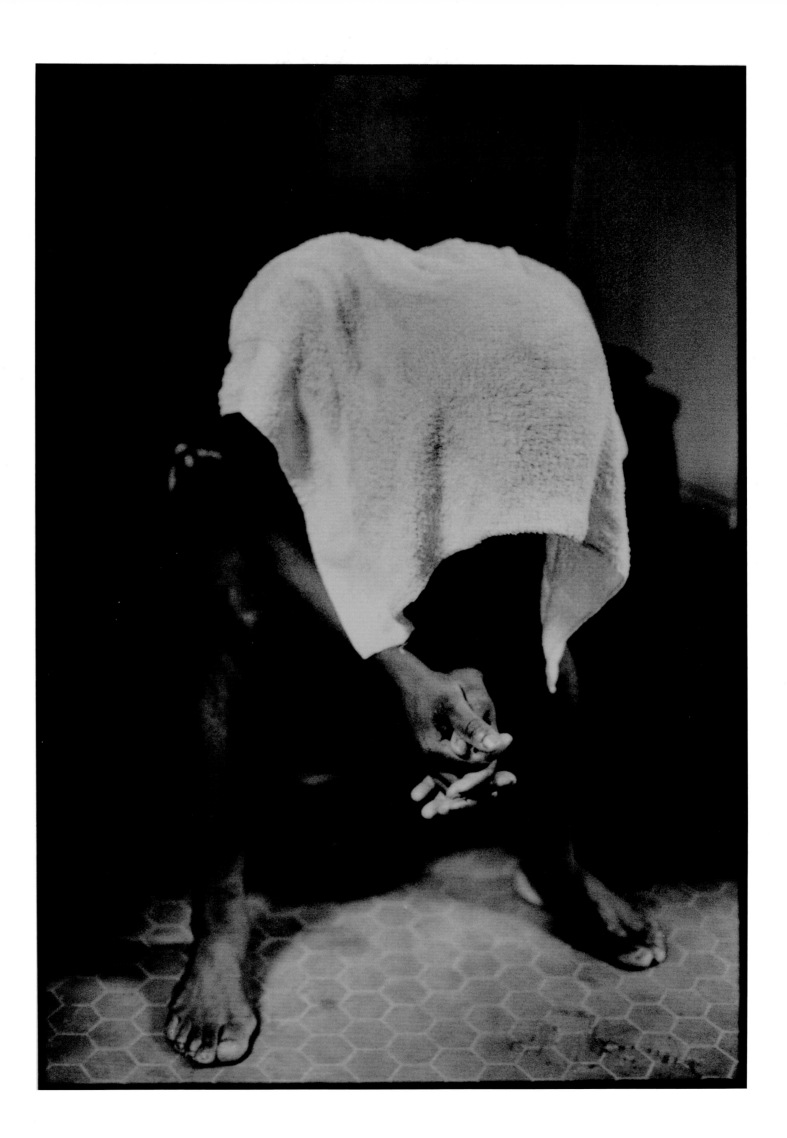

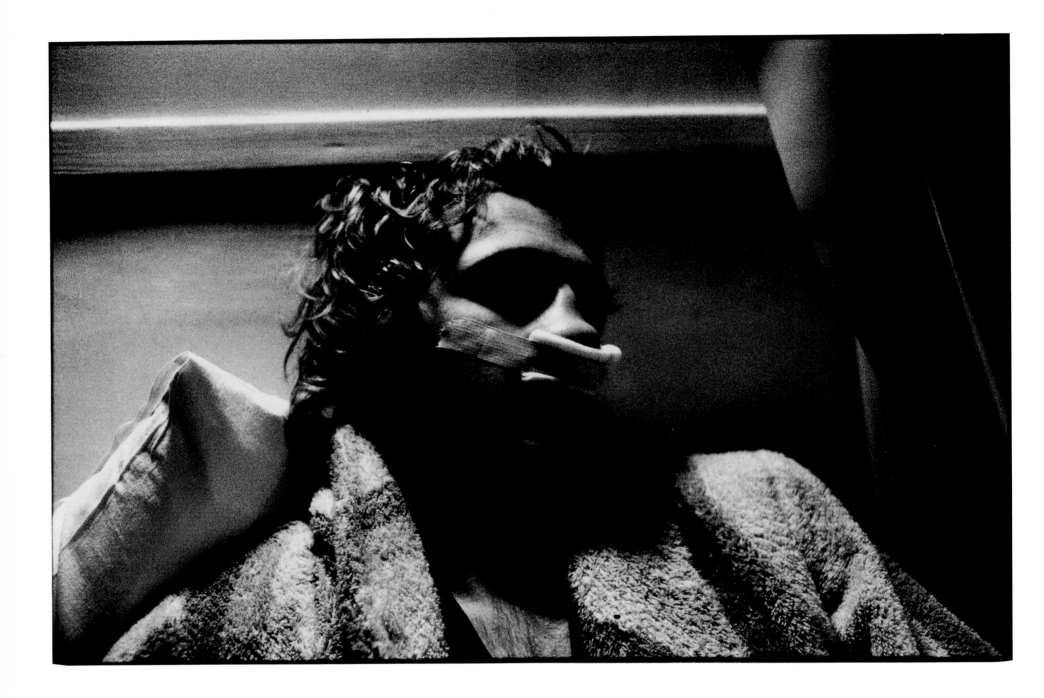

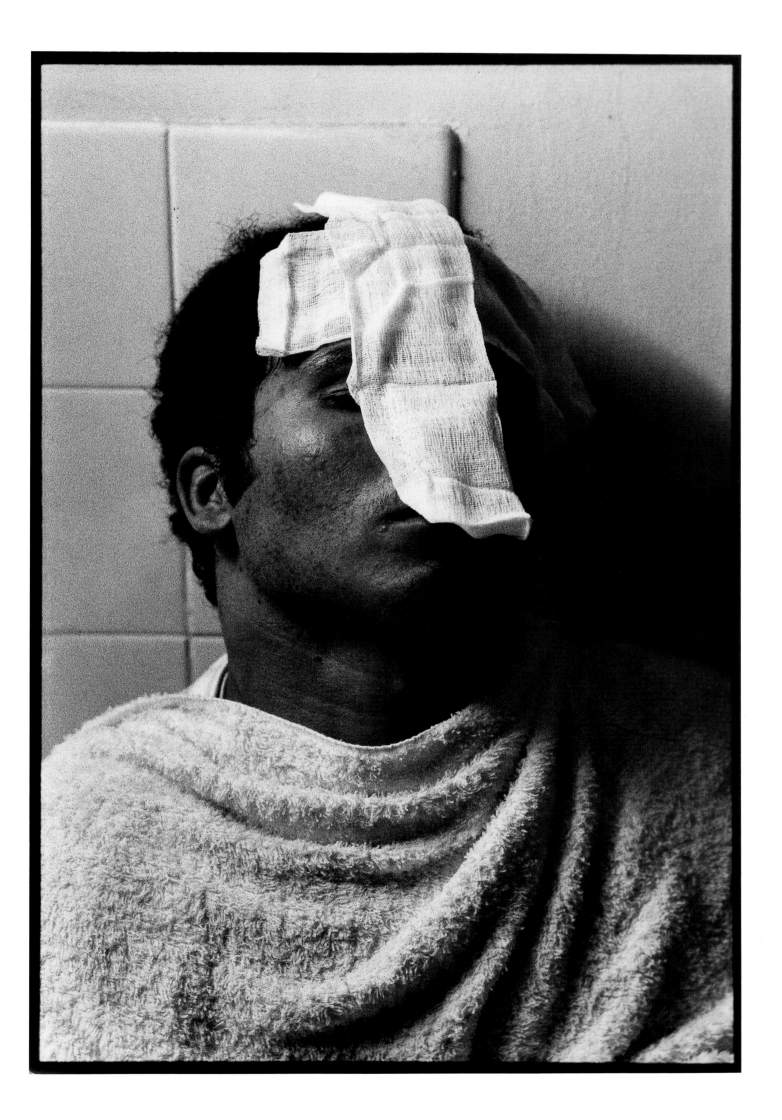

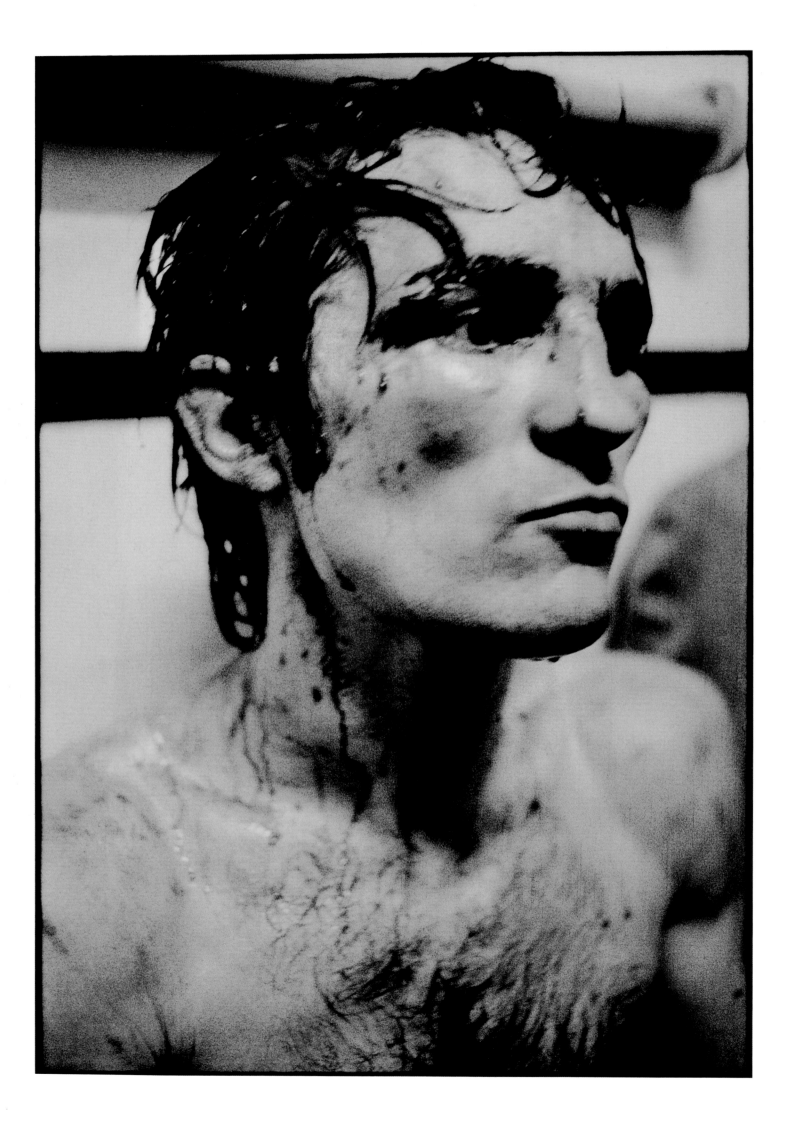

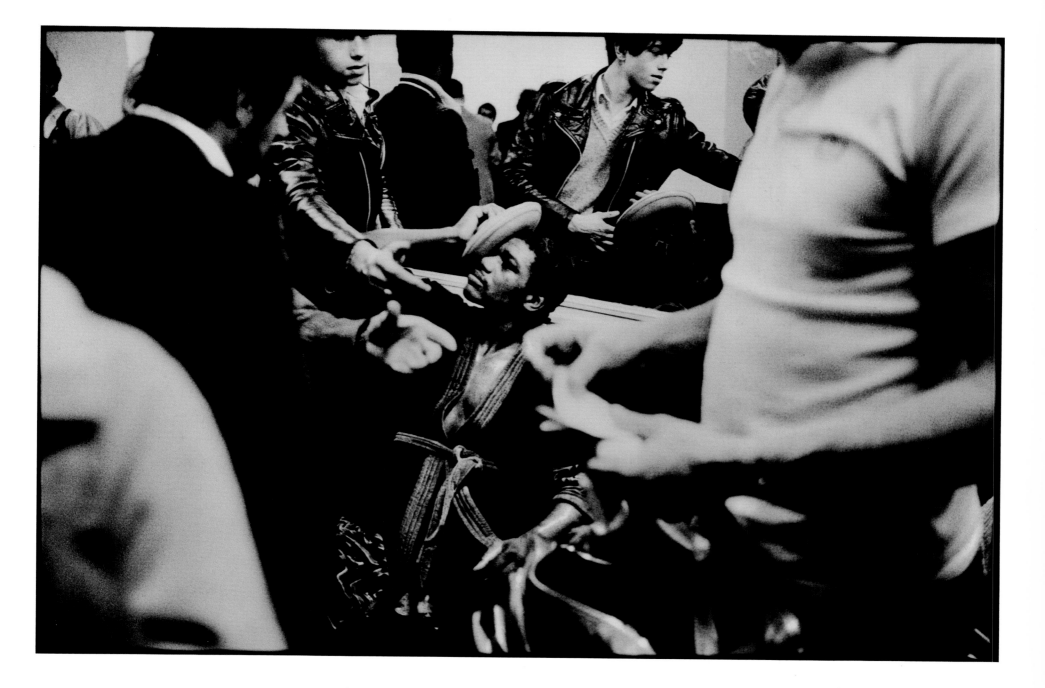

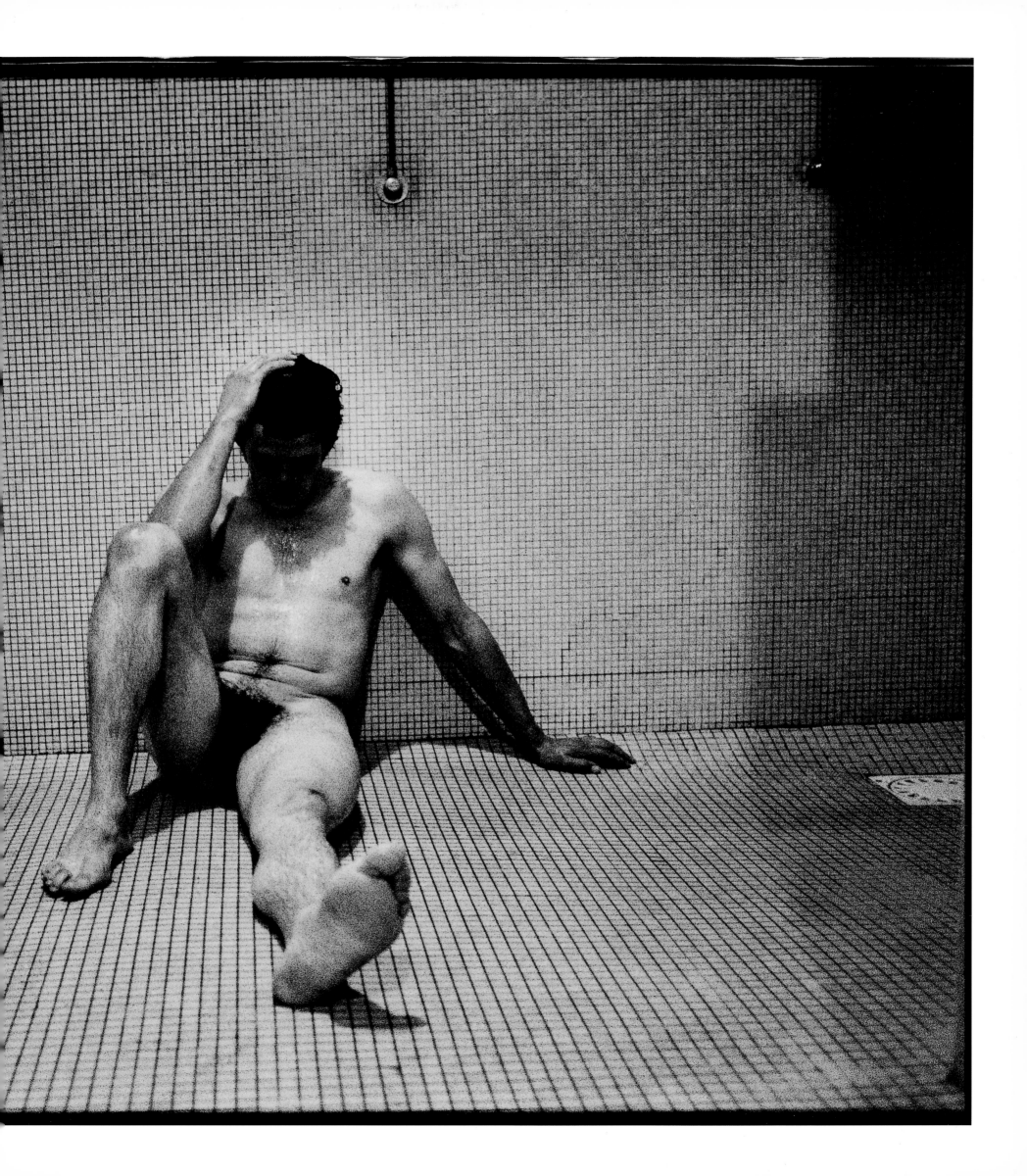

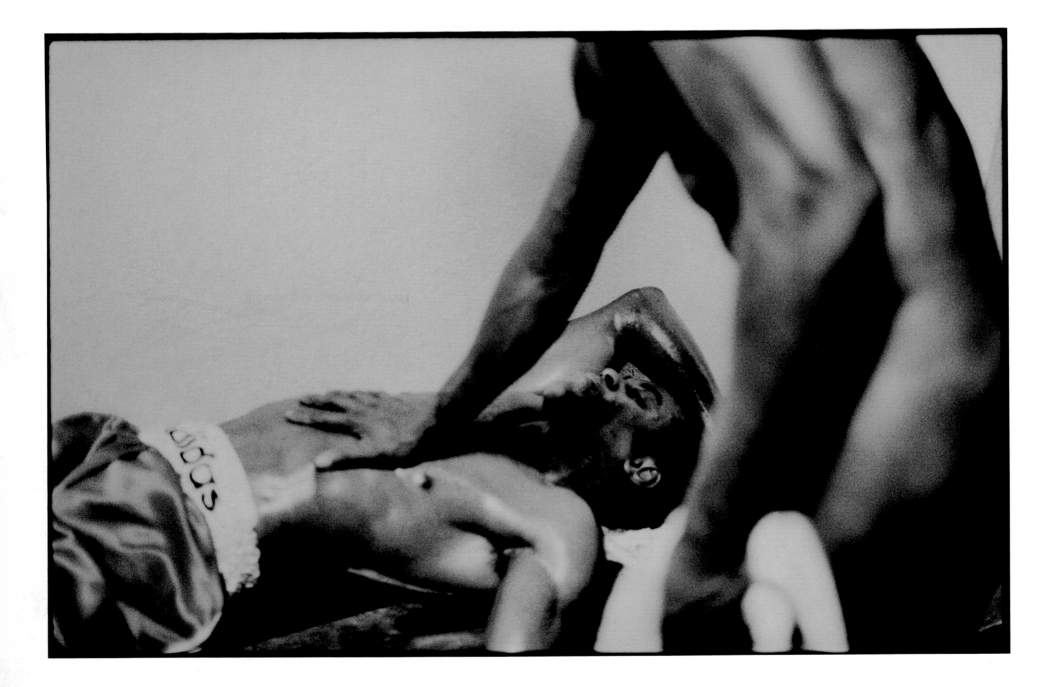

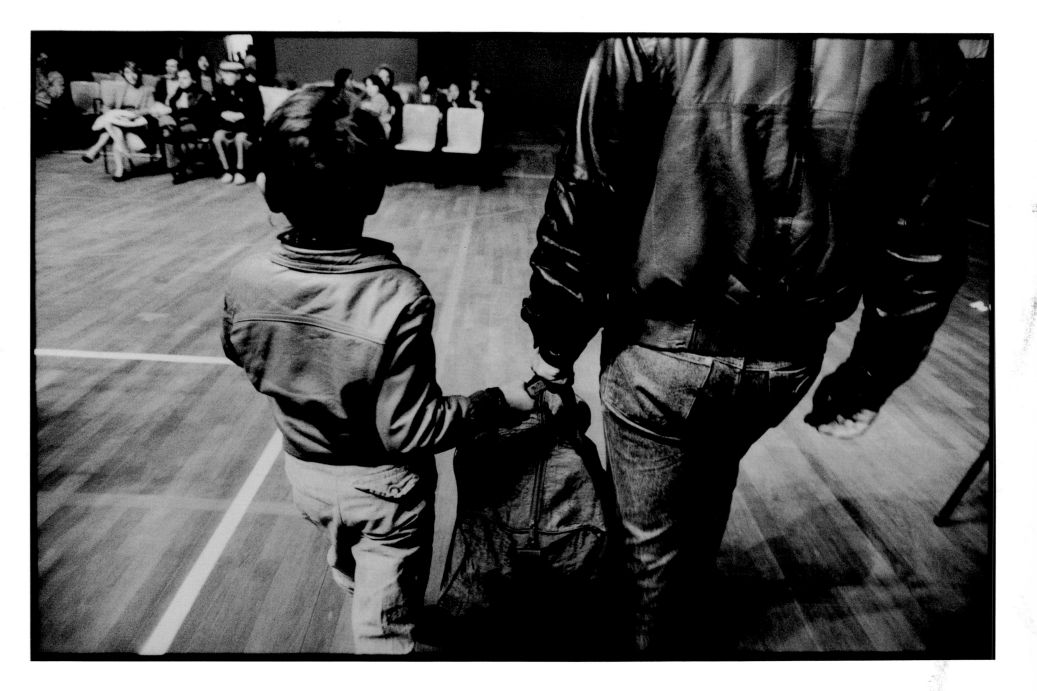

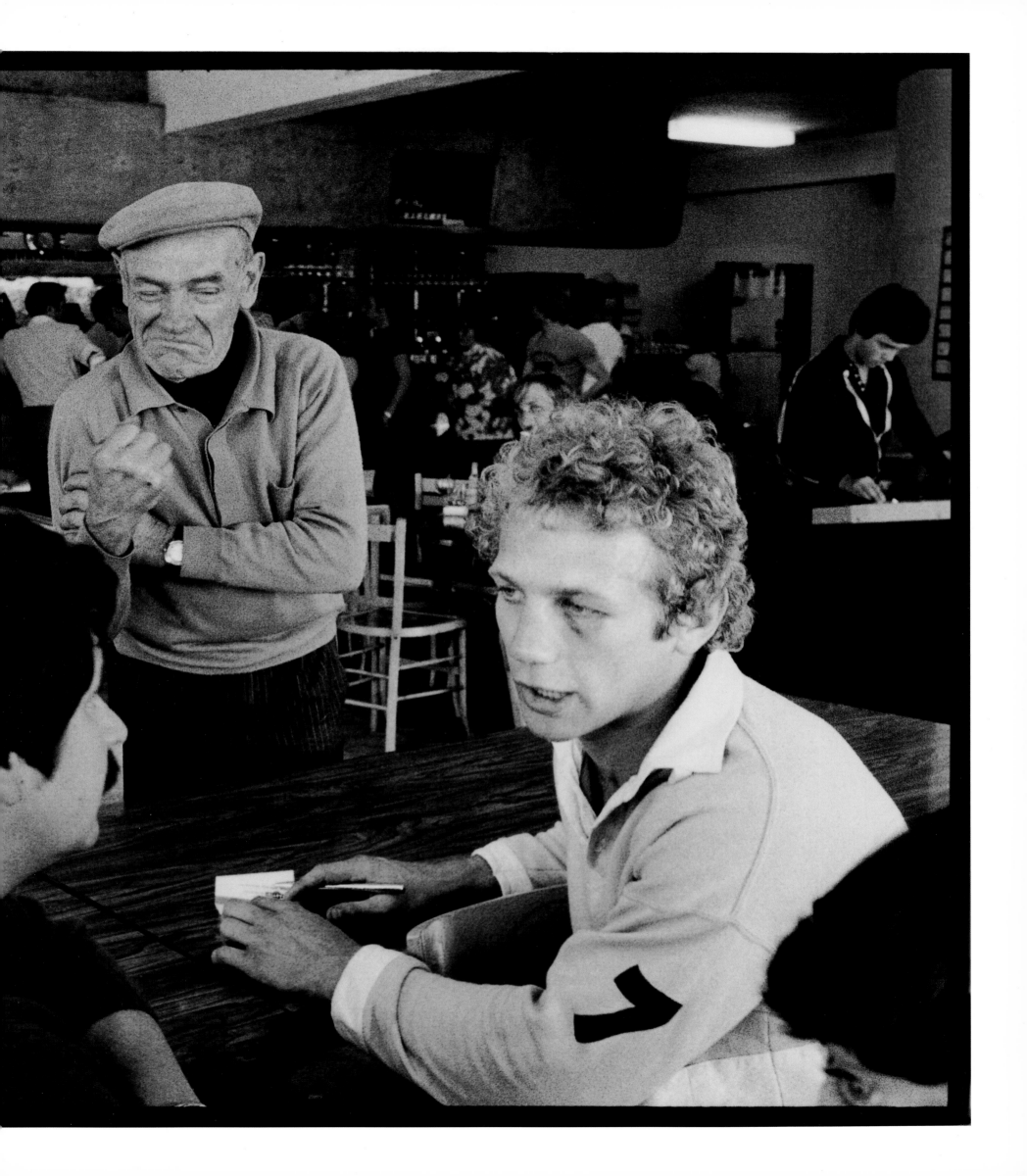

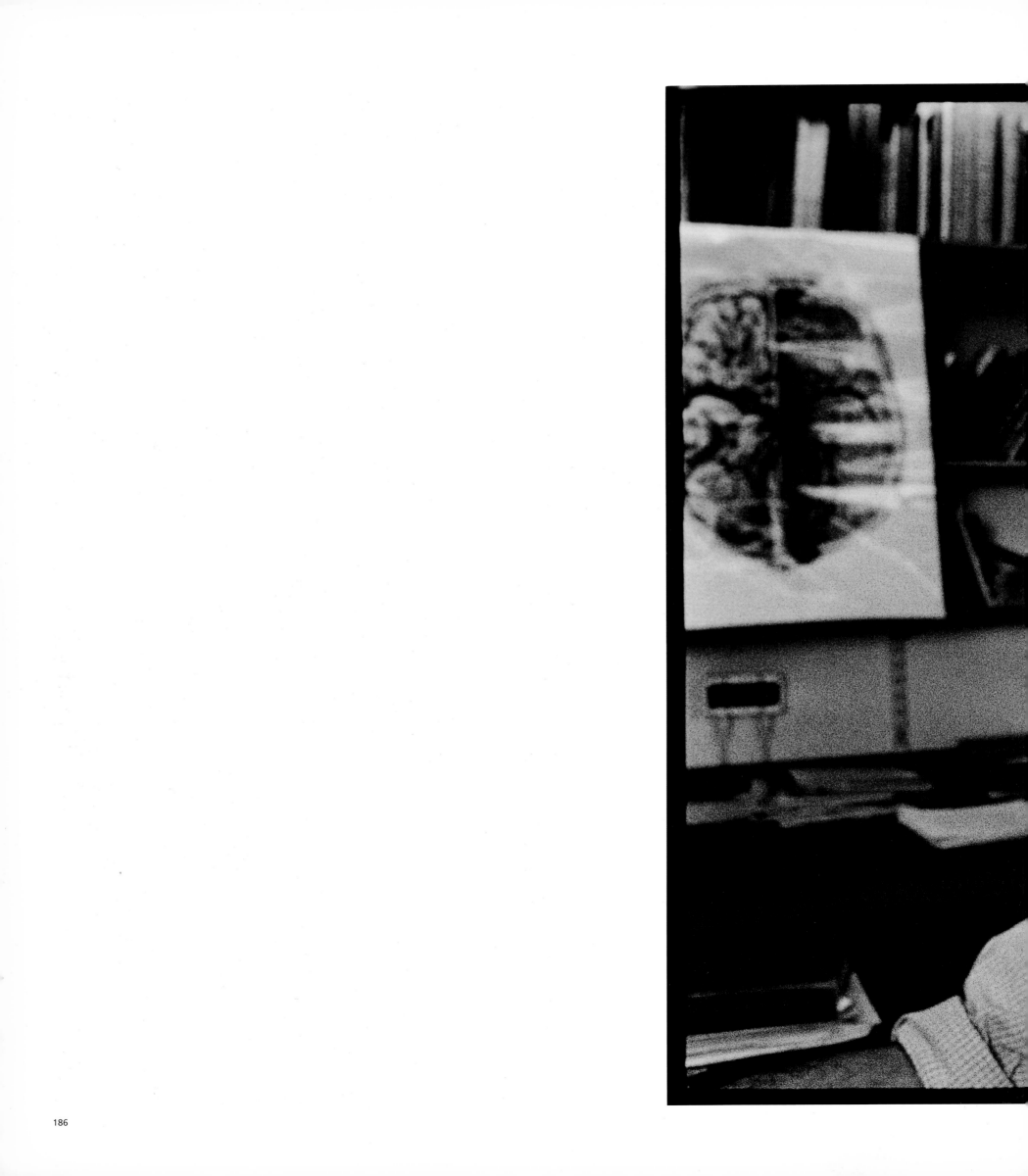

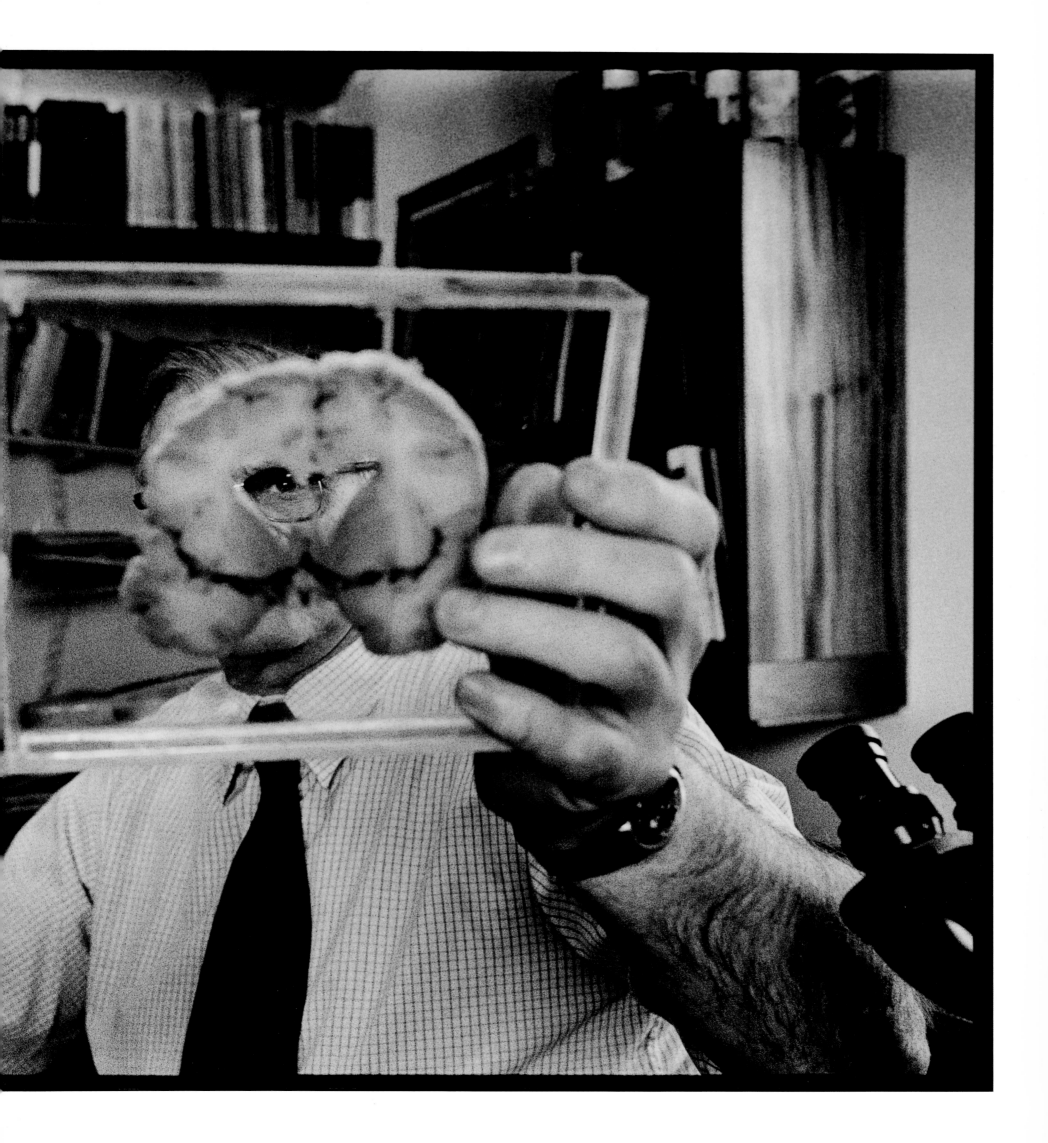

Captions

The Making of a Prizefighter

PAGE 4 (ABOVE) Joël Bonnetaz at the age of one with his sister Josiane and a babysitter. Berck-Plage, France, 1952.

PAGE 4 (BELOW) Joël aged ten. He was always a keen football fan, even during his boxing career. Bois de Vincennes, France.

PAGE 5 (ABOVE) Joël's first boxing portrait at the age of fourteen and a half. Berck-Plage.

PAGE 5 (BELOW) A portrait of Joël Bonnetaz at age seventeen and a half, on a shelf at his parents' home. Berck-Plage.

PAGE 6 (ABOVE) Although he was living in Paris, Joël sometimes made it home to his family. Here he shows his son David how to box. Berck-Plage, March 1973.

PAGE 6 (CENTRE) Joël gives his son some little red boxing gloves. Alfortville, France, May 1974.

PAGE 6 (BELOW) The Bonnetaz family: Joël, Josette and their son David. Alfortville, May 1974.

PAGE 7 (ABOVE) Joël with his wife and mother-in-law, visiting his grandfather. Provent, France, August 1974.

PAGE 7 (BELOW) One of the few times Joël took his son David to a fight was the night he beat Jean-Claude Warusfel for the French middleweight championship. Still bruised, he took David on his lap to watch the other fights. Cirque d'Hiver, Paris, 22 April 1976.

PAGE 8 (ABOVE) On weekends or during vacations Joël jogs in the dunes of his home town. Berck-Plage, July 1973.

PAGE 8 (CENTRE) Joël's last training session before the summer holidays at Jean Bretonnel's gym. Paris, June 1975.

PAGE 8 (BELOW) Joël's son David helps to remove his father's bandages after a fight. His old friend Claude Correa has followed his career since he arrived in Paris to become a professional boxer. Paris, August 1976.

PAGE 9 (ABOVE) Joël in his home town. He would get up early every morning and run 8 km in the nearby woods. Berck-Plage, July 1973.

PAGE 9 (BELOW) Joël happy to have defeated his Dutch opponent, Stan Driesche. The Hague, Netherlands, March 1975.

PAGE 10 Portrait of James A. Fox with his cameras at ringside. (Photo courtesy of Michel Bernier.)

Training

PAGES 18–9 Boxer Martin Nieves, from the Bronx, paces the floor of the Times Square Gym, 42nd Street, in front of a wall of posters advertising local and championship fights. New York, May 1979.

PAGE 20 Close to the Coliseum, in galleries below street level is the oldest boxing club in Rome. It's a real boiling pot – boxers, Africans, and some Swiss Guards trained there, as did Gregory Peck for a TV movie in which he played a cardinal during the Second World War. Società Pugilistica Audace, Rome, June 1988.

PAGE 21 Only amateur boxing is permitted in Algeria. Kubla Boxing Club in the densely populated suburbs of Algiers is surprisingly well equipped, perhaps as another way of keeping kids away from street violence. Algiers, April 1987.

PAGE 22 Commonwealth champion Bunny Sterling during afternoon training. Noble Art Gymnasium, London, June 1972.

PAGE 23 Beneath the Olympic Stadium in Rome is the Marina Militare boxing club. Team member Francesco Preziosa rolls his bandages before training. Rome, September 1979.

PAGES 24–5 The Solar Sporting Club on 28th Street attracts both kids and pros, training under the watchful eye of Django Diaz. New York, June 1975.

PAGE 26 American boxer Don Curry made the Méridien Hotel into his training centre for a championship fight, a carpeted and air-conditioned gym to which the press were invited. Paris, January 1989.

PAGE 27 Joël Bonnetaz in training for a demonstration fight. Club Med village, Al Hoceima, Morocco, July 1976.

PAGE 28 The Marina Militare Boxing Club under the Olympic Stadium in Rome is for members of the Italian Navy. Rome, September 1979.

PAGE 29 Everyone from pros to schoolkids comes to the Solar Sporting Club on 28th Street; it is a beehive of young hopefuls from the city and the suburbs. Emile Griffiths gives Gil Clancy a helping hand with the training. New York, June 1975.

PAGE 30 Amateurs training at the Institut National du Sport et de l'Education Physique (INSEP) boxing gym. The French Olympic team also train here. Paris, March 1973

PAGE 31 French boxer Eric Daponte in training at Ciboure Kirol Eskola boxing club. Saint-Jean-de-Luz, France, May 1992.

PAGES 32–3 The Etoile Sportive is an amateur club mostly attended by young boys. A local school gave them an upstairs room where the club fitted some poles from floor to ceiling and spanned ropes to make a ring. One small bulb lights the room, there are no changing rooms and the boxers stand on crushed cardboard boxes on the cold floor. Marrakech, Morocco, January 1988.

PAGE 34 The Naseria Club in the medina at Tunis dates back to 1907. Although it has limited funds, it produces good amateur boxers. On the left is Montassar Gannoni, a promising fighter who later won a scholarship to train at the Sports University in Havana, Cuba. Tunis, June 1988.

PAGE 35 A young French fighter and his coach prefer to train away from the stress of dressing rooms. Before the fight the boxer mentally centres himself, becoming unaware of his surroundings. Porte Pouchet, Paris, 1984.

PAGE 36 Francesco Preziosa, a sailor, does abdominal reflex press-ups. Marina Militare Boxing Club, Rome, September 1979.

PAGE 37 Boxer José Manuel Ruiz dries his hair against the warm radiator after a session while others train. Palacio de los Deportes, Madrid, October 1978.

PAGE 38 Commonwealth champion Bunny Johnson rests between sparring bouts at a famous club situated above a pub, the *Thomas Beckett*. London, June 1973.

PAGE 39 Ken Norton trains for a fight against Duane Bobick at Madison Square Garden. Solar Sporting Club, New York, May 1977.

PAGE 40 The laundry room at the Marina Militare Boxing Club. Rome, September 1979.

PAGE 41 Tunisian football club Espérance Sportive run a boxing club with three trainers in a large tin hangar that plays host to several sports. The boys train in the blistering summer heat as other kids and parents walk in off the street to watch. Tunis, June 1998.

PAGE 42 Bunny Johnson rests after a sparring session while his trainer reads a newspaper. London, June 1973.

PAGE 43 After training, Spanish champion Alfredo Evangelista wraps himself in a rubber cape and sweats it out in front of a radiator. Palacio de los Deportes, Madrid, October 1978.

PAGES 44–5 Although it is in the basement of a sports centre, the Levallois Sports Club is well equipped and attracts a lot of boxers, many of whom have African roots. They train and shadow-box to blasting music, sometimes looking like tribal warriors, swinging their arms in unison. Levallois-Perret, France, May 1994.

PAGE 46 The Società Sportiva boxing club near the Vatican dates back to 1909. Young Luciano Crescenzi rests his hand on the ringside ropes before training. Rome, September 1979.

PAGE 47 Headguards and skipping ropes hang on hooks in a local boxing club. Paris, March 1979.

PAGE 48 Gleason's Gym stays open all day, attracting not only professional fighters but also former boxers who enjoy the atmosphere. New York, May 1975.

PAGE 49 A young French boxer in a dressing room concentrates and poses before his fight. Porte Pouchet, Paris, November 1978.

PAGE 50 The Solar Sporting Club is popular with Hispanic-American fighters. A plaster statue of Christ stands close by as they train. New York, May 1977.

PAGE 51 A thirteen-year-old with the Virgin Mary tattooed on his back trains in the oldest boxing club in Madrid. A.D. Ferroviaria Boxing Club, Madrid, October 1978.

PAGES 52–3 Trainer Jaran Manzanet massages a fighter after training. The ever-present cigar in his mouth did not seem to bother the boxers. Solar Sporting Club, New York, June 1975.

PAGE 54 A trainer with a new boxer at the ASPTT Boxing Club. Paris, September 1976.

PAGE 55 Shadow-boxing is an important part of training, learning how to stay well balanced on both feet and yet have a good arm movement, keeping the fists high to ward off punches. Gleason's Gym, New York, May 1975.

PAGE 56 After a boxing lesson, young boys between the ages of nine and ten eat lollipops in the dressing room. Solar Sporting Club, New York, May 1977.

PAGE 57 The Argentinian world champion Carlos Monzon trained at the Fillipi Club in Paris for his title fight against Jean-Claude Bouttier. Among the spectators was actor Alain Delon who helped Bouttier with his training programme. Paris, September 1973.

PAGE 58 When Joël Bonnetaz was preparing for a French national championship fight, his club was kept open for him to train on Saturday afternoons without the distraction of other fighters. Salle Bretonnel, Paris, 1976.

PAGE 59 Young British boxer Ronnie Gibbons from Liverpool enjoys working out in the international atmosphere of the Solar Sporting Club. New York, June 1975.

PAGE 60 The Olympic Boxing Club is hidden away in the maze of alleys of the Mella district of Fez, where Jewish merchants used to trade before the country became independent. The building is three storeys tall with decorated alcoves and used to be a synagogue. It's barely big enough to hold a ring, with a few planks and *Rocky* posters on the walls, yet the young boxers give it all their heart and enthusiasm every night. Fez, Morocco, October 1991.

PAGE 61 Vasilica Vaciliv was a young Romanian refugee when I first saw him fight. Former boxer Stéphane Gondouin and his wife sheltered the boy and gave him their loft to train in. He had the instincts of a good boxer, having started at school in his homeland. Le Havre, France, November 1997.

PAGES 62–3 The official boxing club of Venice is outside the city centre, but the local council have opened a sports centre in a disused 18th-century church, La Misericordia. The amateurs train around the massive pillars and beneath the stained-glass windows decorated with religious scenes. The church was also used as an ammunition depot during the Napoleonic wars. Venice, Italy, April 1982.

PAGE 64 Joël Bonnetaz was fourteen-and-a-half years old when he first stepped into a boxing ring. He came to live in Paris to start a professional career but his wife and son stayed behind. He goes back to his home town for visits and holidays and still trains in his old club, abandoned due to a lack of members. Berck-Plage, France, July 1973.

PAGE 65 Joël Bonnetaz in training at the Salle Bretonnel. Paris, May 1973.

PAGE 66 Saoussem Bougham is fifteen and a half years old and a student. Her father brings her to box at the Naseria Club in the old medina of Tunis, but according to regulations, she is only allowed to do demonstration fights. There are three other women boxers in the club, an unusual thing to find in a Moslem country. Tunis, June 1998.

PAGE 67 Twelve-year-old Benjamin Perez training at the Solar Sporting Club, New York, 1979.

PAGES 68–9 Before training, Italian fighter Franco Siddu rolls his bandages. Firenzi Pugilato Club, Florence, Italy, April 1982.

PAGE 70 Julio Garcia bandages his fists before training. Solar Sporting Club, New York, May 1979.

PAGE 71 Joël Bonnetaz spars at the Salle Bretonnel, Paris, May 1973.

PAGE 72 Bunny Sterling has his face covered in Vaseline before sparring. Noble Art Gymnasium, London, June 1973.

PAGE 73 The Etoile Sportive Boxing Club is a small room above a school with peeling walls and only one light, but the boxers still enjoy their sessions. Marrakech, 1988.

PAGE 74 A sparring session between two champions, Bunny Sterling and Bunny Johnson. Noble Art Gymnasium, London, June 1973.

PAGE 75 The dressing room at the Noble Art Gymnasium, London, June 1973.

PAGES 76–7 Boxer Hervé Corak training at the Avia Club. It was here that Jean-Paul Belmondo trained before becoming an actor. Issy-les-Moulineaux, Paris, March 1973.

Before the Fight

PAGES 78–9 The Berg sports equipment factory makes five thousand pairs of boxing gloves a year. Each pair requires 228 g (8 oz) of pure horsehair, 114 g (4 oz) of Napa sheepskin, and four women and one man (the leather-cutter) to assemble it, each glove taking thirty minutes. The gloves are weighed on scales and reminded me of fat newborn babies. Nuremberg, Germany, December 1975.

PAGE 80 A satin gown and gloves lie on a ringside table, waiting for a boxer in a local competition. Paris, March 1979.

PAGE 81 The Salle Wagram is an old dance hall, but boxing competitions have been held here regularly since the beginning of the century. This boxer's suitcase holds his supper; some fruit and a sandwich. A portrait of legendary French fighter Marcel Cerdan keeps him company while he waits in the dressing room. Paris, December 1973.

PAGE 82 Jimmy Cruz's father helps him to prepare for a match. Sunnyside Garden Arena, Queens, New York, 1977.

Page 83 Mexican boxer José Figueroa has his skull massaged by his trainer before a fight. Cirque d'Hiver, Paris, May 1976.

PAGE 84 A boxer's dressing room after a fight, with his clothes and discarded bandages. The teddy bear on the poster looks like he's just been knocked out. Paris, March 1979.

PAGE 85 Mexican World Featherweight champion Julio Chavez was in Paris to defend his title against Faustino Barrios of Argentina. Alone in his dressing room, bandaged, a Mexican flag at the ready for his entry into the ring, he spends the last minutes concentrating. His whole life has been spent boxing; how many thousands of dressing rooms has he endured before? Stade Pierre de Coubertin, Paris, May 1986.

PAGES 86–7 Away from the lights of the ring, a boxer warms up against a wall among spectators. Paris, March 1991.

PAGE 88 Sometimes fights were held at the Porte de Pantin in a large circus tent, with dressing rooms built from chipboard. The evening would begin with some amateur fights. This boy stands anxiously waiting to be called to the ring, unaware of the spray-painted hand on the wall behind him reaching out for help. Paris, November 1982.

PAGE 89 A boxer's hand waiting to be gloved for a sparring session. Paris, 1979.

PAGE 90 Two brothers wait for their first amateur fight. Paris, February 1973.

PAGE 91 There is often tension in the dressing rooms as the fighters wait for their bouts to be announced and listen to those who have finished. Nemours, France, December 1973.

PAGE 92 In a dressing room a boxer's small son has watched his father from a young age. Twenty years later I saw him doing an amateur demonstration fight at a fundraising event. Salle Japy, Paris, January 1980.

PAGE 93 The annual Tournoi de Paris is a highlight of the amateur boxing season. A defeated boxer returns from the ring and watches another getting ready for his fight. Porte Pouchet, Paris, January 1992.

PAGE 94 In a suburban sports stadium, boxers warm up before their fights in the stairwell of the two floors leading to the ring. Paris, February 1982.

PAGE 95 Waiting for the fight to be announced is always an anxious moment. Fully dressed and gloved, the boxer spends a last few minutes concentrating after months of training. Paris, March 1988.

PAGES 96–7 Muhammad Ali and British boxer Joe Bugner at a press conference for a forthcoming fight. Hall of Fame, Madison Square Garden, New York, May 1975.

PAGE 98 Boxers are mentally and physically geared up for their fights, but if a match ends quickly they are sometimes over-tense. After his fight this boxer did many anti-stress exercises including jogging several times around a nearby football field. Paris, November 1984.

PAGE 99 A boxer sits alone in the shower area, hoping for some pre-fight tranquillity. Stade Pierre de Coubertin, Paris, March 1993.

PAGE 100 One night at the Salle Wagram there was a fight between two young actors, Marc Porel and Stéphane Jobert, both keen boxers. Stéphane is seen here waiting to go out into the ring in front of a real audience. Paris, July 1978.

PAGE 101 A boxer waits patiently for his bout in the ornate dressing room of the Napoleon Room at the Café Royal, Piccadilly, where the National Sporting Club holds monthly private boxing competitions for its members. London, June 1973.

PAGES 102 AND 103 This young boy is about to demonstrate his boxing skills at a juniors and professionals night, a proud moment for his parents out in the audience. Fontenay-sous-Bois, Paris, May 1996.

PAGE 104 The Porte Pouchet stadium is a breeding ground for amateur boxers, and many a champion has climbed the ladder of success from there onwards. The amateurs do only three rounds and must wait their turns; sometimes they find a seat behind the handball nets. Paris, January 1982.

PAGE 105 Boxer Hervé Corak with hands bandaged for training. Paris, 1976.

PAGES 106–7 Marks on a dressing room wall, left by the blood-splattered hands of a boxer after a wound to his nose. Paris, March 1979.

The Fight

PAGE 109 A charity fundraising event at Detroit's Olympia Stadium. Muhammad Ali took part in a short exhibition fight with local boxer Jimmy Ellis and stood pensively to listen to the Black National Anthem and the Star-Spangled Banner. Detroit, Michigan, June 1975.

PAGE 110 To the theme from *Rocky* and streams of smoke, a fighter makes his way to the ring in true Hollywood style. Salle George Carpentier, Paris, October 1991.

PAGE 111 Going up to the ring from the underground dressing rooms is like moving out of the twilight zone. French boxer Fabio Bettini comes out for a title fight against his compatriot Max Cohen in front of four thousand spectators. Stade Pierre de Coubertin, Paris, December 1973.

PAGE 112 A boxer captured in the spotlight as he enters the ring, the centre of attention of five thousand spectators. Stade Pierre de Coubertin, Paris, 1982.

PAGE 113 Laser beams, loud music from the film *Rocky*, and artificial smoke bombard the ring as Yugoslav boxer Edip Secevic raises his arms to announce his fight. Salle de la Mutualité, Paris, February 1986.

PAGE 114 Boxer Alain Ruocco from Toulon, France always kept a framed photo of his father as a young boxer at ringside and kissed it after a fight. Salle Wagram, Paris, April 1976.

PAGE 115 At some fights two pairs of gloves are placed on a towel in the centre of the ring before the fight. One of the trainers will flick a coin to see which boxer gets first choice of the gloves he is to wear. This old tradition can be still seen at smaller local events. Paris, April 1980.

PAGES 116–7 A moment's rest for Joël Bonnetaz before he knocked out Jean-Paul Serra in the fourth round. His trainer removes his mouthguard and another loosens his belt to allow better breathing. Salle Wagram, Paris, February 1974.

PAGE 118 Ringside spectators watch Joël Bonnetaz fight Gérard Nosley. Périgueux, France, January 1979.

PAGE 119 A trainer from Marseilles gives his fighter advice between rounds. Salle Wagram, Paris, December 1976.

PAGE 120 Enthusiastic local supporters hail their hero at an out-of-town competition. Conflans-Sainte-Honorine, France, June 1974.

PAGE 121 The National Sporting Club holds boxing tournaments in the Napoleon Room at the Café Royal. Dinner jackets are obligatory for the three hundred all-male members. London, June 1973.

PAGE 122 A spectator waits for the night of boxing to begin. Salle Edgar Quinet, Calais, France, April 1973.

PAGE 123 One of the best-known French managers and trainers was Jean Bretonnel, who regularly helped to organize bouts in Paris at the Salle Wagram. Here he is seen studying the seating plan for a competition at the Galaxy stadium. Paris, February 1974.

PAGE 124 Joël Bonnetaz before a fight. His fists are bandaged to prevent the metacarpals from being crushed by the force of the punches. Paris, 1975.

PAGE 125 A cigar-smoking spectator watches Joël Bonnetaz fight from a ringside seat. Paris, 1976.

PAGES 126–7 The ornate ballroom at the Café Royal, Piccadilly becomes a boxing venue for the private members of the National Sporting Club. The press is restricted to the orchestra balcony, which gives a magnificent view of the bouts through the chandeliers. London, June 1973.

PAGE 128 The Tournoi de Paris is the highlight of the amateur season for junior boxers. Porte Pouchet, Paris, November 1973.

PAGE 129 Algerian boxer Loucif Hamani is a hero to many young fighters of North African origin. He comes to watch the Tournoi de Paris from ringside and support his friends. Paris, April 1975.

PAGE 130 Ringside officials protect their suits from splashes of blood from an injured boxer. Palais des Sports, Paris, April 1976.

PAGE 131 A French boxer with a head injury. Cuts to the face can look spectacular but the wounds usually respond to quick treatment. Porte Pouchet, Paris, March 1989.

PAGES 132 AND 133 The final of the Tournoi de Paris amateur championships, lightweight division. A knockout ends the round at the ref's decision. Porte Pouchet, Paris, October 1979.

PAGE 134 Dozens of gypsy supporters crush around the ringside as their hero was proclaimed French champion. A sea of pride and raised hands blocks his path back to the dressing room. Stade Pierre de Coubertin, Paris, December 1980.

PAGE 135 This lady told me that she had once been an opera singer and enjoyed regular visits to fights. Cirque d'Hiver, Paris, March 1979.

PAGE 136 Sunday afternoon amateur tournaments are a gathering place to watch fathers and sons in the ring. Their wives and children come prepared for this family event. Paris, October 1982.

PAGE 137 At ringside for a Loucif Hamani fight is the young French actor Patrick Dewaere who often came to matches. It was the year of his film *Préparez Vos Mouchoirs*, which won an Oscar for best foreign-language film. Four years later, in July 1982 he committed suicide. He had been about to start work on a new film about the boxer Marcel Cerdan (*Edith et Marcel*) and had been in training for the part. Palais des Sports, Paris, June 1978.

PAGE 138 Two boxers in an amateur match. Salle Wagram, Paris, March 1973.

PAGE 139 A view from ringside, reflections in a spectator's glasses. Paris, April 1973.

PAGE 140 Joël Bonnetaz walks back to his corner as his opponent Jean-Claude Midoux is counted out in the eighth round. Salle Wagram, Paris, November 1974.

PAGE 141 Boxers tussle against the ropes, and the ringside spectators get all the excitement and tension of a night at the fight. Paris, March 1975.

PAGE 142 A break in the third round. Salle Wagram, Paris, March 1973.

PAGE 143 An amateur competition at the Salle des Fêtes, Issy-les-Moulineaux, Paris, March 1973.

PAGES 144–5 Between bouts, a boxer listens to his trainer giving instructions for the next round. Paris, April 1973.

PAGE 146 Boxers are trained to channel their strength into head punches. A full blow under the chin, called an uppercut, is the equivalent of three tons of power and can lift a man off his feet. These fighters are punching straight to the face with the full power of an outstretched arm and the strength of their body behind it. Paris, December 1981.

PAGE 147 An anxious spectator in the front row. Cirque d'Hiver, Paris, 1979.

PAGE 148 The circular building of the Cirque d'Hiver is often given over to boxing competitions. This fighter peers through the red velvet curtains to watch the progress of other fights before his turn comes. Paris, January 1980.

PAGE 149 A Chuck Wepner fight at Madison Square Garden, New York, May 1977.

PAGE 150 French boxer Gilles Elbilia on the mat during a count. Alfortville, France, 1979.

PAGE 151 Sunday afternoon amateur fights attract a lot of spectators, including children who copy the moves in the ring. Paris, 1977.

PAGE 152 Falling to the count, Mbuyanga Kalombo, a boxer from Zaire, is defeated by Taoufik Balboli. Stade Pierre de Coubertin, Paris, 1986.

PAGE 153 The referee raises and crosses his hands as the sign that the defeated boxer is out; his opponent jumps for joy. Cirque d'Hiver, Paris, October 1981.

PAGES 154–5 Not everyone can afford a ringside seat for an international championship gala evening. This is the view from the back row of the domed stadium during the match between Tony Mundine (Australia) and Bunny Brisco (USA) which ended with a knockout in the fifth round. Palais des Sports, Paris, February 1974.

PAGE 156 Joël Bonnetaz in his tenth winning round against Kevin White of England. Paris, November 1976.

PAGE 157 An unfortunate fall for Joël Bonnetaz in the years before he became French champion, yet he eventually won this match against Hassen Feguiri in the Tournoi de Paris. Salle Wagram, Paris, March 1974.

PAGE 158 Despite a very hard fight, these boxers have a high regard for one another and no ill feelings after a difficult six rounds. There is a great deal of mutual respect; they all have to train very hard and only one can be the winner. Paris, January 1980.

PAGE 159 The referee counts out an exhausted boxer struggling in his corner. Salle Wagram, Paris, January 1976.

PAGE 160 Italian boxer Vincenzo Nardiello was declared loser at the WBA World Middleweight Championship against Victor Cordoba of Panama. He angrily mounted the corner ropes, encouraging the thousands of spectators to acclaim him as the victor. Palais Omnisports de Bercy, Paris, December 1991.

PAGES 162–3 Waiting for the judges' results, the referee holds each boxer's hand. When the winner is announced his hand is raised high into the air as a sign of victory. Stade Pierre de Coubertin, Paris, September 1980.

PAGES 164–5 A happy moment for Gilles Elbilia as he wins the European welterweight championship against Frankie Decaestelker. Stade Pierre de Coubertin, Paris, October 1983.

PAGES 166–7 Hundreds of spectators watched Jean-Claude Bouttier and Max Cohen compete for the French middleweight championship. Cohen won the match, as Bouttier suffered a face injury. The new hero was carried shoulder-high back to the dressing room. Palais des Sports, Paris, December 1974.

After the Fight

PAGE 168 French boxer Gilles Elbilia hugs his mother in the dressing room after winning the French championship. Cirque d'Hiver, Paris, 1978.

PAGE 169 Boxer Christian Garcia is consoled by his trainer after losing a fight. Paris, February 1978.

PAGE 170 After a hard fight this boxer ran cold water over his sore fists for half an hour, not even bothering to get changed. Palais des Sports, Paris, December 1973.

PAGE 171 The fights are over and some discarded bandages and an icebag are the only remaining traces of the twelve-round championship. Palais des Sports, Paris, February 1978.

PAGES 172–3 Boxer Mick Hussey rests in the dressing room after a fight at the Napoleon Room. Café Royal, Piccadilly, London, June 1973.

PAGE 174 In his makeshift dressing room after a fight, a French boxer exhaustedly tries to take off his remaining boot, while flowers from his fans lie untouched on a chair. Paris, October 1985.

PAGE 175 An exhausted boxer in the dressing room after a tournament. Paris, June 1979.

PAGE 176 French boxer Joël Bonnetaz at the age of twenty-two, working his way up to pro standard. This broken nose required two days in hospital. Paris, 1974.

PAGE 177 It's after midnight and this boxer needs eight stitches above his eye. Salle de Fêtes, Issy-les-Moulineaux, Paris, March 1973.

PAGE 178 It takes a great deal of courage to get into a ring and fight. This boxer came away with a cut above the eye, requiring the referee to stop the match. Salle Wagram, Paris, February 1974.

PAGE 179 After a fight against French boxer Georges Warusfel, Achile Mitchel returns to the dressing area with an icepack to protect his swollen eye. Salle Wagram, Paris, November 1979.

PAGES 180–1 After a France–Portugal fight, this dazed boxer found himself alone in the dressing room and collapsed on the floor of the shower. I helped pick him up and found the ringside doctor; the young man was obviously suffering from exhaustion. Paris, November 1973.

PAGE 182 A boxer collapses exhausted after his fig[h]t a friend feels for his heartbeat. Porte Pouchet, Pa[ris] October 1978.

PAGE 183 Sunday afternoon tournaments are family gatherings. After his father's fight th[is] boy proudly helps to carry his bag to the e[] October 1986.

PAGES 184–5 Joël Bonnetaz returned t[] for a match against an English boxer After the fight, which he won, the l[] enthusiasm. Berck-Plage, August

PAGES 186–7 Dr J. Corsellis of [] Neuropathology at Runwell H[] called *The Aftermath of Boxi[ng]* likelihood of brain damage as a result of boxing. Wic[] January 1975.

PAGE 192 After mont[hs] running, young boxe[] a fight. Lost in his model of innocen[] My film had no[] half-invisible, Paris, 1982.

Acknowledgments

This book is the culmination of more than a quarter of a century of my work on boxing.
It is a kind of 'road movie' of my impressions, and I cannot include everything
and everyone I have met and seen, so I must apologize to the hundreds of boxers,
trainers, managers and spectators who helped me but who do not appear on these pages.
Above all I would like to express my deepest gratitude to Joël Bonnetaz and his family,
who were my first contact with boxing in early 1973, and to my family and friends
for their patience and understanding during my many years of wandering through
this twilight zone of the rings. It has been a memorable journey, one that I owe
to so many kind people, and it has opened my eyes and emotions
to a previously unknown world.

Photographic prints by Philippe Salaun, Georges Fevre, Voya Mitrovick and Nathalie Loparelli

The photographs in this book were taken using Nikon equipment.